Museums and Galleries of London

Abigail Willis

Museums and Galleries of London

Written by Abigail Willis
Cover photograph: Marcus Foster, Untitled, Image courtesy
of the Saatchi Gallery, London © Marcus Foster, 2010
Photo by Sam Drake © Saatchi Gallery

Edited by Andrew Kershman
Book design by Susi Koch and Lesley Gilmour
Illustrations by Lesley Gilmour

5th edition published in 2012 by
Metro Publications Ltd, PO Box 6336
London. N1 6PY

Metro® is a registered trade mark of Associated
Newspapers Limited.
The METRO mark is under licence from Associated
Newspapers Limited.

Printed and bound in India.
This book is produced using paper from registered
sustainable and managed sources. Suppliers have
provided both LEI and MUTU certification

© 2012 Abigail Willis
British Library Cataloguing in Publication Data.
A catalogue record for this book is available from
the British Library.

ISBN 978-1-902910-44-4

To Alex, with love

Acknowledgements

This 5th edition of *Museums and Galleries of London* would not have been possible without the help of many people. Thanks must go firstly to the team at Metro Publications – Andrew, Susi and Lesley – who published the first edition back in 1998 and who have kept the book in print through all the subsequent editions. Their support for the book has been unwavering and it has been great fun developing the format and style of the book with them over the years.

Researching a book about London is something of a logistical challenge for a Somerset-based author, and I would like to thank June Warrington, Tania Goodman and Clare Preston for having me to stay during my various research trips and for so cheerfully welcoming me into their homes. June also helped out with essential research information and materials, and, in common with all my friends, was an unfailing source of encouragement. I am also indebted to Toot Bunnag and Ingrid Grubben, who have continued to show me unstinting hospitality at the Bangkok Restaurant in South Kensington and whose delicious food has nourished me on many a museum-going expedition.

I must also mention Berry's Coaches, Taunton, whose amazing 'Superfast' service to and from the West Country has enabled me to write this book without breaking the bank.

My thanks also go to the numerous museum staff who helped me with my enquiries, and without whose kind co-operation this book would not have been possible. British life would grind to a halt without its army of volunteers – what I suppose we must now call 'the Big Society' – and the museum sector is no exception; I would like to pay tribute to all those whose unpaid work helps to keep our museums open.

Finally, I would like to thank my husband Alex, whose love and enthusiasm have sustained me through all five editions of this guide. He has patiently endured my regular absences while museum-mania took over my life and has been unfailingly supportive. I could not have written this book without him.

About the author

Abigail Willis is a freelance writer. Her passion for London's museums and galleries was ignited when she arrived in the capital as a fresh-faced history of art graduate, working at the Courtauld Institute. A member of the Critics' Circle, she is currently working on a book about London's gardens, to be published by Metro in 2012. She lives in Somerset with her husband Alex Ballinger, and a Norfolk terrier called Louis.

Contents

How To Use This Book

museum/gallery name

address &
contact details

chapter

website

nearest transport

opening times

admission price

shop

wheelchair access

location

Churchill War Rooms

- Clive Steps, King Charles Street, SW1A 2AQ
- 020 7930 6961
- www.iwm.org.uk
- St James's Park LU, Westminster LU
- Daily 09.30-18.00 (last admission 17.00)
- £15.95* (adults), £12.80* (senior citizens, students), free (under 16s) (*includes a voluntary donation)
- Shop
- Café
- Wheelchair access

Churchill War Rooms

museums

central

review

Winston Churchill and his ministers spent much of World War II holed up in these underground offices, for six years a secret nerve centre for the British government and military top brass. Preserved as an historic site since 1948 and still sporting original fixtures and fittings (although now staffed by a few mannequins), the CWR are a spookily atmospheric time capsule for the years 1939-45.

Built to withstand the Nazi Blitzkrieg, the CWR now surrender themselves daily to armies of visitors who file past rooms where history was made: the converted broom cupboard from which Churchill telephoned Roosevelt, the Prime Minister's spartan office-cum-bedroom, the Map Room, as well as the inner sanctum of the whole complex – the Cabinet Room itself. Less glamourous rooms like the typing pool evoke the drudgery of war work and there are displays examining different aspects of the war.

Introduction

Welcome to the 5th edition of Museums & Galleries of London. The capital is home to some of the greatest museums in the world and this book is designed to help you get the most out of them, whether you're a first time visitor or a dyed in the wool Londoner. Big institutions such as the Natural History Museum, the British Museum and the National Gallery are London landmarks but the capital is also remarkably rich in smaller, specialist outfits, and local museums, which perfectly reflect the city's origins as a series of neighbouring villages. Whether you're interested in dinosaurs or dentistry, firefighting or freemasonry, medicine or modern art, the chances are there's a London museum devoted to the subject – for proof, just turn to the subject index at the back of this book.

Visiting London's museums, I'm always struck by the intricate web of connections that binds London's history – for example William Hogarth, the British painter and printmaker, crops up in several museums: the Foundling Museum, the Sir John Soane Museum and St Bart's Hospital, while his 'country' house in Chiswick is also open to the public. Exploring London through its museums is a fascinating way to get a handle on the city's multi-faceted development, from its mercantile and maritime roots to its emergence as the capital of a global empire, and a powerhouse of technological and cultural innovation.

Since the first edition of this book was published in 1998, London's museumscape has undergone a revolution, with Heritage Lottery Fund money and the Millennium initially acting as a catalyst for major development projects at museums and galleries across the capital. Since the introduction of free admission in December 2001, visitor numbers at national museums in London that used to charge for entry have increased by an average of 152%, and indeed museum going has become something of a national pastime, eclipsing even football in popularity.

Although facilities have improved hugely, some of the more obvious museums on the tourist trail can get crowded at peak times. This is where London's excellent smaller, less well-known museums come into their own. If you're interested in Ancient Egypt but can't face the hordes at the British Museum, why not try the charming Petrie Museum nearby? Or perhaps you're keen on science and technology but want to avoid legions of hyperactive kids at the Science Museum – check out the Kew Bridge Steam Museum, the Faraday Museum or the gory, glass-cased specimens at the Hunterian Museum.

Buoyant visitor numbers however don't tell the whole story, and today the museum sector faces uncertain times – cuts in central government funds and even bigger cuts at the local authority level spell tough times ahead. Staff redundancies at museums like the Museum of London, reduced opening hours (even at the British Museum which in January 2011 cut its late night openings from two to one night a week) and an increased use of volunteers over trained staff will gradually take their toll on services. Since the last edition, there have been a few casualties – among them North Woolwich Old Station and the Pumphouse Educational Museum in Rotherhithe – but big projects, such as the new Herzog & De Meuron building at Tate Modern, expansion at the Geffrye Museum and the relocation of Design Museum to the former Commonwealth Institute building are still going ahead.

Although entrance to the national museums is still free, visiting can be expensive, with charges now being made for floor plans and increasingly hefty ticket prices for special exhibitions. If you're planning regular visits to these, one way to get your money's worth is to become a 'Friend' or 'Member' of the institution in question. Perks typically include unlimited free access to paying exhibitions, special viewings and events, a glossy magazine and use of a special 'friends room'. Forward planning helps time-poor visitors too, and you can usually download a map from the bigger museum websites, and work out your route in advance. Museums can be hungry work and while in-house museum cafés and restaurants often provide excellent fare, they can be pricey. Packed lunches are a practical solution, particularly for families, and many of the bigger museums provide picnic areas.

Museums can be hard on the feet too – London doesn't seem to be getting any smaller and this guide includes museums at several extremes of the Underground network, from the Museum of Nostalgia in Upminster to the Windmill Museum in Wimbledon and all points in between. So leave your high heels at home but don't forget to bring this guide and, above all, enjoy London's museums – they are among the best in the world.

Abigail Willis
January 2012

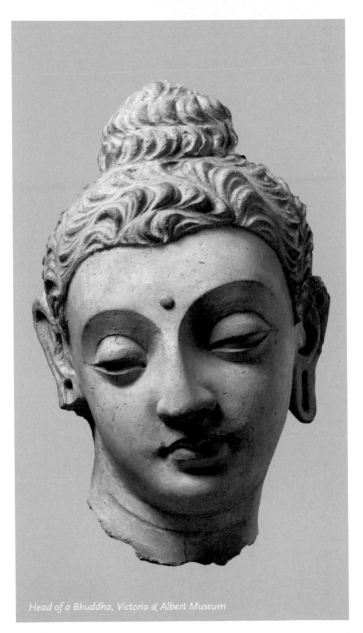

Head of a Bhuddha, Victoria & Albert Museum

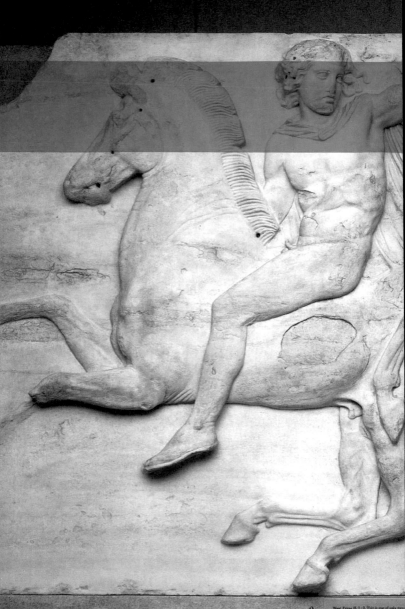

Frieze from the Parthenon, 5th century BC

2

West Frieze II, 2 - 3. This is one of only two ro... of the west frieze in the British Museum. It s... two horsemen, one of whom leans over his ... shoulder. His left arm is raised, perhaps to ad... the bronze wreath that once adorned his head ... to signal. Drill-holes indicate where the wreath ... was attached.

Museums

Central	6
North	88
West	108
South	226
East	159
Outskirts	172

The West Frieze is mostly still in Athens. A few have been made of the reliefs, and copies may be seen in the Museum. Unlike Slab N to the Acropolis seen the west side of the frieze first, where scenes of preparation form for the cavalcade than ran along the and south sides.

Central

All Hallows by the Tower Crypt Museum

- 🔲 Byward Street, EC3R 5BJ
- ☎ 020 7481 2928
- ✎ www.abbtt.org.uk
- 🚇 Tower Hill LU
- 🕐 Mon-Sat 10.00-17.00
- 💷 Admission free (donation appreciated); brass rubbing centre
- 🛍 Shop

This tranquil church is worlds away from the teeming tourist trap that is Tower Hill. Housed in the original Anglo-Saxon church, exhibits range from archaeological finds and church plate to a tessellated Roman floor and rare Anglo-Saxon stone crosses. Founded in AD675, All Hallows is one of London's most historic churches: Samuel Pepys watched the Great Fire from its tower and William Penn, the founder of Pennsylvania, was baptised here (the beautifully carved font cover by Grinling Gibbons can be seen in the church itself). On a more nautical note, tucked away in the undercroft is the barrel-shaped crow's nest used by Sir Ernest Shackleton on his last Antarctic expedition. Free guided tours run most afternoons between April and September.

Anaesthesia Heritage Centre

- 🔲 21 Portland Place, W1B 1PY
- ☎ 020 7631 1650
- ✎ www.aagbi.org
- 🚇 Oxford Circus LU, Regent's Park LU, Great Portland Street LU
- 🕐 Mon, Tues, Thurs, Fri 10.00-16.00
- 💷 Admission free (appointment recommended)
- ♿ Wheelchair access

A one room display relating to anaesthesia, pain relief and resuscitation. Early objects include the primitive hand bellows and pipes used to literally pump comatose patients back to life. Treasures in the 2000-object collection include an original 19th century John Snow chloroform inhaler from the early days of anaesthesia and the ECG machine used during George VI's final lung operation at Buckingham Palace.

Apsley House, The Wellington Museum

🏠 149 Piccadilly, Hyde Park Corner, W1J 7NT

☎ 020 7499 5676

✎ www.english-heritage.org.uk

🚇 Hyde Park Corner LU

🕐 Wed-Sun 11.00-17.00 (Nov-Mar 11.00-16.00)

💷 £6.30 (adults), £5.70 (concessions), £3.80 (children)

🛍 Shop

♿ Limited access for visitors with disabilities

Home of the 1st Duke of Wellington, Apsley House, No. 1 London, must be the swankiest address in town. Its plush interiors are dressed to impress, gleaming with gilt and gold to reflect their owner's status as the hero of Waterloo. Many medals and orders can be admired in the basement gallery, along with a changing display of the (often vicious) satirical cartoons the Duke inspired. His military successes brought material gain, and the house positively groans under the weight of lavish gifts from grateful heads of state. Commemorative porcelain and silver dinner services crowd the cabinets of the Plate and China Room while the staircase is dominated by Canova's deeply kitsch nude statue of Napoleon (apparently even the Emperor himself was embarrassed by the outsized sculpture and banished it to the Louvre).

The first Duke's painting collection is still in situ and contains some real showstoppers, among them Velazquez's justly famous *Waterseller of Seville* and Goya's portrait of the Duke on horseback. Elsewhere in the vast Waterloo Gallery earthy Dutch and Flemish genre scenes, like Jan Steen's bawdy *Egg Dance* rub shoulders with devotional subjects like van Dyck's *Saint Rosalie* and Correggio's *Agony in the Garden* – a strange mix which makes for interesting viewing. Paintings of Wellington's comrades in arms hang in the ultra masculine environment of the Striped Drawing Room and include Lawrence's stirring portrait of him, looking every inch the Iron Duke.

The Bank of England Museum

🖾 Threadneedle Street, EC2R 8AH (entrance in Bartholomew Lane)

☎ 020 7601 5545

🖎 www.bankofengland.co.uk

🚇 Bank LU

🕒 Mon-Fri 10.00-17.00

💰 Admission free (audio tour wands may be hired for £1)

🛍 Shop

♿ Disabled access (please telephone in advance)

What better place to get a handle on monetary matters than at the Old Lady of Threadneedle Street herself? The museum tells the story of the bank from its foundation as a private enterprise in 1694 and, like many an old institution, its history is a flamboyant one – on some occasions the gatekeeper wears full 17th-century livery, and up until 1971 the bank had its own military guard.

Displays trace the development of banking practice from goldsmiths' receipt notes through to electronic dealing, and include a full-sized reconstruction of Sir John Soane's 18th-century banking hall, one of the earliest surviving cheques (dated 8th December 1660) and a million pound note. Gold bullion and one of the millions of quill pens that the Bank's clerks in the 19th century got through every year can be found in the 1930's-style Rotunda. The Banknote Gallery displays some fine examples of the paper money-maker's art, including the master drawings for various notes, as well as following the chequered history of the £1 note from 1797 to 1988. Historically the 'quid' was a popular subject for forgery and visitors can see for themselves the tools of the trade used by forgers such as Charles Hibbert (hanged in 1819 for this treasonable offence).

A permanent display celebrating the career of Kenneth Grahame, the author of *The Wind in the Willows*, opened in October 2008. Exhibits throw light on Grahame's 30 year tenure at the Bank which included being shot at by an unhinged intruder and the author's resignation under mysterious circumstances.

Interactive computers are a feature of the contemporary banking displays and offer proactive participation to help visitors get to grips with modern issues such as inflation, interest rates and the Euro. If you're feeling flush after a go on the foreign exchange game, treat yourself to a gold proof sovereign in the museum shop or cut your losses with a chocolate bullion bar.

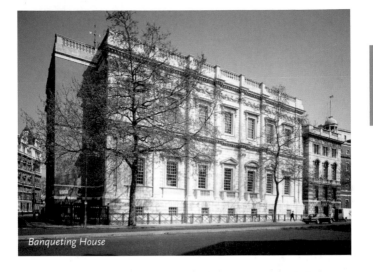

Banqueting House

The Banqueting House

- Whitehall, SW1A 2ER
- 0844 482 7770 (group booking)
 0844 482 7777 (Historic Royal Palace's 24-hr information)
- www.hrp.org.uk
- Charing Cross Rail/LU, Embankment LU, Westminster LU
- Mon-Sat 10.00-17.00 (sometimes closes at short notice for functions)
- £5.00 (adults), £4.00 (senior citizen/students), free (under 16s); DVD and Audio Tours are included in admission fee
- Shop
- Wheelchair access (telephone in advance)

Designed by Inigo Jones, the Banqueting House is an architecturally distinguished building, its beautiful Renaissance proportions having been calculated in accordance with the Roman ideal of perfection. Inside, its ceiling is graced with some typically fleshy paintings by Rubens, commissioned by King Charles I to glorify the divine nature of monarchy. Ironic, then, that the Banqueting House's place in history is assured as the venue for the execution of said king in 1649. However, in a nice example of historical symmetry the Banqueting House was also where his son, Charles II, was offered the throne back in 1660. Still in demand as a function room today, the Banqueting House often closes at short notice for events – to check opening times before your visit, ring 0203 166 6154/5.

British Dental Association Museum

🖼 64 Wimpole Street, W1G 8YS
☎ 020 7935 0875
✎ www.bda.org/museum
🚌 Oxford Circus LU, Bond Street LU
🕐 Tues & Thurs 13.00-16.00 (other times by appointment)
♿ Admission free
🛍 Shop
♿ Wheelchair Access

Probably not one to visit en-route to your dentist, this one room museum shows a carefully edited selection of dental artefacts from the BDA's vast collection. Displays concentrate on dentistry in the 19th century with scary-looking extraction implements, a clockwork drill, early toothbrushes and a red plush hydraulic dentist's chair from the 1890s – complete with spittoon. Technical developments in dentures, fillings and orthodontics are also charted and the displays also find time to recount the story of the nation's dental health and the surprisingly new concept of 'teeth for life'. Visitors can also watch vintage footage of dentists at work and admire 'Harry' the dissectible papier maché anatomical model. The small sales point keeps its sense of humour intact with 'molar' golf tees at 3 for a £1 and postcards of 18th-century dental cartoons.

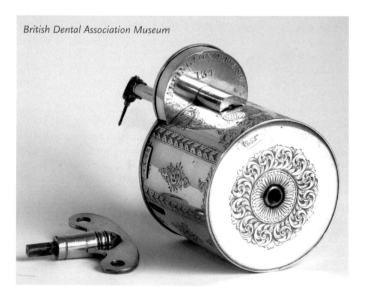

British Dental Association Museum

British Museum

- Great Russell Street, WC1B 3DG
- 020 7323 8181 (Ticket Desk)
 020 7323 8299 (general information)
- www.britishmuseum.org
- Holborn LU, Russell Square LU, Tottenham Court Road LU
- Daily 10.00-17.30 (late views of selected galleries Fri until 20.30);
 Great Court opening hours Sat-Thurs 9.00-18.00, Fri 9.00-20.30
- Admission free (a charge may be made for temporary exhibitions)
- Shops, Bookshop
- Cafés & Restaurant
- Disabled access

<div style="writing-mode: vertical">museums central</div>

The ultimate perch for culture vultures. Established by an act of Parliament in 1753 and occupying a majestic 13½ acre site in Bloomsbury, the BM is for many the quintessential London museum. With some 8 million artefacts and 90-odd galleries contained behind its Greek-temple-on-steroids façade, the BM is far too big a beast to do justice to in this review – or indeed in a single foot-slogging visit. Both should rather be regarded as an appetizer to a multi-course banquet; like most big museums, the BM is better suited to regular visits. The main entrance hall bears the brunt of the BM's annual influx of about 5.8 million visitors so if you're planning to visit galleries on the north side of the building (eg. Prints and Drawings, Oriental Collections, Egypt and Africa) you may prefer to try the often less crowded Montague Place entrance, just off Gower Street.

Once inside, where to start? The Great Court is the obvious place. Transformed by a soaring roof of glass and steel, the BM's once open central courtyard is the largest covered public square in Europe and now houses cafés, shops as well as the information desk. The circle in the heart of this light-filled square is the Reading Room, formerly a haunt for pen pushers as various as Karl Marx, Oscar Wilde and Virginia Woolf, but currently used as an exhibition space.

At this early stage of your visit it might be worth your while asking at the Information Desk which galleries are closed – an ongoing programme of development means that some galleries may be closed and only selected galleries are accessible on late night openings.

For first timers, the free introductory 'Eye Opener' tours are a painless way to find your feet – each tour lasts about 30-40 minutes and topics include 'Ancient Rome', 'Ancient Egypt', 'Art of the Middle East' and 'Early Medieval Europe'. If you prefer to explore under your own steam but with the benefit of some professional input, Multimedia guides can be hired for about £5 and these, available in 10 languages, provide detailed commentary on 200 of the museum's highlights.

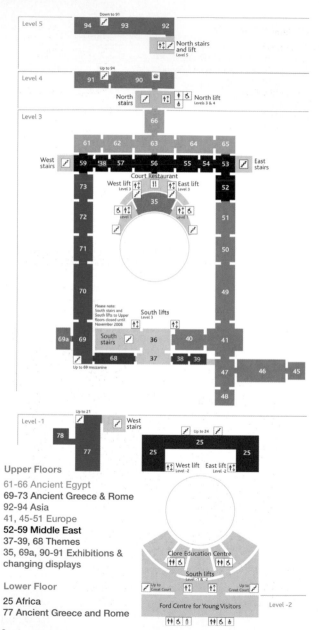

Level 5

94 93 92

Down to 91

North stairs and lift
Level 5

Level 4

Up to 94

91 90

North stairs North lift
Levels 3 & 4

Level 3

66

61 62 63 64 65

West stairs 59 58 57 56 55 54 53 East stairs

Court Restaurant

West lift East lift
Level 3 Level 3

73 52

Level 1 35 Level 1

72 51

71 50

70 49

Please note:
South stairs and
South lifts to Upper
floors closed until
November 2008

South lifts
Level 3

69a 69 South stairs 36 40 41

68 37 38 39

Up to 69 mezzanine

47 46 45

48

Level -1

Up to 21

West stairs

78

77

Up to 24

25

25 25

West lift East lift
Level -2 Level -2

Upper Floors

61-66 Ancient Egypt
69-73 Ancient Greece & Rome
92-94 Asia
41, 45-51 Europe
52-59 Middle East
37-39, 68 Themes
35, 69a, 90-91 Exhibitions &
changing displays

Lower Floor

25 Africa
77 Ancient Greece and Rome

Clore Education Centre

South lifts
Level -1 & -2

Up to Up to
Great Court Great Court

Ford Centre for Young Visitors Level -2

Ground Floor

26-27 Americas
4 Ancient Egypt
11-15, 17-23 Ancient Greece and Rome
33, 33a, 33b, 67, 95 Asia
6-10, 34 Middle East
1, 24 Themes
2-3 & Reading Room
Exhibitions and changing displays

KEY

ℹ️ Information	🎧 Audio tour		
🎫 Tickets	Stairs		
Cloakroom	Lift		
Large luggage	Level access lift		
Toilets	Shop		
♿ Accessible toilet	🍴 Court Restaurant		
Baby changing	☕ Café		
Baby feeding	☎ Telephone		

museums central

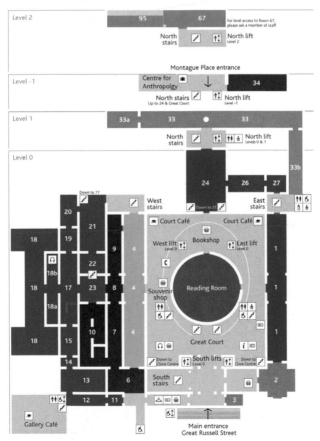

Level 2

95 67 For level access to Room 67, please ask a member of staff

North stairs North lift Level 2

Montague Place entrance

Level -1 Centre for Anthropolgy 34

North stairs Up to 24 & Great Court North lift Level -1

Level 1 33a 33 33

North stairs North lift Levels 0 & 1

Level 0

Down to 77

20 West stairs Down to 25 East stairs 33b

21 Court Café Court Café 24 26 27

18 19 West lift Level 0 Bookshop East lift Level 0 1

9 4

18b 22

18 17 23 8 4 Souvenir shop Reading Room 1

18a

10 7 4

18 15 Great Court 1

14 South lifts Level 0 Down to Clore Centre

13 6 South stairs 2

Gallery Café 12 11 3

Main entrance
Great Russell Street

For those going solo, personal preference will dictate your route but fans of the acclaimed BBC Radio 4 programme 'A history of the world in 100 objects' may want to start by tracking down the artefacts described in the series. The location of the 100 objects – from the BM's oldest object (a 1.8 million year old stone tool) to a modern credit card – have been marked on the museum map and besides being a useful crash course in human history, it's a great way to get to know the museum. If you're feeling strong, start with the perennially popular Egyptian Galleries. Plough your way through the crowds of clipboard-carrying kids hell bent on answering the next question on their activity sheets and admire the inscrutable beauty – despite the broken noses – of the colossal Egyptian and Assyrian sculptures on the ground floor (rooms 4 and 6-10), and the world class collection of antiquities from Egypt on the upper floor (galleries 62-66). Pride of place in the ground floor sculpture galleries goes not to a statue but to the Rosetta Stone – an undistinguished-looking slab whose multilingual inscriptions helped crack the 'code' of hieroglyphics. In the upper floor galleries the evolution of Egyptian make-up palettes shows that vanity is as old as civilization, but among a host of ancient artefacts and funerary finds, the real crowd pleasers here are the mummies – animal as well as human – and their richly decorated coffins. One of the most popular exhibits in the whole museum is a particularly well preserved corpse from 3,400 BC which is located in room 64 (Early Egypt), curled up and surrounded by essentials for the afterlife – including a make-up palette.

Galleries 62 and 63 explore Ancient Egyptian attitudes to death and the afterlife, covering a period of about 3,000 years, from the Old Kingdom to the 4th century AD. Among the exhibits are 1,500 year old food offerings and a heartbreakingly tiny coffin accompanied by the skeleton of a child who suffered from brittle bone disease. If ancient civilisations really are your thing, don't miss the Ancient Middle East galleries (rooms 52-59) which cover Ancient Anatolia, and Early and Later Mesopotamia. Exhibits include finds from Ninevah and Babylon, such as a fragment from a 3,000 year-old cuneiform thesaurus and artefacts excavated from the 'Great Death Pit' at Ur.

The museum is also famously well endowed with antiquities and sculpture from ancient Greece and Rome. On the ground floor, room 18 is devoted to sculptures from the Parthenon, aka the Elgin Marbles. Leaving aside the controversial issue of repatriation (there is a leaflet setting out the BM's position on this), these truly are marvels of craftsmanship and artistry, from the lovingly depicted tunics of the gods in the pediments, to the action packed frieze showing the Panathenaic procession in full swing. Another ancient structure, the Nereid Monument – the first ever example of a temple tomb – is displayed

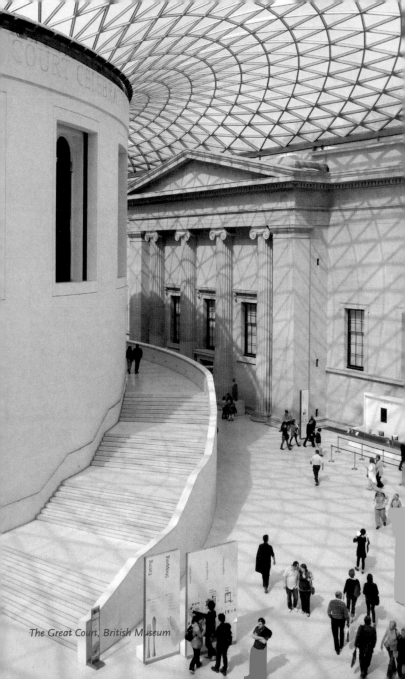

COURT CELEBRA

The Great Court, British Museum

in room 17 and more classical architectural odds and ends are littered around the lower floor (rooms 77-85) – including massive Ionic volutes from Ephesus and an elegantly draped caryatid from the Erectheum. There's plenty in the way of smaller artefacts like pottery and jewellery too – look out for the Portland Vase, a stunning example of Roman cameo work (room 70). Room 69 provides a kaleidoscopic insight into daily life in the ancient world – a 4th century BC jury ticket, a Roman dog tag and a frying pan are among the down-to-earth exhibits.

Still on a Roman theme, the Weston Gallery of Roman Britain (room 49) is a beautifully displayed collection of artefacts from the Roman Occupation. Much of the display focuses on the Roman military presence: cavalry armour, a bronze army diploma and so on – but glitzier exhibits are the hoards of treasure that have been unearthed over the years. The Thetford Treasure of late-Roman jewellery includes some amazingly flamboyant finger rings, while the elegant silver tableware from the Hoxne hoard and Mildenhall treasures bespeak the ultimate in gracious living. Not to be outdone by the corpses elsewhere in the museum, room 50 (Britain & Europe 800BC-AD43) is home to Lindow man – a sacrificial victim from the first century AD, preserved for posterity in a peat bog until he was discovered a few years ago.

Moving onto more recent European history, the applied arts in the Medieval, Renaissance and Modern collections (rooms 46-48) chart the dramatic social, religious and political changes of the era. The wonderfully gnomic 12th-century Lewis Chessmen can usually be tracked down in room 40 but the diffuse range of artefacts goes right up to the 20th century with elegant porcelain, jewellery and a few curiosities like Lord Palmerston's garter thrown in for good measure. The march of time can be seen – and heard – in the BM's horological collection, the most comprehensive in existence (room 38-39). The HSBC Money gallery (room 68) explores the history of money over the past 4,000 years through the development of coins, notes, electronic money and the systems that regulate them. It's also home to one of the 'Hands On' object handling desks that are dotted around the museum.

Flagging yet? Perhaps it's time for a coffee and a bite to eat. The museum's Gallery Café serves hot and cold light lunches while the Great Court's ground floor cafés provide a straightforward self-service experience. The posher Court Restaurant on the Upper Ellipse floor caters for deeper pockets and bigger appetites, with table service. If culture-induced claustrophobia has set in, investigate some of the local eateries in the Museum Street/Coptic Street area.

Ease back gently into the fray with a potter around room 90, which hosts temporary exhibitions organised by the Prints and Drawings Department. Curated from the department's collection of some

50,000 drawings and over 2 million prints, exhibitions are manageable in size but of high quality, and are invariably worth a separate visit – past shows have included Picasso linocuts, Rembrandt etchings and American prints.

Further up the North Stairs are the BM's exquisite Japanese galleries (92-4). Displays here change regularly because of the delicate organic materials of most Japanese cultural artefacts, but might include a magnificent set of Edo period Samurai armour, ceramic vessels from the prehistoric Jomon period, scrolls, contemporary prints and modern ceramics crafted by some of Japan's 'Living Treasures'. The charming wooden tea house, built in situ by Kyoto craftsmen is however a permanent fixture.

The North Wing is also home to the Korea Foundation Gallery (Room 67), a permanent gallery which presents an overview of Korean art and archaeology from early times to present day. As well as treasures such as royal ritual manuscripts and Buddhist sculpture, the gallery features a reconstructed sarangbang, or traditional scholar's study, designed and built by Korean architect Shin Young-Hoon. A small, changing display of top-quality contemporary Korean arts complements the historic items.

Room 33 is a vast and absorbing gallery (also just off the North Stairs) which covers China as well as South and South-East Asia. Among its jumble of exhibits are ritual vessels, Tang dynasty tomb pottery figures, statues from Jain temples, snuff bottles, Vietnamese ceramics and Buddhas galore. Tucked away at the far end, room 33a is home to relief carvings of scenes from the life of Buddha from the Great Stupa at Amaravati (this room will be closed from September 2011

'until further notice' for long term building work). Just off the Montague Place entrance, Room 34, the John Addis Gallery of Islamic Art contains graphic art, weaponry, intricately patterned Iznik tiles and fabulously decorative glass mosque lamps as well as hosting changing displays of works on paper.

Although the BM celebrated its 250th anniversary in 2003, and is one of Britain's most visited museums, it's not sitting on its laurels. The restored King's Library, just off the Great Court, reopened in 2003 as The Enlightenment Gallery, a permanent exhibition devoted to discovery and learning in the 18th and early 19th centuries. This was an age of curiosity and the objects which fill this enormous room – from fossils to Easter Island ancestor figures, via classical Greek vases – tell the story of the origins of the British Museum itself, as well as the Enlightenment's urge to classify everything in sight.

Equally exciting has been the return of the Ethnography Collections to Bloomsbury after years of exile at the old Museum of Mankind as well as the Mexican (room 27) and the North American (room 26) galleries. The latter stages regularly changing exhibitions about native North America – tribal costumes, pueblo pottery and walrus ivory snow goggles are among the items you might expect to see. The Mexican gallery covers the period from the Olmec culture of 1200-400BC through to the demise of the Aztecs in the 16th century. Here, the intricately carved Yaxchilan Lintels depict the bloodthirsty rituals performed by Mayan rulers; other exhibits include a 'ball game belt' from Classic Veracruz – a grisly remnant of a culture which settled political rivalries with ball game contests, in which the losers faced not relegation but decapitation.

The Sainsbury African Galleries (room 25) show how African cultures have interacted with each other and the West. Benin bronzes, ceramics, carved wood artefacts and masks are among the attractions here with audio visual presentations helping to show them in context. Contemporary art works by artists such as Sokari Douglas-Camp are the focus of temporary displays. En-route, the Wellcome Trust Gallery (room 24) offers a lively look at how people the world over deal with the harsh realities of living and dying, including how different cultures approach the treatment of AIDS.

Retail therapy is of course the strategy of choice in the West for overcoming life's difficulties and shopaholics will not be disappointed here. A well-stocked bookshop by room 6 caters for bibliophiles while the family shop in the Great Court is filled with Egyptian themed trinkets like chocolate filled 'mummy' tins and 'colour your own papyrus kits'. The Culture shop next to room 3 (off the main entrance) deals in more grown-up treats – colourful enamelled coffee spoons, replica historic jewellery and ancient statuary and reproduction Lewis chess sets.

British Optical Association Museum & Library

College of Optometrists, 42 Craven Street, WC2N 5NG

020 7766 4353

www.college-optometrists.org/museum

Charing Cross LU/Rail, Embankment LU

Admission free (Meeting Rooms tour £5 per person)

Mon-Fri 09.30-17.00 (by appointment only)

Never mind the somewhat drab title – appropriately enough for its subject matter, this museum is an eye-opener. Its imaginatively created collection centres around two small basement rooms, crammed with visual aids dating from the 17th century onwards. The extensive collection of spectacle frames through history is apparently a mecca for fashion and design students, and there's even a handy mirror so you can try some out for size. Technical apparatus like the fully deconstructible 17th-century ivory eye, a 1930's sight-testing suite and a spring loaded contact lens applicator chart the rise of optometry as a profession. Curator Neil Handley makes an enthusiastic guide, pointing out prize exhibits like the world's earliest pair of glasses with sidebars, 'wig' spectacles and celebrity curios like Leonardo DiCaprio's contact lenses. Perhaps the real delight for the non-specialist visitor though is the top-notch fine and decorative art collection. Treasures include portraits of bespectacled sitters, such as Admiral Peter Rainier and Benjamin Franklin (whose house is just a few doors away, see p.35), 18th-century satirical prints, beautifully embellished porcelain eye baths and charming fans equipped with hidden spy glasses. The museum's entertaining website is equally worthy of a visit, complete with an 'object of the month' spot and details of supernatural comings and goings at the museum.

The British Postal Museum & Archive

◻ Freeling House, Phoenix Place, WC1X 0DL
☎ 020 7239 2570
◌ www.postalheritage.org.uk
🚇 Chancery Lane LU, Farringdon LU/Rail,
 King's Cross St Pancras LU/Rail
🕓 Mon-Fri 10.00-17.00 (until 19.00 Thurs); visitors must bring ID
💷 Admission free
♿ Wheelchair access

Sadly, the National Postal Museum closed back in December 1998 but there are plans for a new Heritage Centre, for which a permanent site is being sought. In the meantime the archive at Freeling House is open to the public and is a useful family history resource, with material such as postal staff's pension records. There's also a small exhibition space showing displays of philatelic material – that's stamps to you and me. The busy events programme includes walks, talks and film screenings. Guided tours of the museum's store in Debden, Essex take place throughout the year, but these must be booked in advance.

British Red Cross Museum & Archives

◻ 44 Moorfields, EC2Y 9AL
☎ 020 7877 7058
◌ www.redcross.org.uk/museumandarchives

The museum and archive records the history and activities of the British Red Cross Society from its foundation in 1870 as the British National Society for Aid to the Sick and Wounded in War. The collection includes medals and badges, first aid kits, paintings by the war artist Doris Zinkiesen, and the Changi quilt – one of only three known examples made by women interned by the Japanese in Singapore in WWII. At the time of going to press the Red Cross is planning a new permanent exhibition at the British Red Cross HQ in London. Further information about the collection can be found on their website, which is where details about the proposed new museum will also be posted. The archive and historical collections are open to researchers by appointment.

Churchill War Rooms

⌨ Clive Steps, King Charles Street, SW1A 2AQ
☎ 020 7930 6961
✎ www.iwm.org.uk
🚇 St James's Park LU, Westminster LU
🕐 Daily 09.30-18.00 (last admission 17.00)
💷 £15.95* (adults), £12.80* (senior citizens, students), free (under 16s)
 (*includes a voluntary donation)
🛍 Shop
☕ Café
♿ Wheelchair access

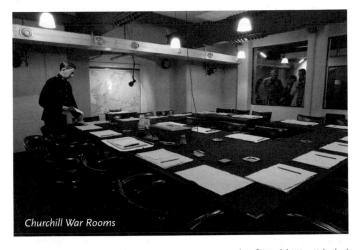

Churchill War Rooms

Winston Churchill and his ministers spent much of World War II holed up in these underground offices, for six years a secret nerve centre for the British government and military top brass. Preserved as an historic site since 1948 and still sporting original fixtures and fittings (although now staffed by a few mannequins), the CWR are a spookily atmospheric time capsule for the years 1939-45.

Built to withstand the Nazi Blitzkrieg, the CWR now surrender themselves daily to armies of visitors who file past rooms where history was made: the converted broom cupboard from which Churchill telephoned Roosevelt, the Prime Minister's spartan office-cum-bedroom, the Map Room, as well as the inner sanctum of the whole complex – the Cabinet Room itself. Less glamourous rooms like the typing pool evoke the drudgery of war work and there are displays examining different aspects of the war.

Some rooms previously hidden from the public have also been restored and opened to visitors and include the private rooms set aside for Churchill's wife and key members of staff, the Chief of Staff's Conference Room, as well as the tiny kitchen that kept Churchill supplied with 3 square meals a day. Free audio guides in a range of languages are issued on arrival and, lasting an hour, are essential listening for visitors who wish to explore the site thoroughly. Shorter guides are available for those with less time and there's a children's version for the under 11s. The Switch Room Café offers simple light meals of the sandwich, coffee and cake variety, served to the strains of popular music from the 1940s. The shop doesn't ration the nostalgia either, stocking a selection of goods with a wartime theme.

Time capsule they may be but the CWR certainly aren't standing still – in 2005 the Churchill Museum opened at the site, exploring the life, leadership and legacy of the man himself and featuring material never publicly exhibited before. Divided into 5 colour coded chapters, the museum begins with Churchill's finest hour – his war years – and his transformation from political outsider to against the odds victor. Churchill's gruelling war time regime saw him working 17 hour days and notching up an incredible 40,000 'war miles' as he sought to keep his Allies on side. The displays brilliantly reflect the multi-faceted character of their subject, allowing visitors to enjoy audio excerpts from Churchill's famous speeches as well as ponder the letter from his wife reprimanding him for his deteriorating behaviour to colleagues. Other chapters look at the rest of Churchill's life, from wayward public school boy, to intrepid reporter and army officer to maverick politician, Nobel Laureate, painter and Cold War statesman. At the heart of the displays is a high spec, 15 metre touch screen time line that gives a day by day account of Churchill's life with spectacular animations for key events such as the Dambusters' Raid and Churchill's 90th birthday.

The Cartoon Museum

⌨ 35 Little Russell Street, WC1A 2HH
☎ 020 7580 8155
✎ www.cartoonmuseum.org
🚌 Tottenham Court Road LU/Holborn LU
🕐 Tues-Sat 10.30-17.30, Sun 12.00-17.30 (last admission 17.15)
💷 £5.50 (adults), £4 (concessions), £3 (students), free (under 18s, Friends of the Cartoon Museum)
🛍 Shop
♿ Wheelchair Access

For some years a peripatetic institution, the Cartoon Art Trust has now found a home for its museum – a stylishly converted former dairy in the heart of Bloomsbury. Incredibly (given that Britain invented the art form) this is London's first cartoon museum and it is dedicated to showing the best of British cartoon art. The ever-growing permanent collection contains examples by all the big names, from the bitter satires of 18th-century exponents such as Hogarth, Gillray and Rowlandson to more recent works by current household names like Searle, Matt and Posy Simmonds. The displays cover all aspects of cartoon art, embracing not just political satire and caricature but also 'gag' cartoons, classic war cartoons, comic strips and graphic novels. Top quality temporary exhibitions make repeat visits here a must – recent offerings have included a Steve Bell retrospective and a show about Dr Who in comics. For those eager to sharpen their pencils and have a go themselves the well equipped activity room runs workshops for adults as well as youngsters, while the research library is available for those with more academic interests. Naturally, this being a 21st-century museum, retail opportunities are not lacking and the museum shop features a choice selection of cartoon books, history titles and greetings cards, mugs by Simon Drew and Quentin Blake, and some rather fetching Dennis the Menace wrapping paper.

The Clink Museum

- 1 Clink Street, SE1 9DG
- 020 7403 0900 (Box Office)
- www.clink.co.uk
- London Bridge LU/Rail
- Mon-Fr 10.00-18.00, Sat-Sun 10.00-21.00
- £6 (adults), £5.50 (under 15s/concessions), £15 (families)
- Shop

This exhibition, built on the site of the original Clink prison, is more an attraction than a museum. Although a variety of authentic torture instruments are displayed, perhaps the most painful feature of the museum is reading the spelling mistakes in the wall labels. Tableaux depict the less than appealing aspects of life in the clink and, for those keen to experience the harsh character of an earlier criminal justice system more closely, some exhibits like the weighty ball and chain are hands-on.

The Clockmakers' Museum

- Guildhall, Aldermanbury, EC2V 7HH (entrance via the West Wing entrance to Guildhall Library)
- 020 7332 1868
- www.clockmakers.org
- Bank LU, Mansion House LU, Moorgate LU, St Paul's LU
- Mon-Sat 09.30-16.45
- Admission free
- Wheelchair access

Time waits for no one – especially here, at the Museum of the Worshipful Company of Clockmakers, where some 700 clocks and watches testify to man's ingenious attempts to keep tabs on this most slippery of concepts. Refurbished in 2002, the neatly ordered displays tell the story of timekeeping and watchmaking in London against a background noise of gentle ticking and harmonious hourly chimes. Some unusual timepieces lurk amongst the more elegant pocket watches and stately longcase clocks – like a macabre silver skull watch reputedly owned by Mary Queen of Scots and an innocuous-looking device which turns out to be the timer for an early nuclear weapon. There are also timepieces by Thomas Tompion ('the Father of English clockmaking') and fine examples of John Harrison's work, including the marine timekeeper that eventually secured him the 'Longitude Prize'.

The Crypt

⌧ St Paul's Cathedral, St Paul's Churchyard, EC4M 8AD

☎ 020 7246 8348 / 020 7246 8358 (group bookings)

✐ www.stpauls.co.uk

🚌 St Paul's LU

🕒 Cathedral Floor, Crypt & Ambulatory Mon-Sat 08.30-16.30
(last admission 16.00); Galleries Mon-Sat 09.30-16.15
(last admission 16.00)

💷 £14.50 (adults), £13.50 (concessions), £5.50 (children);
Audio tours can be hired in English, French, German,
Italian or Spanish £3.50 (£3 concessions)

🛍 Shop

☕ Café & Restaurant

♿ Wheelchair access (via southern transept)

Once you've done gazing at the splendid interior of Wren's Baroque masterpiece, climbed up to the Whispering Gallery, and admired Holman Hunt's *The Light of the World*, a look around the crypt is a good antidote to the cricked neck you've probably acquired. As well as being home to the splendidly kitted out OBE (Order of the British Empire) chapel, the crypt is filled with the tombs and memorials of Britain's illustrious dead – including Wellington and Nelson and of course, the cathedral's architect himself, Sir Christopher Wren. The Cathedral's Guided tours are included in the price of admission and reach parts of the cathedral not usually available to members of the public – such as the geometric stairs and the quire with its Grinling Gibbon carvings.

For those visitors who wish to explore online before visiting, a virtual tour is available on the website and includes 360° panoramas, maps and images. Actual visitors can purchase a guidebook for £4.

The Design Museum

28 Shad Thames, SE1 2YD

020 7940 8783 (tickets); 020 7940 8790 (programme)

www.designmuseum.org

London Bridge LU/Rail, Tower Hill LU;
bus 42, 47, 78, 188, 381, 100, 225

Daily 10.00-17.45 (last entry 17.15)

£11 (adults), £10 (concessions), £7 (students), free (under 12s)
(prices include £1 voluntary donation)

Shop

Café

Wheelchair access

This museum, as its title implies, is a shrine to design. Its riverside home, a sleek white building in 1930s cruise-liner style, looks every inch the modernist icon and stands in stark contrast to the historic red brick shipping warehouses of Shad Thames.

The museum specialises in international industrial design, architecture, and the built environment; its eclectic exhibition programme reflects the breadth of its vision. Recent exhibitions have celebrated the work of designers as diverse as Dutch graphic designer Wim Crouwel and leading product designer Kenneth Grange. The museum also features a cluster of computer screens where visitors can explore the Museum's beautifully designed website (of course you can do this from the comfort of your own home but you may not get to sit on a snazzy designer chair, as you do here). As well as containing news about the Museum's exhibitions the site is also home to an online archive with info on designers from Alvar Aalto to Michael Young.

For aesthetic gratification of the take home variety, the museum shop carries tempting designer knick-knacks and a well-chosen selection of design books and magazines, with glossy coffee table tomes on fashion and design jostling for space with more technical sounding titles like 'Secrets of Digital Illustration'. The foyer coffee shop offers light refreshments while the Blueprint Café is also on-site for those with more sophisticated tastes and bigger budgets. Elegant as its current home is, the Design Museum is set to relocate to larger, and arguably more glamourous, premises in the former Commonwealth Institute building, by 2014'.

The Charles Dickens Museum

🏠 48 Doughty Street, WC1

☎ 020 7405 2127

✎ www.dickensmuseum.com

🚇 Russell Square LU, Chancery Lane LU, Holborn LU

🕐 Daily 11.00-17.00

💷 £7 (adults), £5 (concs), £3 (children), free (children under 10)

🛍 Shop

☕ Café

The London novelist par-excellence, Charles Dickens moved into this pleasant Georgian terraced house in 1837 as an up-and coming writer; when he left 2 years later in 1839 he was a household name. It was at 48 Doughty Street that he completed the final installments of *The Pickwick Papers* and wrote his next two bestsellers, *Nicholas Nickleby* and *Oliver Twist*, but it was also here that Dickens was overtaken by tragedy when his beloved sister-in-law Mary Hogarth died, an event that caused the prolific wordsmith to miss a deadline – for the first and only time in his illustrious career.

The only surviving London home of the great Victorian novelist, 48 Doughty Street has been preserved as a museum since 1925 and contains an important collection of Dickens' manuscripts and letters, as well as rare editions. For such a literary haunt, the exhibits are surprisingly visual with numerous book illustrations, portraits of the writer and his family by eminent Victorians, including works by WP Frith and the gloriously named Augustus Egg. The eclectic collection also feature personal items such as desk paraphernalia (which the writer liked to arrange in a very particular way) and a grill from the infamous Marshalsea Prison, the debtors' jail which loomed large in Dickens own life as well as his fiction.

A multi-million pound redevelopment has gently transformed this much-loved old museum in time to celebrate the bicentenary of Dickens' birth in 1812. The interiors of 48 Doughty Street have been redisplayed and returned to their Victorian appearance, with each room focusing on an aspect of Dickens' life – from his circle of friends to his family life, while the basement domestic quarters include a working Victorian kitchen. Modern and fully accessible educational and visitor facilities are now housed next door at number 49 – which the far-sighted Dickens' Trust purchased back in the 1920's when the museum first opened. The newly enlarged café serves top-notch coffee, cakes and light bites and if the weather is clement, these can be enjoyed in Mr Dickens' small but perfectly formed back garden.'

The Faraday Museum

⊡ The Royal Institution, 21 Albemarle Street, W1S 4BS

☎ 020 7409 2992

✐ www.rigb.org

🚌 Green Park LU

◷ Mon-Fri 09.00-21.00

♨ Admission free

☕ Café & Restaurant

♿ Wheelchair access

There's a bit of a buzz about the Royal Institution these days – not bad for a 200-year-old plus organization worthily dedicated to educating the general public about the latest scientific developments. But with an illustrious history and 14 Nobel Prize winners to its name, the RI has a lot to shout about and thanks to a multi-million pound redevelopment, it does so with some panache.

The museum trumpets some of the scientific greats who have worked in this building, including Humphry Davy (he of the lamp), James Dewar (he of the flask) and the museum's namesake, Michael Faraday, the London bookbinder turned experimental scientist whose discovery of electromagnetic induction helped shape the modern world. The lower ground floor displays are focused on experimentation and include iconic original apparatus used by Faraday et al - this is the place to see William Crooke's cathode ray tube, the gauze covered lamp with which Davy revolutionized safety in British mines, prototype Dewar flasks as well as Faraday's first ever sample of benzene. Faraday's original dark, wooden shelved laboratory is still in situ but is now accompanied by a gleaming white 21st century nano-technology lab, where visitors can observe Faraday's modern counterparts at work, or perhaps just having a coffee break. The e-guide elucidates the science on display in a humourous way, doesn't tie you down to a set itinerary and is well worth its hire price.

Of course, it's no good making lots of whizzy scientific discoveries if you can't tell everyone what you've done and at the heart of the Royal Institution's dedication to communicating science is its horseshoe shaped Lecture Theatre. This is the scene of the RI's Friday Night Discourses and its equally celebrated Christmas Lectures, started by Faraday in 1825. So popular were these lectures that Albemarle Street became London's first one-way street to cope with the sheer weight of carriage traffic. Other historic rooms on the first floor continue the communication theme with a well-stocked library and 'lecturer's corridor' accessorised with an eclectic selection of original props – from the stuffed toy kangaroo used in George Porter's lecture on Mechanics to the saw which illustrated Charles Taylor's lecture on Music. Portraits

museums central

of RI alumni and paintings of historic lectures adorn the walls alongside more light-hearted images such as James Gillray's cartoon of an experiment with laughing gas.

Combining civilized opening hours with a convivial Wi-Fi enabled in-house café and sophisticated 'Time and Space' restaurant next door and with its popular lecture programmes and deft displays, the RI has really stepped up to the mark on its mission to enlighten us about science. When London's bigger museums are packed out with holiday crowds, savvy seekers after scientific knowledge might be well advised to follow in the footsteps of their Victorian forbears and head for Albemarle Street.

The Fashion and Textile Museum

- ▦ 79-85 Bermondsey Street, SE13XF
- ☏ 020 7407 8664
- ✐ www.ftmlondon.org
- 🚌 London Bridge Rail/LU
- ◷ Tues-Sat 11.00-18.00 (during exhibtions)
- 🕸 £7 (adults), £4 (students/concessions), free (under12s)
- 🕸 Shop
- ▭ Café
- ♿ Wheelchair access

With its shocking pink and custard yellow façade, the FTM (designed by Mexican architect Ricardo Legorreta), is a vibrant landmark in this still rather down-at-heel part of town. This museum was the brainchild of flamboyant fashion designer Zandra Rhodes and originally opened in 2003. It was re-inaugurated in 2008, as part of Newham College, and hosts a programme of changing exhibitions exploring contemporary fashion, style and couture, as well as hands-on workshops and masterclasses. Visitors wishing to accessorize need look no further than the museum shop, which stocks funky contemporary jewellery and textiles by emerging designers, as well as a small selection of design books and mags.

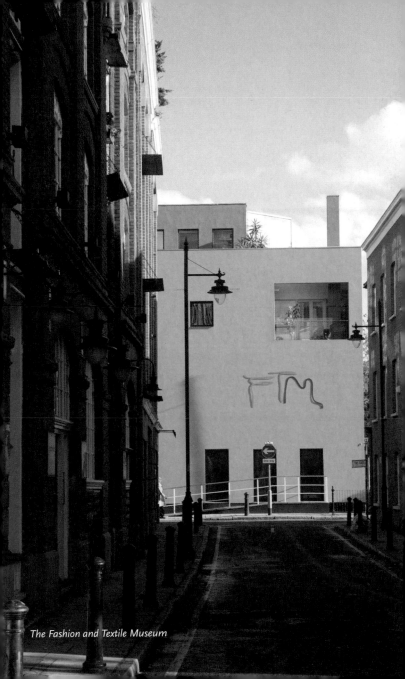

The Fashion and Textile Museum

The Florence Nightingale Museum

⌑ St Thomas' Hospital, 2 Lambeth Palace Road, SE1 7EW
☎ 020 7620 0374
🖎 www.florence-nightingale.co.uk
🚇 Lambeth North LU, Waterloo Rail/LU, Westminster LU
🕐 Daily 10.00-17.00 (closed Easter & Christmas); last admission 16.00
💷 £5.80 (adults), £4.80 (concessions), £16 (families), free (under 5s)
🛍 Shop
♿ Wheelchair access

A legend in her own lifetime, Florence Nightingale was much more than simply 'the lady with the lamp'. Recently revamped in time for the centenary of its subject's death in 2010, the museum follows this eminent Victorian from her privileged but unfulfilled upper-class childhood to the bloodshed of the Crimean War to the energetic campaigning for health reform which occupied the rest of her life.

The imaginatively presented displays are divided into three main areas, each with a strong visual identity – a thick evergreen 'hedge' encircles the exhibits recounting Florence's stuffy upbringing while the area devoted to the Crimean War is swathed in bandages and Eastern style tiles. Florence's later, 'letter-writing', years are explored within an enclosure of bookcases and bureaux. Visitors are issued with stethoscope audio guides but are free to explore at will, simply placing their stethoscope over the listening points to hear the appropriate commentary. Peepholes offer additional glimpses into Victorian life, and touchscreen interactive displays introduce interesting 'Crimea characters' including nurses who worked alongside Florence.

Witty, intelligent, shrewd and single-minded, this ministering angel didn't mind putting a few backs up to achieve her goals. The museum reveals a complex, driven woman, who as a young girl won over her family's objections to train as a nurse, persuaded the British government to send her to the Crimea and who in later life founded the first school for nurses, here at St Thomas's. Florence's compassion for her patients was underpinned by a flair for admin, considerable mathematical ability and a fondness for statistics – Miss Nightingale should be remembered as much for her pie charts as for her lamp.

Exhibits include the famous lamp, the well-stocked medicine chest Florence took to Turkey as well as the mortal remains of her pet owl Athena, and Jimmy, the pet tortoise at Scutari Hospital. Nurses' uniforms, original letters and a Victorian amputation kit are also among the artefacts on show. The museum runs an events programme as well as hosting temporary exhibitions on nursing themes. A selection of affordable souvenirs and books are available at the shop, and refreshments are served on the hospital site.

The Foundling Museum

40 Brunswick Square, WC1N 1AZ

020 7841 3600

www.foundlingmuseum.org.uk

Euston Rail/LU, King's Cross St Pancras Rail/LU, Russell Square LU

Tues-Sat 10.00-17.00, Sun 11.00-17.00

£7.50 (adults), £5 (concessions), free (children)

Small shop

Café

Wheelchair access

Fresh from a £4.2 million refurbishment, this museum re-opened in June 2004 and tells the story of the Foundling Hospital, London's first children's charity. It's a fascinating tale, an extraordinary blend of social injustice, campaigning fervour, creative genius and enlightened self-interest. Founded in the 18th century, at a time when over 1,000 babies a year were being abandoned, the hospital was the brainchild of Thomas

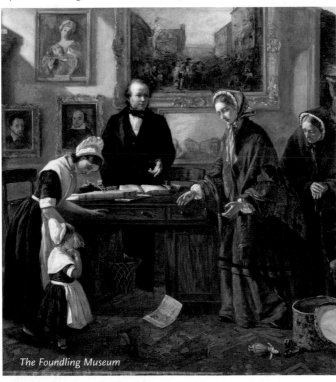

The Foundling Museum

Coram, sea captain and philanthropist. Illegitimacy was the main reason for children being abandoned and the museum's poignant exhibits include some of the personal tokens left by mothers with their infants as means of their identification, should they ever be reunited. Displays on the ground floor emphasise the social history surrounding the Foundling Hospital and include a range of materials such as Thomas Coram's passionate letters, prints and photographs of Foundlings in the Hospital grounds, and recorded oral histories of living Foundlings.

The museum is also home to a cracking art collection, a legacy of the days when the Foundling Hospital was also London's first public art gallery. Under royal patronage the hospital had become a fashionable attraction and the artist William Hogarth, a Founding Governor of the hospital, quickly spotted its potential as a venue for promoting the best in British art. He kick started the collection in 1740 by presenting the Hospital with a painting of its founder, Thomas Coram. This was his first portrait in the 'grand manner' (although it does feature some notably down-to-earth touches); a more typical work by the master satirist is his *March of the Guards to Finchley*, also in the collection. Other artists of the day followed Hogarth's lead and donated works, with the cream of the collection featuring paintings by Ramsay, Reynolds and Gainsborough and sculpture by Roubiliac and Rysbrack. Established in an age when art was seen as a force for moral improvement, the collection was intended to benefit the public and formed a precursor of the Royal Academy (see p.212). These works by the hospital's early artist supporters are displayed in historic interiors preserved from the now demolished Foundling Hospital building formerly at nearby Coram's Fields.

The composer G F Handel (see p.40) was another of the Hospital's eminent benefactors and the museum's collection includes a manuscript copy of *The Messiah*, an early performance of which raised the then enormous sum of £7,000 for the charity. A second floor gallery displays this and Handel's will, together with books, paintings, prints and memorabilia from the world renowned Gerald Coke Handel Collection. A group of rather nifty 'musical chairs', allow visitors to sit and listen to extracts from Handel's works.

Perhaps spurred on by the re-invigorated Brunswick Centre nearby, the museum also houses a sleek new café serving Mediterranean influenced light lunches as well as cakes and drinks.

Benjamin Franklin House

🏠 36 Craven Street, WC2N 5NF

☎ 020 7839 2006
 020 7925 1405 (booking hotline)

🖱 www.benjaminfranklinhouse.org

🚌 Embankment LU

🕐 Wed-Sun 12.00-17.00; Entrance by tour only (shows at 12.00, 13.00, 14.00, 15.15, 16.15, ticket collection 15mins prior to these times)

💷 £7 (adults), £5 (concessions), free (under 16s)

🛍 Shop

Scientist, diplomat, inventor, postal pioneer, Founding Father and all-round American icon Benjamin Franklin lived at this elegant Georgian townhouse between 1757 and 1775. After years of neglect the house re-opened in January 2006, on Franklin's 300th birthday, having been carefully conserved (not restored). So don't expect fully recreated 18th-century interiors here – what you get is a rather more imaginative approach to historical interpretation. The pared down, ghostly interiors of the house are used as a blank canvas to project (quite literally) the life and times of Benjamin Franklin while an actress playing the role of landlady's daughter Polly Hewson, interacts with the pre-recorded audio visual material. Appropriately enough for the man who invented the lightning conductor, Franklin was something of a live wire himself – and each room explores the wide-ranging achievements of this 'citizen of the world'. Although his primary reason for being in London was to mediate between Britain and the increasingly fractious American colonies, Franklin still found time to invent bifocal spectacles and the glass armonica, reform the alphabet and hobnob with the leading figures of the day. Franklin led a fascinating life and although the 'Historical Experience' may sound gimmicky it proves an effective way of telling his story. If the 'historical experience' really doesn't appeal, more straightforward guided tours of the hours run every Monday (same start times as for the Historical experience shows) and cost £3.50. For those who want to find out more, Benjamin Franklin's autobiography can be purchased in the small shop while a Student Science Centre is open by appointment.

Library and Museum of Freemasonry

🏛 Freemasons' Hall, Great Queen Street, WC2B 5AZ
☎ 020 7395 9257
✎ www.freemasonry.london.museum
🚇 Covent Garden LU, Holborn LU
🕐 Mon-Fri 10.00-17.00
💷 Admission free
🛍 Shop
♿ Wheelchair access

While this museum and permanent exhibition doesn't spill the beans on funny handshakes and rolled-up trouser legs, it does shed a glimmer of light on the elusive yet high profile organisation that is Freemasonry.

Housed in the intimidatingly expansive Freemasons' Hall (erected in the 1930s), the museum is itself pretty cavernous. Case after case displays the United Grand Lodge's extensive collection of masonic glass, china and silverware from lodges around the world. Insignia and regalia are also much in evidence, and with names like 'the Order of the Secret Monitor' the masons' reputation for clandestine practice seems understandable. Documents include the minutes and account books kept by PoW masons at Stalag 383, Nuremburg and a letter congratulating Queen Victoria on her escape from an assassination attempt.

The permanent exhibition broadly charts the 'history of English Freemasonry and its development from medieval obscurity to worldwide prominence' but, again, without giving too much away. Portraits and photographs of masons include those of Elias Ashmole, the 17th-century founder of Oxford's Ashmolean Museum, Alexander Fleming (see p.112) and Peter Sellers. Among the unusual artefacts on display are an outsized Grand Master's throne and a beautifully hand-embroidered masonic apron from the 18th century. Books, videos and regalia are available from The Grand Charity's souvenir shop on the ground floor.

The Garden Museum

St Mary-at-Lambeth, Lambeth Palace Road, SE1 7LB

020 7401 8865

www.museumgardenhistory.org

Lambeth North LU, Waterloo LU/Rail,
Westminster LU; buses 3, 344, C10, 77

Sun-Fri 10.30-17.00, Sat 10.30-16.00

£7 (adults), £6 (Senior Citizens), Free (under 16s, students, carers)

Shop

Café (open Daily 10.30-17.00; closed first Monday of the month)

Wheelchair access

You don't have to be a horny-handed son or daughter of the soil to appreciate this museum. With its ecclesiastical setting and intricately-planted knot garden, it's an oasis of verdant tranquillity amid the turmoil of Lambeth Bridge roundabout. Formerly known as the Museum of Garden History, the museum reopened in October 2008 with a new name and a spacious new mezzanine gallery for its permanent collection. Telling the story of gardening through the centuries, the redisplay includes plenty of unusual tools and items not previously shown while freeing up the ground floor for temporary exhibitions – recent offerings include a retrospective of garden designer Tom Stuart-Smith's work and an 80th birthday celebration of top garden photographer Jerry Harpur. The Museum is a focal point for garden-related events and activities with a year long programme of events, talks, children's activities and plant fairs.

Out in the well-tended garden the plants (all clearly labelled) vie for attention with the churchyard's illustrious dead – William Bligh (captain of the ill-fated Bounty) and Elias Ashmole (freemason, see p. 36) are both buried here. Back inside, the shop stocks a wide range of gardening books and good quality gifts with a floral theme. The deservedly popular café serves vegetarian food and freshly baked cakes, its air is thick with talk of borders, bedding-out and bad backs.

The Golden Hinde

⊞ Office & Souvenir shop, 1 & 2 Pickfords Wharf, Clink St, SE1 9DG
☎ 020 7403 0123
✎ www.goldenhinde.com
🚌 London Bridge LU/Rail
🕓 Phone for opening times
💷 £6 (adults), £4.50 (concessions & children), £18 (families)
🛍 Shop

This part of London is so steeped in history that it comes as little surprise to see this full-sized replica of Sir Francis Drake's 16th-century warship moored up in St Mary Overie dock near Southwark Cathedral. Although describing itself as a 'Living History Museum', the brightly coloured vessel has clocked up over 140,000 miles and with its neatly-trimmed rigging and sturdy structure, feels very much like a working ship. Armed with a tour leaflet, the visitor has a pretty free run of the ship – from the depths of the hold, up to Drake's cabin (the only private one on board). A few sea chests and barrels aside, there's really not much to see and below decks, low ceilings and steep stairs make the going difficult for grown-ups, causing one parent of my acquaintance to rename the ship *the Golden Fleece*. Nonetheless, it's pretty atmospheric and children should enjoy the challenging terrain. Sleepovers for young buccaneers (and accompanying adults) are available, and guided tours can be booked for group visits.

Grant Museum of Zoology & Comparative Anatomy

⊞ Rockefeller Building, UCL, 21 University Street, WC1E 6DE
☎ 020 3108 2052
✎ www.ucl.ac.uk/museums/zoology/visit
🚌 Euston Rail/LU, Euston Square LU, Goodge Street LU,
 Russell Square LU, Warren Street LU
🕓 Mon-Fri 13.00-17.00
💷 Admission free
♿ Wheelchair access (ring in advance)

One of the pioneers of evolutionary theory and teacher to Charles Darwin, Professor Robert Grant founded this natural history museum way back in 1828. It has recently relocated to its current address after 14 years in the nearby Darwin Building, The museum retains an old fashioned feel – in true Victorian style its glass cases are crammed with skeletons and specimens suspended in jars of yellowing liquid. Arranged in taxonomic order, the displays cover the whole of the animal kingdom and feature exotic animals such as a hairy frog and

a giant anteater. Among the rare skeletal specimens are three extinct
species: the dodo, the marsupial wolf and the quagga. Extraordinary
Glass models of invertebrates made by 19th-century Czech glassmakers
Leopold and Rudolk Blaschka are another highlight of the collection. An
important teaching and research resource, the museum offers 'hands-
on' sessions and activity days by special arrangement.

Museum of Great Ormond Street Hospital for Children NHS Trust

- 55 Great Ormond Street, WC1
- 020 7405 9200 (ext 5920)
- Holborn LU, Russell Square LU
- Mon-Fri 09.30-16.30 by appointment
- Admission free

This rather dingy, one-room museum is housed in a 17th-century
building across the road from the main hospital buildings. The exhibits
illustrate the history of the hospital (the oldest dedicated children's
hospital in Britain) with photographs and various pieces of vintage
medical equipment enlivened, after a fashion, by curiosities such as a
model ship made by inmates at HMP Dartmoor.

The Guards Museum

- Wellington Barracks, Birdcage Walk, SW1E 6HQ
- 020 7414 3271/3428
- www.theguardsmuseum.com
- St James's Park LU
- Daily 10.00-16.00 (last admission 15.30)
- £4 (adults), £2 (students, senior citizens), £1 (serving military
 personnel), free (children under 16)
- Shop
- Wheelchair access (telephone in advance)

The history of the five regiments of foot guards – the Grenadier, Coldstream,
Scots, Irish and Welsh Guards – in one museum. With their distinctive
scarlet tunics and bearskin caps, guards are perhaps best known for their
ceremonial role in the capital but they are in fact primarily combat soldiers
who have also played their part in Britain's numerous military campaigns.
Uniforms include a guard's tunic worn by Edward VIII, the Grand Old
Duke of York's bearskin and a Dervish chain mail shirt, while among the
more unusual exhibits are souvenirs from the Battle of Waterloo, a device
for tattooing deserters and the wicker picnic basket used by Field Marshal
Montgomery while on campaign in Italy. For visitors inspired to play war
games, the Toy Soldier Centre is close by.

Handel House Museum

- 25 Brook Street, W1K 4HB (entrance at rear in Lancashire Court)
- 020 7495 1685
- www.handelhouse.org
- Bond Street LU
- Tues-Sat 10.00-18.00 (Thurs till 20.00), Sun 12.00-18.00
- £6 (adults), £5 (concessions), £2 (children); children free on Saturdays & Sundays
- Shop
- Wheelchair access

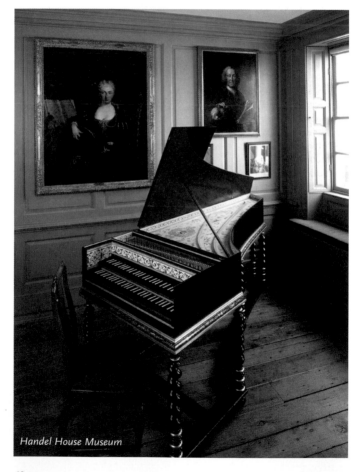

Handel House Museum

G F Handel lived in this elegant town house from 1723 until his death in 1759 and it was here that he composed landmark works such as the *Messiah* and *Zadok the Priest*. The museum itself opened in 2001 and, incredibly, is the first in London to be dedicated to a composer.

Although beautifully restored and furnished with 18th-century furniture, paintings and prints, the restrained dark grey interiors don't try to recreate the historic house in full and are instead themed around Handel's life, work and times. Visits start on the 2nd floor with a short audio visual presentation about Handel in London – the talking heads include Timothy West, Nicholas Hytner and even a musical cab driver (proof, if proof were needed, that they really do have an opinion on everything). Handel's dressing room doubles as 'The London Room' with portraits of Georgian literati such as John Gay and Alexander Pope while the displays in Handel's bedroom (including a magnificent canopied bed) strive to get to the heart of 'Han the Man'. The combination of carefully chosen artefacts, to-the-point information sheets and friendly room stewards is surprisingly effective at bringing house and owner to life, revealing rather an endearing character who liked his grub, had a famously short fuse and was probably a very noisy neighbour.

One floor down, the focus is firmly on Handel's music: rehearsal, performance and composition. Handel's original rehearsal room explores the world of 18th-century opera and theatre with portraits of Handel's favourite artistes such as singer Susanna Cibber, and the castrato Senesino. It's very much the hub of the place and still functions as a rehearsal space and there's a chance that on your visit (as on mine) that the house will reverberate to the sound of live baroque music, perhaps played on the Museum's reproduction Ruckers double-manual harpsichord. Leading off the rehearsal room is the small room where Handel composed, overseen today by a very fine portrait of the man himself by Philip Mercier along with portraits of the composer's closest musical collaborators, his copyist John Christopher Smith the Younger and librettist Charles Jennens.

Although celebrating a long dead musician, the museum is far from moribund. The museum's events and education programme features a lively mix of temporary exhibitions, baroque music master classes, lectures and performances. Family orientated activities include a selection of trails and quizzes. Intriguingly, some of the temporary exhibition rooms are located next door at no. 23 which in 1968-9, some 210 years after Handel's death, was home to a rather different sort of musician – Jimi Hendrix.

HMS Belfast

- ☎ Morgan's Lane, Tooley Street, SE1
- ☎ 020 7940 6300
- ⌨ www.iwm.org.uk or www.hmsbelfast.org.uk
- 🚇 London Bridge LU/Rail, Monument LU, Tower Hill LU
- 🕓 Daily 10.00-18.00, last entry 17.00 (March-Oct);
 10.00-17.00, last entry 16.00 (Nov-Feb)
- 💷 £13.50* (adults), £10.80* (Seniors/students),
 free (under 16s) (*ticket price includes voluntary donation)
- 🛍 Shop
- ☕ Café
- ♿ Partial Wheelchair access

Weighing in at 11,553 tonnes, HMS Belfast is Europe's last big-gun armoured warship to have seen action in World War II, and the first warship to be preserved for the nation since Nelson's *Victory*. Moored just upstream of Tower Bridge, she is boarded, in proper nautical style, via a gangplank. Once on board there are nine decks to explore, but be prepared for low-slung doorways and steep ladders. An audio guide is included in the ticket price and provides the low-down on key features of the ship. For ease of orientation each visitor is given a handy map – which you will need as Belfast is a labyrinthine lady. Rather more sophisticated navigational tools can be seen on the Bridge, home of the wireless office (now manned by an amateur radio society).

HMS Belfast's big guns are still very much in evidence on the upper decks, while deep below the waterline are the claustrophobic shell rooms. In service from 1939-1966, Belfast's career was eventful and displays reflect on her contribution to the D-Day landings and the sinking of the German battlecruiser *Scharnhorst*. Mannequins and sound tracks bring the living quarters to life, while the operations room reconstructs the Battle of North Cape.

A permanent exhibition, 'HMS Belfast in War and Peace' fleshes out the biography of the ship and those who served aboard her, charting her career beginning with her building and launch in 1938. Another exhibition 'Life at Sea' reveals what life was like aboard with fascinating first hand audio accounts. The operations room – the nerve centre of the entire ship – has recently been reopened and now features recreated rotating radar screens. To get an idea of what fighting at sea would really have been like, squeeze yourself into the newly launched 'gun turret experience', which simulates the hectic and cramped conditions in one of Belfast's Triple Gun Turrets.

In both menu and ambience, the ship's Walrus Café offers a functional place for refreshment while back on dry land the museum shop sells model boat kits and books on naval and wartime subjects.

Household Cavalry Museum

Horse Guards, Whitehall, SW1A 2AX

☎ 020 7930 3070

🖉 www.householdcavalrymuseum.co.uk

🚆 Charing Cross LU/Rail, Westminster LU, Embankment LU

🕓 Daily 10.00-18.00 (Mar-Sept), 10.00-17.00 (Oct-Feb);
closed 24-26 Dec & Good Friday

💷 £6 (adults), £4 (5-16 years, conc), £15 (family)

🛍 Shop

♿ Disabled access (ring for details)

Set in an historic 18th-century building, this regimental museum is slap bang on the tourist trail between Westminster and Trafalgar Square, just opposite the Banqueting House (see p. 9). Guarded by oft-photographed mounted soldiers in scarlet jackets and shiny helmets, the Horse Guards is still the HQ of the Household Cavalry, the soldiers who guard the Queen on ceremonial occasions in London. The museum opened in 2007 and traces the origins of the regiment from its inception by Charles II (when its members paid for the privilege of guarding the monarch) to its current hard-core operational roles in Iraq and Afghanistan. The stable block setting means that visitors get a unique behind the scenes insight into daily regimental life – a clear partition allows a view (and smell) of the famous black chargers in their stalls, being mucked out, tacked up and groomed. Videos show the relentless training involved in getting men and horses ready for duty with footage of novice riders being put through their paces and troopers hard at work preparing kit for the daily inspection. Younger visitors should also enjoy the touch screen interactive quizzes and trying on the uniforms strategically placed in the empty stalls.

Moving on, the displays look at the earlier days of the regiment and include a section devoted to its role at the battle of Waterloo. Relics from this epic confrontation include the field bugle used to call for the decisive charge of the Life Guards and the artificial leg of the 18th Marquess of Anglesey who famously lost his leg watching the battle with the Duke of Wellington. A bullet stopping French dictionary from WWI and the bridle of Sefton, the horse who was injured in the 1982 Hyde Park Bomb, are sobering mementos of more recent conflicts. Packed with a marvellous array of plumed helmets, shiny breastplates and swords, the displays also trace the development of the HC into the modern, mechanised fighting force that it is today. The small gift shop offers regimental memorabilia and model soldiers for all ages.

Hunterian Museum at the Royal College of Surgeons

🖼 35-43 Lincoln's Inn Fields, WC2A 3PE

☎ 020 7869 6560

🖂 www.rcseng.ac.uk/museums

🚇 Holborn LU

🕐 Tues-Sat 10.00-17.00 (group visits must be booked in advance), free public tour every Wednesday at 13.00

💷 Admission free

🛍 Small shop

♿ Wheelchair access (via external lift, accessible toilet)

Packed with case upon case of anatomical and pathological specimens, human and otherwise, the Hunterian Museum is not for the squeamish. John Hunter's research into bone growth, regeneration and reproduction paved the way for modern scientific surgery and such was his reputation that his collection was purchased by the government and given to the RCS in 1799. In 2005, a multi-million pound refurbishment transformed the formerly old-fashioned displays and a glittering 'Crystal Gallery' now houses over 3,000 of John Hunter's original 18th-century specimens. Not without their own macabre beauty, the specimen jars contain all sorts of innards and outards (many with congenital disorders) suspended in sepulchral solutions – the alimentary canal of a sea cucumber, a camel's palette and a collection of hernias are just some of the offerings. After these, it's almost a relief to look at the skeletons such as the 7ft 10in frame of 'the Irish Giant' Charles Byrne, master criminal Jonathan Wild and a solitaire (an equally defunct relative of the dodo). Other human remains include the left hemisphere of the brain of mathematician Charles Babbage and the Evelyn anatomical tables. Not content with collecting medicalia, Hunter was chummy with many of the leading painters of his day, and the museum contains some of the art works he amassed, including sculpture by Roubiliac and animal studies by Stubbs and Agasse.

Also on the ground floor, the Silver and Steel Gallery displays a menacing assortment of surgical instruments from East African 'thorn' needles to modern skin 'staplers', and some ingenious tools for removing foreign bodies (and indeed, some of the foreign bodies they removed). The McRae Gallery is a 'discovery space', on my visit filled with sketching students, but also containing toothsome treasures from the Odontological Collection. The comparative nature of the displays means that one can compare pin sharp piranha teeth with Winston Churchill's dentures, elephant molars with Anglo Saxon gnashers, and observe that, sadly, animals suffer from similar dental problems as humans.

Upstairs the Moynihan Gallery explores the nitty-gritty of surgery from the gore spattered early days of do-or-die 'heroic' operations to the rise of aseptic modern techniques and developments such as open heart surgery and keyhole procedures. Regularly changing temporary exhibitions and a lively programme of events and talks complement the permanent displays. In his day Hunter used to give 'peripatetic lectures' around his collection to amuse his friends; today's visitors can take advantage of free guided tours as well as virtual and audio tours of the collection, accessed via the website.

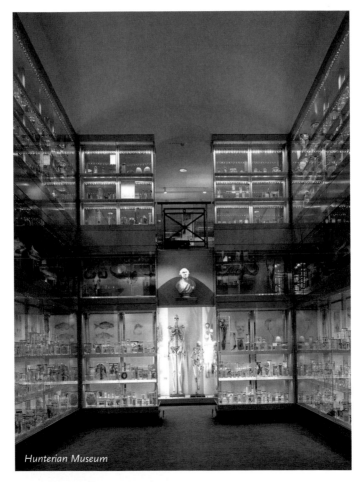

Hunterian Museum

FLOOR PLAN

There are direction signs on all floors to temporary as well as permanent exhibitions. Museum staff will be happy to direct you.

4 *Crimes against Humanity*

3 *The Holocaust Exhibition*

2 *Art galleries*
John Singer Sargent room
Toilets ♿

1 *Secret War*
Victoria Cross and George Cross
Survival at Sea: Merchant Navy
Toilet ♿

G *Large exhibits*
Temporary exhibitions
Telephone
Cinema
Shop and Café
Toilets ♿
Baby changing facility 👶
Picnic room
(weekends and
school holidays only)

Main Entrance

LG *First and Second World*
War displays
Trench Experience
Blitz Experience
Toilets 🚹 🚺 ♿

Park entrance ♿

46

Imperial War Museum

⌨ Lambeth Road, SE1 6HZ
☎ 020 7416 5000
✎ www.iwm.org.uk
🚌 Elephant and Castle LU/Rail, Lambeth North LU,
 Southwark LU, Waterloo LU/Rail
🕐 Daily 10.00-18.00 (last admission 17.45)
💲 Admission free
🛍 Shop
☕ Café
♿ Wheelchair access

War is often described as a kind of madness, so perhaps it's appropriate that a museum dedicated to 20th-century conflict should be housed in the former lunatic asylum known as Bedlam. The subject of an ongoing redevelopment programme, the museum's facilities and displays are top notch, taking visitors beyond just the instruments of war to focus on the people – both the perpetrators and the victims of conflict. The lofty entrance hall is dominated by the bulky hardware of modern warfare: aeroplanes, tanks, jeeps, rockets and a World War I German periscope mast, so powerful that through it you can see the dome of St Paul's, two miles away.

A permanent exhibition examining 20th-century warfare occupies the lower ground floor and is divided into four parts: World War I, the inter-war years, World War II and post-war conflicts. Displays within each section are thematic rather than strictly chronological, reducing a vast, potentially daunting subject into manageable chunks. As well as artefacts such as uniforms, equipment and weaponry, important historical documents are also displayed: letters and manuscripts from World War I poets and, more chillingly, a facsimile of Adolf Hitler's fateful directive ordering the invasion of Poland.

Personal artefacts from both well-known and anonymous soldiers shift the emphasis from the political to the personal. Recorded eyewitness accounts can be accessed through headsets and these, along with interactive videos showing archive film footage, help visitors develop an accurate picture of events. 'The Trench' and 'Blitz' participatory displays are always popular (unlike the real thing), although some people may find the 'experience' rather too voyeuristic for comfort.

Upstairs on the first floor, 'The Secret War' dishes the dirt on Britain's spies and has no end of nifty gadgets. Ian Fleming's 'Q' would have been chuffed with the interactive computers which let visitors sift through the files of various real-life agents and have a go at encoding messages. 'Survival at Sea' reviews the crucial role played by

the Merchant Navy in WWII and recounts dramatic stories of merchant seamen like the two survivors of the SS Anglo Saxon who endured 72 days adrift on the mid Atlantic. Their 'jolly boat' is shown here along with their logbook which contains laconic entries like '2nd cook goes mad, dies. Two of us left'.

On the fourth floor the Lord Ashcroft Gallery of Victoria and George Cross Medals is the first major permanent gallery at IWML for a decade. It commemorates the 'extraordinary heroes' who have been awarded these medals and contains the world's largest collection of VCs. The ultra interactive displays tell the inspiring stories and outstanding bravery behind each medal – from the naked aggression of WWI fighter ace Edward Mannock to the endurance displayed by undercover agent Odette Samsom and the fearless initiative shown by Parkash Singh.

The museum's art collection is housed on the second floor and, with holdings of 20th-century art second only to those of the Tate Gallery, merits a visit in its own right. The art displays are changed periodically but expect to see works by Stanley Spencer, Paul Nash, Henry Moore and Graham Sutherland. John Singer Sargent's unforgettable depiction of World War I, *Gassed*, has been allocated a room of its own.

The Holocaust Exhibition on the third floor tells the harrowing story of the Nazis' persecution of the Jews and other groups before and during World War II. Topics include a history of anti-Semitism, ghettoes, Jewish resistance, death marches and the discovery of the camps. A funeral cart from the Warsaw Ghetto, a deportation railcar, and a huge case of items belonging to people who were killed at Auschwitz are among the exhibits. The displays effectively convey the remorseless scale and pre-meditation of the Nazi programme of industrialised murder but never lose sight of the individuals involved, be they victim or perpetrator. Video testimonials of survivors as well as photographs, letters and personal possessions such as Leibish Engelberg's prison jacket and Paul Sondhoff's toy bear ensure that the human impact of the Holocaust always stays in focus. Due to the strong content of the exhibition it is not recommended for children under 14. And if you thought mankind might have learnt its lesson from the Holocaust, a visit to 'Crimes Against Humanity' on the fourth floor should stop any complacency in its tracks. From the killing fields of Cambodia to the civil war in the former Yugoslavia, this gruelling audiovisual shows that genocide and ethnic violence remains an ongoing problem for the international community. Again, the material in this exhibit is not suitable for children.

The sheer quantity of the IWM's holdings shows the extent to which conflict dominated the last century. The museum holds the national collection of 20th-century military firearms as well as having the oldest

collection of wartime film in the country. Only a small proportion of these collections is on display in the public galleries but the museum stages regular film shows and visitors can use the Museum's reference departments by prior appointment. Major temporary exhibitions such as 'Women War Artists' and 'Once upon a Wartime: Classic War Stories for Children' supplement the excellent permanent displays.

With such a quantity of material to see, audio tours of the museum highlights (£3.50) are a useful aid for visitors with limited time, while special family events help children get the most out of a visit – contact the museum for details and times. The pleasant ground floor café provides a convenient venue for a spot of R&R. For those in a retail frame of mind, the shop offers a good range of books and videos on 20th-century war, and souvenirs such as trendy camouflage jackets, bags and 1940s music CDs.

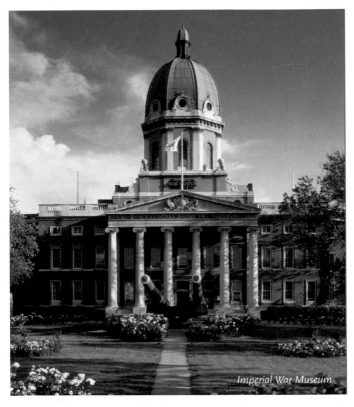

Imperial War Museum

Inns of Court & City Yeomanry Museum

🖼 10 Stone Buildings, Lincolns Inn, WC2

☎ 020 7405 8112

✎ www.iccy.org.uk/museum.htm

🚇 Chancery Lane LU

🕑 Mon-Fri 10.00-16.00 By appointment only

💷 Admission free

🛍 Shop

Cunningly camouflaged among the legal buildings of Lincoln's Inn, this small military museum tells the story of two historic London regiments. Weapons, uniforms, medals, equipment and original documents follow their history to the present day, revealing the many roles the regiments have been required to play – from 18th-century riot-quelling militia to the 'Rough Riders' of the Boer War to modern communication corps. The highlight of the collection is a rare and complete set of Georgian drums of the Law Association Volunteers, a regiment dubbed the 'Devil's Own' by lawyer-phobe King George III.

The Jewel Tower

🖼 Abingdon Street, Westminster (opposite the south end
of the Houses of Parliament), SW1P 3JX

☎ 020 7222 2219
0870 333 1181 (customer services)

✎ www.english-heritage.org.uk

🚇 Westminster LU

🕑 Daily 10.00-17.00 (April-Oct), 10.00-16.00 (Nov-March)

💷 £3.20 (adults), £2.90 (concessions), £1.90 (children)

🛍 Shop

Constructed in 1365, the Jewel Tower is one of the only two surviving buildings from the original Palace of Westminster. King Edward III built it as a treasure house and wardrobe but its later incarnations were distinctly downmarket: junk room, kitchen, and a testing centre for weights and measures. A smallish selection of unglamourous objects on display underline the antiquity of the site and include a 9th-century sword, part of the Tower's original elm foundations and 11th-century carved 'storytelling' stone capitals.

Mindful of its location opposite 'the Mother of Parliaments', the Tower also contains an excellent introductory exhibition about the English Parliament charting its evolution from Anglo-Saxon *'witenagemot'*, (a meeting of wise men) to today's gathering of the (ahem) same. The exhibition is arranged over the two upper floors of the Jewel Tower, and is accessible only by a steep spiral stone staircase.

Dr Johnson's House

🖿 17 Gough Square, EC4A 3DE
☎ 020 7353 3745
✍ www@drjohnsonshouse.org
🚌 Blackfriars LU/Rail, Chancery Lane LU
🕓 Mon-Sat 11.00-17.30 (May-Sept), 11.00-17.00 (Oct-April)
💰 £4.50 (adults), £3.50 (OAPs/students), £1.50 (children), £10 (family)
🛍 Shop

Dr Johnson's House

It was in the garret of this early 18th-century house that Dr Samuel Johnson compiled his famous Dictionary: the first comprehensive lexicon of the English language. The house has been restored to its condition during Johnson's 11-year occupancy (from 1748 to 1759) and retains many original features – including some heavy-duty crime prevention measures and an ingenious 'cellarette' in the dining room. Arranged over several floors, the house has no shortage of stairs, but then to quote the friendly attendant, 'the chairs are for sitting on, not gawping at'.

The house has other unexpected surprises. A brick from the Great Wall of China is a tangible reminder of Johnson's unrealised ambition to visit it, while the garret is home to a model toy workshop presented to the house by firefighters in World War II. Books, paintings and memorabilia of Dr Johnson and his circle can be found throughout the house and there's an entertaining and informative video show as well as free information sheets. Changing displays and exhibitions keep things fresh for regulars while younger visitors can try on a selection of replica Georgian clothing. Cards and collections of Johnson's sayings and bon mots are available in the small shop. (Incidentally, a glance in a facsimile of the Dictionary reveals that the great man defined a museum as 'a repository of learned curiosities').

Kirkaldy Testing Museum

🏛 99 Southwark Street, SE1 0JF (entrance on Prices Street)
☎ Perry Perrin 07821337553
🚌 Southwark LU, Blackfriars LU/Rail, London Bridge LU/Rail
Waterloo LU/Rail
🕐 First Sunday of the month 10.00-16.00, other times by appointment
💰 Admission free (donations appreciated), £3 per person for groups

Kirkaldy Testing Museum

This atmospheric museum celebrates three generations of the Kirkaldy family who worked in Southwark from 1866-1965 testing engineering and building materials. The Kirkaldy motto, 'Facts not Opinions', is inscribed above the entrance to the firm's Victorian works building, where David Kirkaldy's original all-purpose testing machine is still in place. Some 48 feet long and able to apply a load of over 300 tonnes, this mighty machine tested the chains of Hammersmith Bridge as well as the steel used to build Sydney Harbour Bridge and parts of the Comet airliner. Lovingly restored back to working order by the museum's dedicated volunteer staff, the machine is run on special open days. Regular visits last about $1\frac{1}{2}$ hours and reveal both how this extraordinary machine functioned and its role in developing quality-control techniques for construction materials.

London Fire Brigade Museum

🏛 Winchester House, 94a Southwark Bridge Road, SE1 0EG

☎ 020 8555 1200 extn: 39894

✎ www.london-fire.gov.uk

🚌 Borough LU, Southwark LU, elephant & Castle

🕓 Guided tours only (by appointment) Mon-Fri at 10.30 and 14.00

💷 £5 (adults), £3 (under 16s/concessions), free (children under 7)

🛍 Shop

Comprising one of the most comprehensive collections of firefighting equipment in the country, it's probably just as well that admission to this museum is by guided tour only. Arranged chronologically, the exhibits chart the development of the London fire service from 1666 to the present day through the use of paintings, photographs, uniforms, models and medals – including one of only three George Crosses to have been presented to a firefighter.

Equipment ranges from tree-trunk watermains, leather hosepipes and early breathing apparatus (operated by footpump!) to modern thermal imaging cameras. Larger appliances such as the 19th-century telescopic fire escape ladder and a horse-drawn 'steamer' from 1885 are displayed in the former Brigade HQ engine room. Particularly fine paintings of firefighting during the Blitz can be seen in the room dedicated to World War II, while the Overseas Room contains badges and helmets of fire brigades from around the world. The tours are filled with tales of bravery and even the supernatural and last between 1-2 hours. The small but choice selection of gifts in the museum shop features firemen's helmet paperweights, bronze firefighter figures and an excellent fire extinguisher water squirter.

London Transport Museum

London Transport Museum

🖳 Covent Garden Piazza, WC2E 7BB

☏ 020 7565 7299 (24-hour information) / 020 7565 7298 (booking office)

✎ www.ltmuseum.co.uk

🚃 Covent Garden LU, Leicester Square LU, Holborn LU

🕓 Mon-Thurs 10.00-18.00 (last admission 17.15), Fri 11.00-18.00

💰 £13.50 (adults), £10 (concessions) –
 Tickets valid for 12 months from date of purchase

🛍 Shop

☕ Café

♿ Wheelchair access

Located amid the hubbub of the Piazza, and housed in a former flower market, the LTM is a must for train, tram and bus-spotters, or indeed any of the millions who travel by public transport in the capital each year. A two-year long redesign has brought the displays bang up to date, telling the story of London's transport system from Sedan chairs to Oyster cards and congestion charging. The light, airy building is still filled with the historic vehicles and machinery of old but with 1,000 new items on display it is well worth a fresh visit even if you've already visited the museum in the past.

Lumbering horse-drawn vehicles begin the display but quickly give way to the electric and motor-powered trams and buses that revolutionised transport in the capital. Sympathetically restored but retaining a slightly battered feel, the vehicles are all surprisingly atmospheric and you can watch old footage of some of them in action, listen to accounts by transport workers such as 'Cast Iron Billy' and find out why posh places like Hampstead resisted the advent of trams.

The museum follows the transport story underground with Charles Pearson's pioneering Metropolitan Railway and features an 1866 'steam' tube train, complete with carriages you can sit in and grouchy commuters you can eavesdrop on. Incidentally, Mrs Beeton (of cookery book fame) was an early female commuter, regularly travelling from Hatch End to 'town'. A reconstruction of workers digging a Tube tunnel using a shield evokes the sheer hard graft and personal risk involved in bringing transport to the masses.

Moving further into the 20th century, there's a section devoted to London transport at war recalling the dark days of WWI when London buses were pressed into active service on the Western Front and the use of Tube stations as air raid shelters during WWII. Misty eyed nostalgics should enjoy the 1939 electric trolley bus and more recent vehicles like the 1970s Tube train, and the late lamented Routemaster bus.

While the adults take a trip down memory lane, youngsters can get stuck into the numerous hands-on exhibits with no shortage of

buttons to press and handles to turn. Actors bring the exhibits to life – on a recent visit an elegant parasol twirling 19th-century omnibus traveller waylaid visitors venturing into the replica Shillibeer horse bus. Simulators give old and young a chance to get behind the wheel and are a popular attraction; 'drive' a Victoria Line train and try to align it correctly with the station platform or enjoy a driver's eye view from the cab of today's Wright Gemini bus.

From season ticket passes to London's 'intelligent' SCOOT traffic light system, the museum explores every conceivable aspect of London's transport network. A dazzling selection of London transport posters and publications pays tribute to the design geniuses behind one of the world's most famous 'brands' – head of London Underground Frank Pick, typographer Edward Johnston, architect Charles Holden, and Harry Beck, the man behind London's iconic Tube map.

Although the vehicles are the main attraction, neither the social impact of public transport nor contemporary environmental concerns have been forgotten (although with a daily deposit of 1,000 tonnes of horse manure onto London's streets, things weren't too rosy in the 19th century either). A huge light-up map charts traffic congestion live as you watch and new displays flag up the challenge of climate change – a challenge the museum does its bit to meet with solar tiles, low energy lighting and natural ventilation.

If all that travel builds up your appetite, the museum's new Upper Deck café and bar is decked out with LU moquette covered seating and provides a handy pit stop for drinks and snacks. It serves a pretty mean cocktail too – try the evocatively named 'Routemaster' or sip a 'Semi-detached'. For those bringing their own food, a small picnic area is provided within the museum itself, handily sited next to the mini vehicles of the 'All Aboard' play area for the children.

The museum's shop is great fun although with titles like 'Slam doors on the Southern' the selection of specialist books, magazines & DVDs seems aimed squarely at the serious enthusiast and indeed on my last visit this bit of the shop was filled with actual train spotters stocking up on reading material. Posters, postcards and any amount of improbable items emblazoned with the Underground map and the LT logo should satisfy the less anorakish, with models, games and toys for younger visitors. Even LT's hard-wearing moquette fabric gets an image make over in a funky range of handbags, washbags and door stops.

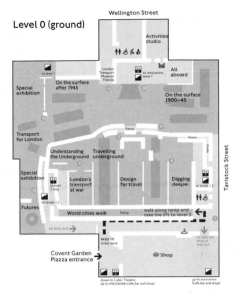

Level 0 (ground)

Wellington Street

Activities studio

London Transport Museum Friends

All aboard

to levels 1

to mezzanine, level 1

Special exhibition

On the surface after 1945

On the surface 1900–45

Transport for London

Ramp

Understanding the Underground

Travelling underground

Special exhibition

to level 2 only

London's transport at war

Design for travel

Digging deeper

to levels 1,2

Futures

to levels 1,2

World cities walk

Ramp

walk along ramp and take the lift to level 2

to levels 1,2

to way out →

way in
ticket desk

to cafe bar, shop & way out

Covent Garden Piazza entrance →

Shop

down to Cubic Theatre,
up to mezzanine (cafe bar and shop)

lift to mezzanine
(cafe bar and shop)

Tavistock Street

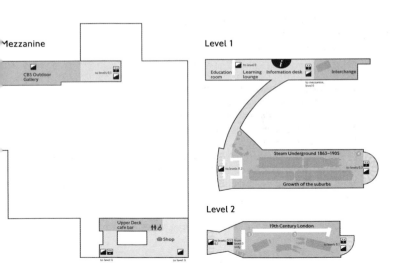

Mezzanine

CBS Outdoor Gallery

to levels 0,1

Upper Deck cafe bar

Shop

to level 0

to level 0

Level 1

Education room

Learning lounge

Information desk

Interchange

to level 0

to mezzanine, level 0

Steam Underground 1863–1905

to levels 0,2

to levels 0,2

Growth of the suburbs

Level 2

19th Century London

to levels 0,1

from level 0 only

to levels 0,1

Museum of London

🖂 150 London Wall, EC2Y 5HN
☎ 020 7001 9844
🖉 www.museumoflondon.org.uk
🚇 Bank LU, Barbican LU, Moorgate LU, St Paul's LU
🕓 Daily 10.00-18.00
🎫 Admission free
🛍 Shop
☕ Café
♿ Wheelchair access

Museum of London

Even if you think you know London like the back of your hand, the chances are that you'll see the city in a new light after a trip to the MoL. Newcomers to the capital could also do a lot worse than make this their first stop. Full of artefacts and insights, the museum offers an excellent overview of London's history from Neanderthal hunting ground to sprawling modern metropolis. The 'London before London' gallery turns the clock back to pre-history and introduces the people who lived in the Thames Valley from around 400,000BC to AD50. Exhibits such as a woolly rhino skull, found beneath Fleet Street, and flint handaxes, excavated off Piccadilly, certainly cast London's busy, built-up streets in a different light.

Things really hot up with the arrival of the Romans though and the displays succeed brilliantly in bringing 'Londinium' to life with lots of archaeology and several reconstructed shops and interiors. The triclinium (or dining room) looks pretty luxurious even by today's standards, while a cookbook in the recreated 1st century kitchen includes tempting recipes for stuffed dormice and peacock rissoles. Modern foodies will be interested to learn that Roman London's cosmopolitan population were kindred spirits, with a taste for food and wine imported from the Mediterranean. A model of the civic centre in AD150 shows the ordered layout beloved of the Romans – no slouches when it came to architecture, they built London's first city wall, a section of which can be glimpsed from this section of the museum. With finds ranging from a skimpy leather bikini to beautifully carved heads from the Temple of Mithras, all aspects of Londinium life are here – from the nuts and bolts of transport and trade to the razzamatazz of Roman religion and entertainment.

Next up is the Medieval gallery, which spans the long and eventful period from the end of the Roman empire to Henry VIII's Reformation. London was a popular destination for successive waves of invaders – Saxons, Danes, Normans – and there's a great deal of weaponry on display, including some fearsome Viking hardware. On a more domestic note, the reconstructed Saxon home looks the picture of cosiness with its glowing hearth and attractive thatched roof. Even London's geography was on the move during this period – Westminster used to be an island! But despite everything that history threw at it – famine, fire, plague and religious argy bargy – London always emerged bigger, better and stronger, becoming by the late 15th century 'the flower of cities all'. Displays are structured around key turning points such as King Alfred's re-founding of London in AD886 and the Black Death in 1348 and feature archaeological finds from old London town. Computer terminals reveal the lives of individual Londoners– such as tragic 7 year old John le Stolere, who was crushed to death by a cart. It's not all gloom and doom though – despite the sleaze, the medieval period had its own glamour, with plenty of luxury imported goods, fine dining and knights in shining armour. Medieval Londoners liked to look good too, if the displays of outlandish pointy-toed shoes and fancy head-dresses are anything to go by. The destruction of the Reformation brings this party to a close – mutilated statues, shattered glass and fragmented altar pieces the tangible results of Tudor intolerance.

Starring the unwholesome trio of war, plague and fire the next period of London's history was no less turbulent and the audio visual Great Fire Experience combines eye-witness accounts of the inferno with an illuminated diorama of the city in flames – an eery precursor of the Blitz.

U1

ACTIVITY SPACE 2 SEMINAR ROOM

ACTIVITY SPACE 1 e-LEARNING STUDIO

E

BARBICAN

1550s–1660s:
WAR, PLAGUE & FIRE

AD 410–1558:
MEDIEVAL LONDON

AD 50–410:
ROMAN LONDON

HIGHWALK

NEW ACQUISITIONS ARCHAEOLOGY
IN ACTION

MOORGATE

450,000 BC – AD 50:
LONDON BEFORE LONDON HIGHWALK

LUNCH SPACE

LONDON WALL
BAR & KITCHEN

ENTRANCE

TERRACE GALLERY

TERRACE
BOARDROOM GARDEN ROOM

ROTUNDA GARDEN

ST PAUL'S ST PAUL'S

museums central

L1

WESTON THEATRE

L2

MODERN LONDON
1670s–1850s:
EXPANDING CITY

VICTORIAN WALK

GARDEN COURT

MODERN LONDON
1850s–1940s:
PEOPLE'S CITY

THE
SACKLER
HALL

MODERN LONDON
1950s – TODAY:
WORLD CITY

LINBURY
GALLERY

INSPIRING
LONDON

CITY
GALLERY

👤 MALE TOILETS	🍴 RESTAURANT
👤 FEMALE TOILETS	☕ CAFÉ
♿ ACCESSIBLE TOILETS	🛍 SHOP
👶 BABY CHANGING	🧥 CLOAKROOM
ⓘ INFORMATION	🛗 LIFTS

61

The museum's new 'Galleries of Modern London' opened in May 2010 and follow the city's astonishing expansion and resurgence after 1666. Vivacious displays, marrying carefully chosen artefacts with whizzy interactives, film and audio, keep visitors, butterfly like, on the move and convey the many faces of life in London. During this period London grew rich on the back of empire, thanks in no small measure to the slave trade, but wealth was not necessarily a talisman against disease, infant mortality and sheer bad luck. The graffitied interior of a Wellclose Prison cell – where debtors had to pay their way out – seems a particularly apt exhibit in these credit-crunched times. An imaginative recreation of the Vauxhall Pleasure Gardens reveals a happier side of Georgian life, showcasing a parade of elegant 18th and 19th century outfits and eavesdropping on the after dark fun enjoyed there by Londoners of all classes. The popular Victorian Walk has been reinstalled, its original period shop fronts and interiors offering a nostalgic glimpse of retail therapy in the age of Queen Victoria – right down to the last dry biscuit in the grocer's shop.

The People's City spans the 1850s-1940s – also a period of extremes, with exhibits ranging from Charles Booth's infamous 1880s map of London poverty to the fantastically luxurious Art Deco lift from Selfridge's department store. Displays fully exploit the advent of film and audio recording in the 20th century to recall the struggles of the first half of the century, such as the Suffragette movement and the traumatic, sometimes liberating experiences of two world wars. The 'World City' brings London's story up to date, and includes a look at young people's experiences of London, from the coffee bars and mopeds of the 1950s to the swinging 60s and beyond.

In a city famed for its pomp and ceremony, it's fitting that the 'City Gallery' should explore some of the rituals that distinguish the Square Mile. The Lord Mayor's carriage takes centre stage here – a 250 year old 'throne on wheels' that is the centerpiece of the annual Lord Mayor's Show. There's a lot of life crammed into this historic patch of land and a wall of City curiosities includes a chain mail butchers glove from Smithfield, a 1960s City gent's bowler hat, and an 18th-century mineral water bottle, unearthed after the 1992 Baltic Exchange bomb.

During the week this part of London – the corporate hub of the city – buzzes with activity, but a weekend visit finds the area much quieter. Thanks to the refurb, the museum now has two cafés for in-house pit-stops and there's a picnic area with tables and benches for those bringing their own fodder. For those keen to dig deeper into London's history, the museum's shop carries a comprehensive range of books about the city, as well as a large range of general gift items.

The Museum of Methodism

🖼 Wesley's Chapel & House, 49 City Road, EC1Y 1AU

☎ 020 7253 2262

✎ www.wesleyschapel.org.uk

🚌 Moorgate LU, Old Street LU, bus 43, 76, 141, 214, 271, 55

🕐 Mon-Sat 10.00-16.00 (closed Thursdays between 12.45-13.30),
 Sun 12.30-13.45; last admission half an hour before closing

💷 Admission free (donations welcome)

🛍 Shop

♿ Wheelchair access

'Perfectly neat but not fine' was how John Wesley, the founder of Methodism, described the chapel he built in 1778, now known rather more grandly as the 'Cathedral of World Methodism'. The museum in the chapel's crypt tells the story of the Movement, with displays including original letters from John Wesley, his death mask and wooden pulpit, as well as a selection of Methodist paintings and commemorative pottery. Across the courtyard from the chapel lies Wesley's house, where he lived for the last 11 years of his life. Relics of the great man on display here include his travelling communion set, and an early electric shock machine, used by Wesley to treat cases of depression – including his own. A 'chamber horse' and 'cockfighting chair' are among the more unusual pieces of furniture in the house, while Wesley's bedroom features its own en-suite prayer room.

The Museum of the Order of St John

🖼 St John's Gate, St John's Lane, EC1M 4DA

☎ 020 7324 4005

✎ www.museumstjohn.org.uk

🚌 Farringdon LU/Rail, Barbican Lu/Rail

🕐 Mon-Sat 10.00-17.00 (guided tours Tues, Fri and
 Sat 11.00 and 14.30)

💷 Admission free (donations suggested for tours)

🛍 Shop

♿ Wheelchair access (except for crypt)

With nearly 1000 years of history to tell, this museum has got its work cut out but, thanks to a recent £3.7 refurbishment, it's a test the classy new displays sail through. A sturdy Tudor gatehouse, one time entrance to the medieval priory of the Order of St John, is the picturesque setting for the museum, which tells the complicated story of the Order from its foundation in the Crusades to its present day incarnation as a chivalric order and healthcare provider (in the form of the St John's Ambulance service). Warlike defender of the faith on one hand, merciful provider for the poor and sick on the other, the original Order seems to have had

something of a personality disorder. Its contradictory roles are neatly encapsulated by the three items in the opening display: a medieval sword, a majolica pharmacy jar and a pair of devotional paintings.

The displays in the Order Gallery follow the changing fortunes of these warrior monks over the centuries, as they migrated around various Mediterranean strongholds, battling their Muslim opponents and setting up hospitals. Exhibits include rare chain mail armour, ancient Crusader coins, portraits of eminent Hospitallers, silverware and furniture, as well as an audio visual presentation about the escapades of two 14th century Knights, brothers Rostand and Claude Merles. Having set up shop in Jerusalem, Cyprus and Rhodes, the Order finally settled in Malta – rented to the Knights for the annual fee of one falcon. They were finally ousted from Malta in 1798, not by the forces of Islam but by Napoleon's army.

The St John Ambulance Gallery brings the story up to date, with the resuscitation of the medical aspect of the Order in the 19th century. Displays cover the role of St John's Ambulance in the Boer War and both world wars and include uniforms, insignia, first aid equipment, and several fine paintings, including portraits by Anna Zinkeisen and George Clausen.

A little further along from the Gatehouse, the Priory Gallery, Church and Crypt are also open to the public, along with the Cloister Garden, planted with medicinal herbs to recall the Order's caring vocation. Although the Church is largely a reconstruction, the 12th-century vaulted crypt is the real deal, a very rare example of Norman architecture in London and the location of the tomb of the last Prior, William Weston. Weston is said to have died of a broken heart after Henry VIII's dissolution of the Order of St John in 1540.

Guided tours take about an hour and give access to parts of the gatehouse not otherwise open to the public, such as the Chapter Hall.

The Museum of the Royal Pharmaceutical Society

🏛 1 Lambeth High Street, SE1 7JN

☎ 020 7572 2210

🖋 www.rpharms.com/about-pharmacy/our-museum.asp

🚌 Lambeth North LU, Vauxhall LU/Rail, Waterloo LU/Rail, Westminster LU

🕐 Mon-Fri 09.00-17.00

💷 Admission free

🛍 Shop

♿ Full Wheelchair access

This specialist museum, based in the Society's headquarters, traces the long and fascinating history of medicinal drugs and their use. The collection is particularly strong on community and retail pharmacy from the 17th century onwards and among its treasures are 'Lambeth delftware' apothecary jars and glass carboys filled with brightly coloured liquid. The displays also include more sophisticated dispensary equipment such as pill-making paraphernalia, a tincture press, and devices for sugar-coating and even silver-coating pills. The first floor displays can only be viewed on a guided tour and include the Ernest Saville Peck bequest of bell metal mortars and 'Healing Science', a permanent exhibition telling the sometimes addictive story of the last 1,000 years of medicinal drugs. There are no catering facilities on-site but The Garden Museum (see p. 37) is just over the road and has a good café.

New London Architecture

🏛 The Building Centre
26 Store Street, WC1E 7BT

☎ 020 7636 4044

🖋 www.newlondonarchitecture.org

🚌 Goodge Street LU. Tottenham Court Road LU

🕐 Mon-Fri 9.30-18.00, Sat 10.00-17.00

💷 Admission Free

♿ Wheelchair access

A series of galleries telling the ongoing story of London's built environment. At the heart of the displays is a giant 1:1500 scale model of central London encompassing Paddington in the west to the Royal Docks in the east, Battersea in the south to King's Cross in the north. New and proposed projects are highlighted so visitors can keep up to date with London's changing skyline. Other permanent displays look at major issues facing the capital, the Olympic development and regeneration of the London boroughs.

The Old Operating Theatre Museum & Herb Garret

⌨ 9a, St Thomas' Street, SE1 9RY

☎ 020 7188 2679

🖱 www.thegarret.org.uk

🚇 London Bridge LU/Rail

🕒 Daily 10.30-17.00

💷 £5.90 (adults), £4.90 (concessions), £3.40 (under 16s), £13.80 (families)

🛍 Shop

Located in the garret of St Thomas' Church, the Old Operating Theatre is perhaps London's most atmospheric museum, as well as one of its most inaccessible. A rickety wooden spiral staircase leads up to the displays, a precipitous climb unsuitable for those with restricted mobility but well worth the effort for those who can make it.

The operating theatre – the oldest in the country – is the centrepiece of the museum and a grisly remnant of pre-anaesthetic and antiseptic surgery. Built in 1822 the theatre was part of the adjoining St Thomas' Hospital but remained hidden for nearly 100 years when the hospital relocated to Lambeth, before being rediscovered in 1956. A semi-circular arena overlooked by raised tiers with leaning rails (from where medical students watched the bloody proceedings), it was not called a theatre for nothing – although the scarred wooden operating table looks better suited to the kitchen than the hospital. Nearby displays of surgical knives and saws, horsehair sutures and early anaesthetic equipment leave no doubt about the horrors of 19th-century surgery.

Festooned with dried herbs hanging from the wooden eaves, the adjacent Apocathary's Garret is only marginally less gruesome. Pickled human specimens are also displayed here, along with some worryingly indelicate medical instruments like amputation kits and obstetrics tools with off-putting names like 'blunt hook and crochet' and 'Smellie's perforator'. Standing as it does on the site of the original St Thomas' Hospital, the museum also has displays on medieval health care, and enterprising younger visitors can follow a 'Plague Trail' around the garret, choosing medicinal ingredients from the bowls of dried herbs liberally dotted around the garret. Contemporary artworks, scattered amongst the medicalia – created by the museum's artist in residence – are an unexpected bonus. The imaginatively stocked shop contains an eclectic range of medical books as well as amusingly macabre knick-knacks like memento mori memo pads and rubber internal organs.

Petrie Museum of Egyptian Archaeology
University College London

🖼 Malet Place, WC1E 6BT

☎ 020 7679 2884

🖉 www.ucl.ac.uk/silva/museums/petrie

🚌 Euston LU/Rail, Euston Square LU, Goodge Street LU,
Russell Square LU, Warren Street LU

🕓 Tues-Sat 13.00-17.00

💷 Admission free

🛍 Salespoint

Founded by the father of Egyptian archaeology, W M F Petrie, and voted one of London's top ten little-known museums, the Petrie is a treasure trove for Egyptophiles. With its huge collection of domestic artefacts dating from Pre-Dynastic times to the Roman era, it's the ideal place to get acquainted with the everyday life and death of ancient Egyptians and the cultural developments of one of the greatest civilizations ever known. Highlights of the collection include the world's earliest surviving dress (complete with original underarm perspiration stains), a pot burial and an exceptionally fine display of Roman mummy portraits. A planned move to a new site has not taken place after all and the museum has instead had a bit of a refurb, with improved interpretation and more space for events and activities. Objects previously tucked away in the reserve store have been put on display and these include a number of musical instruments, including ivory clappers, bells and a wooden flute. The well-stocked salespoint carries a good selection of Egyptology titles for both adults and children as well as jewellery, children's gifts, and other articles of Egyptiana.

Pollock's Toy Museum

🖼 1 Scala Street, W1T 2HL

☎ 020 7636 3452

✍ www.pollockstoytheatres.com

🚌 Goodge Street LU

🕑 Mon-Sat 10.00-17.00 (last admission 16.30)

💷 £5(adults), £4 (students/seniors), £2.50 (children)

🛍 Shop

With its quirky collections of toy theatres, toys, games and pastimes, this dinky museum is the perfect antidote to the increasingly slick and shiny museums of the 21st century. Two ramshackle old houses provide the setting, every available nook and cranny of which is packed with old toys; even the winding, brightly painted staircases double up as display areas, covering topics as diverse as board games, Penny Dreadfuls and war games like the short lived Falklands War Game. Many exhibits are at child height but there's plenty to enjoy for visitors of all ages – from puppets to puzzles, tin toys to Tyrolean carved animals, Victorian wax dolls to Action Man. Scattered throughout the museum are toys from around the world while Room 4 is home to group of grizzled veteran teddy bears and a collection of fine dolls houses. Named in honour of toy theatre-maker Benjamin Pollock, the museum displays a range of charming toy theatres – colourful paper and cardboard theatrical constructions which enabled children in Victorian times to 'stage' popular plays like *Aladdin* and *Cinderella* at home. Modern editions of these DIY paper theatres are available from the excellent ground floor shop, along with a nostalgic selection of good quality toys and puzzles and some brilliant old fashioned stocking filler type gifts.

Prince Henry's Room

🖼 17 Fleet Street, EC4 1AA

✍ www.cityoflondon.gov.uk

🚌 Temple LU

🕑 check website for details

💷 Admission free

Built in 1610 as an office for King James's eldest son, this funny little room has in its time been a tavern and a waxworks. It's worth a peek if only for the fine Jacobean plaster ceiling, wood panelling and quaint leaded light windows overlooking the bustle of Fleet Street. Prince Henry's room is currently closed to the public – see website for further details

The Rose Theatre Exhibition

- 56 Park Street, SE1 9AR
- 020 7261 9565
- www.rosetheatre.org.uk
- Cannon Street LU/Rail, London Bridge LU/Rail, Mansion House LU
- Occasional open days, staged readings, and other events (see website for details). At other times the Rose can be visited by joining tours run by the nearby Globe Theatre (when matinee performances make tours of the Globe impossible, visitors are taken to the Rose), these can be booked via the Shakespeare's Globe Exhibition, tel. 020 7902 1500; exhibit@shakespeares-globe. com, or www.shakespeares-globe.org
- Wheelchair access

The basement of an office block is perhaps not the first place you'd think of staging an exhibition. But this is an office block with a difference because it is built over the site of 'The Rose', Bankside's first purpose-built playhouse, where Shakespeare learnt his craft and for which Marlowe wrote his best plays. Tantalisingly, the theatre's remains are today buried for safekeeping, pending excavation, beneath layers of sand, concrete and water. In the meantime, underwater lighting reconstructs the exact position of the remains and visitors can enjoy a rousing audio-visual presentation, narrated by Sir Ian McKellen, which relates the history of the theatre and its discovery in 1989. In recent years the site has also started staging theatrical performances, with evening shows from Tuesday to Saturday at (19.30) and matinees on Sundays (15.00). The exhibition is also open Saturdays 10.00-17.00, with free guided tours.

Royal College of Physicians

- 11 St Andrew's Place, NW1 4LE
- 020 7935 1174
- www.rcplondon.ac.uk/heritage
- Great Portland Street LU, Warren Street LU
- Mon-Fri 09.00-17.00
- Admission free (by appointment only)
- Wheelchair access

Founded by Henry VIII in 1518, the College is today housed in a Grade I listed icon of modern architecture by Sir Denys Lasdun. As the oldest medical college in Britain it's had plenty of time to build up its heavyweight library, archive and museum collections. The first book printed in the English language is one of the treasures of the library while the archive includes the personal and professional papers of physicians from the 16th century onwards. The museum meanwhile

gives wallspace to some fine portraits of notable physicians past and present – from paintings of Sir Hans Sloane and John Radcliffe to a sculpture of Sir Raymond Hoffenberg by Dame Elisabeth Frink. Other highlights include the Symon's Collection of medical instruments, William Harvey's demonstration rod, the College silver-gilt mace (following the same design as the Commonwealth mace in the House of Commons) and six 17th-century anatomical tables fashioned from preserved human blood vessels and nerves. The garden is something of a 'living museum', and is attractively planted with medicinal plants from around the world.

Royal Fusiliers Museum

⌖ HM Tower of London, EC3N 4AB
☎ 020 3166 6912
🖱 www.fusiliermuseum.org
🚇 Tower Hill LU
🕐 Tues-Sat 9.00-17.30, Sun-Mon 10.00-17.30 (summer); Tues-Sat 9.00-16.30, Sun-Mon 10.00-16.30 (Winter)
💰 included in entrance fee to HM Tower of London)
🛍 Shop

Tucked away within the confines of the Tower, the shiny new galleries of this regimental museum opened in April 2011. It tells the story of this illustrious infantry outfit from their foundation in 1685 to the present day. Mementoes from various historical conflicts range from an 'eagle standard' captured on Martinique during the Napoloenic Wars, to a musket ball that went clean through Colonel Shipley's leg during the Crimean War (and was subsequently mounted by him as a trophy), and the 'sweetheart brooches' given by WWI fusiliers to their womenfolk back home. Using the regiment's rich collections of photographs, war diaries and personal letters, displays recount the personal experiences of soldiers and officers – a brave bunch if their collection of 20 Victoria Crosses is anything to go by (12 of which are on display here). Clearly invigorated by the redevelopment, the museum has launched its first education and outreach programme and is busily recruiting volunteers.

St Bartholomew's Hospital Museum & Archive

🖃 St Bartholomew's Hospital, West Smithfield, EC1A 7BE
☎ 020 3465 5798
🖉 www.bartsandthelondon.nhs.uk/museums
🚈 Barbican LU, Blackfriars LU/Rail, Farringdon LU/Rail, St Paul's LU
🕓 Tues-Fri 10.00-16.00
💰 Admission free
🛍 Small shop
♿ Wheelchair access (by arrangement)

Founded in 1123, St Bart's is what you might call well-established. Its small museum can be reached via the Henry VIII Gate and explores the hospital's antiquity with displays relating to the work of medical people of earlier times – the apothecary, the physician and the surgeon. A short introductory video tells the story of Rahere, the courtier turned monk who founded the hospital and church at 'Smoothfield' (today's Smithfield). Old documents on show include a hospital inventory of 1546, while early syringes, a grisly Victorian amputation set, and a wooden head for practice trepanning are among the gory surgical items. Bart's pre-eminence is reflected in its personnel over the years – William Harvey discovered the circulation of blood here in the 17th century and exhibits include a lancet belonging to surgeon John Hunter (see also The Hunterian Museum p. 44). Visitors can also glimpse two grandiose paintings by William Hogarth on the Grand Staircase.

St Bride's Crypt

🖃 St Bride's Church, Fleet Street, EC4Y 8AU
☎ 020 7427 0133
🖉 www.stbrides.com
🚈 Blackfriars LU/Rail
🕓 Daily 09.00-17.00 (ring to check first as crypt is sometimes closed for Church events)
💰 Admission free

From the top of its wedding cake spire to the depths of its crypt, St Bride's is steeped in history. Samuel Pepys was christened here, and it was here too that novelist Samuel Richardson was buried. Badly bombed in World War II, Christopher Wren's church (the eighth on the site) was restored to its former glory – but not before excavations revealed the site's previously unknown Roman origins. Some of these and later archaeological finds are displayed in the small museum in the crypt: clay pots and pipes, coins and fire-distorted fragments of the old church's bells. St Bride's was the site of the City's first printing press and, although the papers have left, it remains the parish church for the industry known collectively as 'Fleet Street'. The crypt museum explores the church's connections with the print trade.

Shakespeare's Globe Exhibition

- 21 New Globe Walk, SE1 9DT
- 020 7902 1400
- www.shakespearesglobe.com
- Cannon Street LU/Rail, London Bridge LU/Rail, Mansion House LU, Southwark LU, Blackfriars LU/Rail
- Daily 09.00-12.00 (May-Sept), 10.00-17.00 (Oct-April)
- £11.50 (adults), £10 (students/seniors), £7 (under 15s), £32 (family)
- Shop
- Café & Restaurant
- Wheelchair access

Shakespeare's Globe Exhibition

Fifteen years on from its opening season in 1997, it still comes as a bit of a jolt to see this perfectly reconstructed Elizabethan theatre in the middle of 21st-century Bankside. The first Globe Theatre burned down in 1613, the second was pulled down in 1644 and this phoenix-like reconstruction, yards from the original site, was the brainchild of American actor Sam Wanamaker who came to England in the 1940's expecting to see the theatre still standing. After nearly half a century of campaigning, the new Globe is testament to Wanamaker's vision and now every summer an international company of actors takes to the boards to perform Shakespeare's plays in the kind of theatre for which they were written. Attending a performance here is a magical theatre-going experience but if you really want to brush up your Shakespeare, then a visit to the permanent exhibition in the 'UnderGlobe' is a must.

The exhibition offers a lively exploration of Elizabethan theatre: its architecture, actors and audience. Bravely, the displays tackle head-on the oft-debated question of 'Who was Shakespeare?' and take a good look at the days when Bankside entertainment really was down and dirty – a heady cocktail of bear baiting, drinking dens, brothels and, of course, theatres. Dressing up is such a central part of play-acting and costumes from past productions at the Globe are displayed on mannequins as well as in production photographs. Visitors can hear a designer discuss some of the problems creating period clothing in the 21st century and learn how actors cared for their costumes (a valuable asset) in an age when urine was the stain remover of the day. Another display turns the spotlight on music at the Globe and features early instruments such as the tenor sackbut (a precursor of the modern trombone) and the crumhorn. Touch a screen to have a go playing one – and touch again to hear how they sound in the hands of a professional musician. Other nifty computer animations demonstrate Elizabethan special effects such as flying, trick tables and the 'thunder run'. Would-be thespians are invited to 'Join the Cast' and make a sound recording of a scene from Shakespeare while, thanks to the National Sound Archive, visitors can listen to a host of different actors playing Shakespeare – among the mellifluous voices are those of Alec Guinness, Richard Burton and Judi Dench.

A guided tour of the Globe Theatre itself is included in the price of an entrance ticket – tours run every half an hour for individuals (groups must be booked in advance). Visitors during the theatre season (May-Sept) may be able to see the 'Wooden O' in action during rehearsals. Morning coffee, light lunches and afternoon teas are available year round in the Globe Café, while the restaurant offers à la carte, pre- and post-theatre menus. Both eateries enjoy panoramic views over the River.

The Sherlock Holmes Museum

- 221b Baker Street, NW1 6XE
- 020 7935 8866
- www.sherlock-holmes.co.uk
- Baker Street LU
- Daily 09.30-18.00
- £6 (adults), £4 (under 16s)
- Shop

A museum dedicated to a fictional character does seem to stretch the definition of what a museum is and what its purpose should be. This one aims to show visitors exactly how the great detective and his sidekick Watson would have lived in their 19th-century lodgings – although as far as I recall the intrepid duo made do without a souvenir shop.

Smythson

- 40 New Bond Street, W1S 2DE
- 020 7629 8558
- www.smythson.com
- Bond Street LU
- Mon-Tues, Wed and Fri 09.30-18.00; Thurs and Sat 10.00-18.00
- Admission free
- Wheelchair access

Frank Smythson Limited has been catering for the smart set's stationery needs since 1887 and for many this Mayfair emporium is still the last word in leather-bound luxury and pukka paper. Items from the company's archive are displayed in the small museum at the back of the shop: monogrammed paper, photograph albums, engraved wedding invitations and calling cards, individualised seals and luscious leather samples reflecting the tastes of clients who included maharajahs, royals and film stars. Even the shell-encrusted grotto which houses the display is impeccably well-connected, having been designed by the architect who remodelled Downing Street.

Sir John Soane's Museum

⬚ 13 Lincoln's Inn Fields, WC2A 3BP

☏ 020 7405 2107

✎ www.soane.org

🚌 Holborn LU

🕐 Tues-Sat 10.00-17.00, Candlelit openings are held
on first Tuesday of every month 18.00-21.00

⚱ Admission free

🛍 Shop

The son of a bricklayer, Sir John Soane became the most original architect of his day. Luckily for us the house that he built for himself was established as a museum during his lifetime and today remains much as it did when he died – a wonderfully dotty creation. The labyrinth of rooms, each one more fantastical than the last, is a testament to Soane's architectural vision and his dedication as a collector. Clearly he was a stranger to our modern mania for minimalism – every available nook is home to some treasure or other. When they're not made of stained glass or studded with mirrors, walls are adorned with fragments of antique marble statuary. Larger works include a cast of the Apollo Belvedere – an iconic work despite the strategically placed fig leaf – and the curiously named 'Pasticcio', a column made of numerous architectural oddments.

At every turn there is something to delight, intrigue or amaze. In a particularly theatrical flourish the Picture Room is furnished with ingenious hinged-screen walls that allow over 100 paintings to be displayed. Amongst the treasures here are Canaletto's *Riva degli Schiavoni* and 2 series of satirical paintings by Hogarth, *The Election* and *The Rake's Progress*. Gothic morbidity is the order of the day in the basement, where Soane conjured a melancholic monk's yard, parlour and cell, inhabited by his priestly alter-ego Padre Giovanni and featuring a skeleton in the closet and a Pharaonic sarcophagus. The yard is also notable for being the final resting place of Mrs Soane's terrier, whose stone tomb bears the elegiac inscription 'Alas Poor Fanny'. After all these excesses, the upstairs Drawing Room, decked out in 'patent Yellow' colour scheme, seems the model of good taste. A museum tour takes place every Saturday at 11.00 to bring order to the apparent chaos. Tickets cost £5 and are on sale from 10.30; they are limited, so arrive early to secure a place.

After some 175 years of public access, the museum was beginning to feel the strain of its annual influx of nearly 100,000 admiring visitors and is currently undergoing a £7-million refurbishment and improvement project. This will see the reinstatement of Soane's previously unseen private apartments on the second floor of No. 13 as

well as his Model Room and the 'Tivoli recess', London's first venue for contemporary sculpture. All the necessaries for the modern visiting public will be housed in the adjacent No. 12 Lincoln Inn's Fields (which along with No. 14 was also built by Soane) and full disabled access to the museum will finally be achieved. The main house and museum rooms at No. 13 will remain open during the project with completion of the first phase and the re-opening of No. 12 scheduled for 2012, to co-incide with the 200th anniversary of the construction of No. 13. Hopefully the work will leave intact the special atmosphere that make the Soane one of London's best-loved 'secret' museums, ensuring it remains as Soane's great friend Isaac Disraeli (father of Benjamin) described it, 'permanently magical'.

Spencer House

27 St James's Place, SW1A 1NR

☎ 020 7499 8620 (Recorded information line); 020 7514 1958 (pre-booked tours)

🖰 www.spencerhouse.co.uk

🚇 Green Park LU

🕓 Sun 10.30-17.45 (except January & August), last tour 16.45 (tours last approx 1 hour)

💷 £9 (adults), £7 (concessions)

♿ Wheelchair access

This aristocratic palace was designed by John Vardy and James 'Athenian' Stuart for the 1st Earl Spencer, an 18th-century ancestor of Diana, Princess of Wales. A pioneering example of the neo-classical style, the house is crammed with references to ancient Greece and Rome, transplanting details from buildings such as the Temple of Venus in Rome and the Erectheum in Athens to the heart of St James's. The 8 State Rooms range in mood from the quietly gracious Morning Room to the full-on grandeur of the Great Room and the Palm Room – a kitschy jungle of gilded fronds and foliage symbolizing family fertility.

The 'Painted Room' is an important early neo-classical interior and is themed around the 'triumph of love', with festive decorations depicting scenes of music, dancing and drinking. Prodigious entertainers, the Spencer's welcomed the great and the good to Spencer House; today, following a 10-year long restoration, the house has returned to its high society splendour and, as a venue for hire, once again fulfills its role as a social hub. For regular punters, access is by guided tour only and children under 10 years old are not admitted. The 1/2 acre garden has also been restored and is open on specific days between spring and summer each year.

The Tower Bridge Exhibition

- Tower Bridge, SE12 UP
- ☎ 020 7403 3761
- www.towerbridge.org.uk
- London Bridge LU/Rail, Tower Hill LU
- Daily 10.00-18.30 (April-Sept), 09.30-18.00 (Oct-Mar); last admission one hour before closing
- £8 (adults), £5.60 (seniors/students), £3.40 (children 5-15 yrs)
- Shop
- ♿ Wheelchair access

A triumph of Victorian civil engineering, Tower Bridge is one of London's most instantly recognisable landmarks. For those not content with admiring from a distance, a walk around the bridge's innards should be just the thing. Introductory videos and display boards tell the story of this once controversial structure and the technological achievement of its construction. Taking in both North and South Towers, the exhibition also provides access to the two glassed-in walkways which link them offering spectacular views up and down river. Below in the Engine Rooms are two of the massive steam engine pumps that once powered the famous drawbridge. In April 2011 a 3-year long restoration of the bridge was completed – a massive paint job undertaken once every 25 years – which has returned Sir Horace Jones and Sir John Wolfe-Barry's masterpiece to pristine condition. Originally painted a greeny-blue colour, the bridge adopted its current patriotic red, white and blue colour scheme in 1976.

The Tower of London

⌨ Tower Hill, EC3N 4AB

☎ 0870 756 6060 (information line) / 0870 756 7070 (advance tickets)

✎ www.hrp.org.uk

🚃 Tower Hill LU, Tower Gateway DLR

🕐 Tues-Sat 09.00-17.30, Sun-Mon 10.00-17.30

💰 £19.80 (adults), £17.05 (concs), £10.45 (under 16s), £55 (families)

🛍 Shops

☕ Cafés & Restaurant

♿ Partial wheelchair access

London's tourist trail wouldn't be complete without the Tower. Rich in tradition, history and the special brand of arcane ceremony that Britain does so well, the Tower attracts some 2 million visitors a year, despite the hefty entrance price. The traditional guardians of the Tower, the Beefeaters (or Yeoman Warders as they prefer to be known), double up as guides and lead regular free tours and talks, giving plenty of coverage to the bloodier goings on. For those going it alone, the buildings are well labelled and free maps are available; alternatively an audio tour, 'Prisoners of the Tower' can be hired for an extra charge. Visitors with small children should note that access to many of the towers is via narrow, spiral staircases and prams and pushchairs must be left outside buildings.

Built as a palace by William the Conqueror, the Tower has fulfilled many functions and in its time has also served as a royal arsenal, menagerie, mint and jewel house. It is though, perhaps best known as a royal prison, and several of its walls still bear the inscriptions carved by 'guests' – the astrological clock engraved in the Salt Tower by suspected sorcerer Hugh Draper is a notably elaborate variation on the 'I woz 'ere' school of graffiti. Sir Walter Raleigh's cosy apartments can be seen over in the Bloody Tower – 13 years a prisoner, Sir Walter made himself very much at home and even grew his own tobacco. The scaffold site on Tower Green – where two of King Henry VIII's wives got the chop – is commemorated with a plaque. Teched-up visitors can download an 'escape from the Tower' App and help four historical prisoners to do a runner, while the interactive 'Prisoners' exhibition introduces the stories of some of the Tower's historical 'guests'.

Although the Royal Menagerie moved to Regent's Park in 1835, the Tower's famous ravens are still in residence – tradition has it that if they leave the White Tower will fall and disaster overtake the kingdom. Part of William's original fortress, the White Tower is the oldest medieval building in the whole complex. It now contains a selection of arms and armour from the Royal Armouries. Among the suits of armour is a foot combat suit made for Henry VIII in 1540 and a boy's armour

81

possibly made for his son Edward VI. There are also impressive displays of massed weaponry, unusual combination weapons like the deceptively-titled 'Holy Water Sprinkler' and experimental contraptions such as a 19th-century steam operated gun. An extra-long jousting lance designed to shatter on impact with its target is a rare survivor (its presence here leading one to suppose its owner wasn't very adept).

Metalwork of a different kind can be admired in the Jewel House where the coronation regalia of British monarchs makes for a dazzling display. The phrase conspicuous consumption could have been invented for the Crown Jewels: the Cullinan diamond in the Sovereign's Sceptre may not be as big as the Ritz but it isn't far off and is, in any case, the world's largest top-quality cut diamond. Another hefty sparkler – the fabled Kor-i-Noor diamond – is the jewel in the late Queen Mum's crown, while older regalia includes the St Edward's Crown and the 12th-century Coronation spoon. For those not thoroughly versed in Royal ceremonials, footage of the coronation in 1953 introduces the displays, but if you're still none the wiser there's a fully illustrated guide book.

Stout as they are, the Tower's fortifications have proved no defence against naked 21st-century commercialism and with no less than five souvenir shops, cafés, and its own on-site currency exchange, retail opportunities are never very far away.

University College Geology Collections

⌨ Department of Earth Sciences, UCL, Gower Street, WC1E 6BT
☎ 020 7679 7900
🖉 www.ucl.ac.uk/museums/geology/
🚌 Euston LU/Rail, Euston Square LU, Goodge Street LU, Warren Street LU
🕐 Open by appointment
💲 Admission free
♿ Wheelchair access

This collection contains 40,000 geological specimens from all over the world – from fossils to meteorites and minerals. A new display, 'Infinite Possibilities', is open to the public in the aptly named Rock Room (Room 4, First Floor, South Wing). The Regional Planetary Image Facility (www.earthsci.ucl.ac.uk/research/planetaryweb) contains data from almost all of the NASA planetary missions since the 1960s, covering all the planetary bodies in the solar system which have been surveyed to date by spacecraft. This and other specialist collections may be viewed by appointment.

The Tower of London

A Vanitas tableau of a life sized head, on one side resembling Queen Elizabeth I, the other half a skull with attendant insects and reptiles, made from wax.

Wellcome Collection

183 Euston Road, NW1 2BE

020 7611 2222 / 020 7611 7211 (recorded information)

www.wellcomecollection.org

Euston LU/Rail, Euston Square LU, Warren Street LU, King's Cross LU/Rail

Mon closed, Tues, Wed, Fri, Sat 10.00-18.00, Thurs 10.00-22.00, Sun 11.00-18.00

Admission free

Bookshop

Café

Wheelchair access

A hefty £30 million has been lavished on this new medical museum, which opened in June 2007 – and it shows. The previously drab entrance to the Wellcome Library on Euston Road has been transformed into a light and welcoming foyer, complete with an open plan Blackwells Bookshop and a funky café run by acclaimed bakers Peyton & Byrne. Some visitors may not in fact get beyond this point, for those that do, there's a treat in store with three sleekly designed gallery spaces exploring the nature and history of medicine.

The Medicine Man gallery introduces the visitor to the Henry Wellcome – an extraordinary character whose entrepreneurial flair took him from humble American log cabin origins to millionaire pharmaceutical business giant and philanthropist. Along the way Wellcome also found time to run major archaeological digs, pioneer aerial photography and amass a 1 million strong collection of medical and cultural artefacts, 500 of which are displayed here. The offbeat cross-section of material takes in everything from serried ranks of amputation saws to 18th-century nipple shields, from Napoleon's toothbrush to a Peruvian mummy and it's hard not to conclude that Henry Wellcome must have had terrific fun amassing this stuff. Although the apparently random material is tamed into a dozen or so categories such as 'Beginning of Life', 'Understanding the Body', 'Votive Offerings' and 'Masks', there's still a cabinet of curiosity feel about the gallery which is entirely in keeping with the ethos of the collection. There's typically macabre medical humour here too – a dentist's chair and a birthing chair are displayed alongside a torture chair made from razor sharp blades, hinting darkly at the affinity between healthcare and torture. Detailed information about the exhibits are discretely tucked away behind doors set into the wooden wall panelling or in pull out drawers – a stylish and intelligent touch that lets these extraordinary objects speak for themselves first.

The adjoining Medicine Now gallery looks at science and medicine since Wellcome's death in 1936, concentrating on the key topics of obesity, genomes, malaria and the body. The exhibits here are no less fascinating, whether the bacterial colony used by Picker in the Human Genome Project, a plastinated body slice or a larger than life wax model of a malarial mosquito. Ethical dilemmas generated by scientific advances such as the de-coding of human DNA are tackled head on while a selection of contemporary art works offer a different take on the issues under debate. On the ground floor a third gallery houses a programme of challenging temporary exhibitions – tackling subjects such as 'Dirt: the filthy reality of everyday life' and 'High Society: the rich history of mind altering drugs' from different scientific, social and cultural perspectives.

Wellington Arch

- ⊞ Hyde Park Corner W1J 7JZ
- ☏ 020 7930 2726
- ✐ www.english-heritage.org.uk
- 🚇 Hyde Park Corner LU
- 🕓 Wed-Sun and Bank Hols 10.00-17.00 (April-Oct),
 Wed-Sun 10.00-16.00 (Nov-Mar)
- 💷 £3.90 (adults), £3.50 (concs), £2.30 (children),
 free (English Heritage members)
- 🛍 Shop
- ♿ Wheelchair access

Originally conceived as an entrance to Buckingham Palace, this latter-day triumphal arch is one of London's most distinctive landmarks. Set in the midst of the busy roundabout that is Hyde Park Corner and topped by the vast bronze sculpture *Peace Descending on the Chariot of War*, the arch has been the subject of a major restoration by English Heritage and is now open to the public. Visitors can admire the vistas across Hyde Park, Green Park and Piccadilly from the viewing platforms as well as witnessing British ceremonial in action with the twice daily passage of the Horse Guards beneath the arch itself. Inside, away from the incessant roar of traffic, there is a brief exhibition about the, sometimes controversial history of the arch. On the ground floor the shop sells a small selection of souvenirs, books and hot and cold drinks.

Westminster Abbey Museum

⬚ East Cloister, Westminster Abbey, SW1P 3PA

☎ 020 7654 4831

✎ www.westminster-abbey.org

🚇 St James's Park LU, Westminster LU

🕑 Daily 10.30-16.00 (may be closed at short notice for state or other
special events); Chapter House and Pyx Chamber daily 10.30-16.00

♿ Included in Abbey admission fee (see website for details)

Compared to the hubbub of the Abbey, this museum (located in an 11th-century vaulted undercroft) is a haven of tranquillity. Its collection of royal and other funeral effigies is certainly bizarre enough to reduce even the most garrulous tourist to silence. Compelling viewing, the macabre wood and wax images, mostly dressed in original clothing, include those of Edward III, Henry VII, Elizabeth I and Charles II (in his Garter robes). Lord Nelson's effigy joins this royal company and was much admired by his contemporaries (although Nelson himself was buried in St Paul's Cathedral, see p. 25). Other items on display include a Roman sarcophagus and replicas of the Coronation Regalia used for coronation rehearsals (the real thing can be seen at the Tower of London, p. 81). The admission price also includes entry to the historic Pyx Chamber and the medieval Chapter House, which has some fine wall-paintings, an original floor of 13th-century glazed tiles and England's oldest door.

<div style="text-align: right"></div>

Westminster Abbey Museum

North

Arsenal Football Club Museum

🖃 Emirates Stadium, Northern Triangle Building,
 Drayton Park, N5 1BU

☎ 020 7619 5000 (stadium tours bookings)

✎ www.arsenal.com

🚌 Arsenal LU

🕐 Mon-Fr 10.00-18.00, Sat 10.00-18.00, Sun 10-17.00
 (matchdays 10.00 until 1/2 hour before kick off)

💷 £6 (adults), £3 (concs), free (under 5s)

🛍 Shop

♿ Wheelchair access

If you're an Arsenal fan you've probably already visited the Club's swish new Emirates Stadium (opened 2006) and perhaps looked around the in-house museum, but for newcomers it's as good a place as any to be initiated into the wonderful world of Arsenal. The museum recounts the club's eventful history from its impoverished beginnings at the Royal Ordnance workshops in Woolwich to First Division glory days under Herbert Chapman's visionary management, to more recent triumphs like the Club's 'Double' win in 2001/2 and their 'invincible' 2003/04 season.

Divided, like the game itself, into two halves, the displays celebrate legendary players such as Bob Wilson, Pat Rice, and 'old baggy shorts' Alex James as well the ethos and traditions of the club. There's a whole section devoted to the club's recent move from Highbury and copious footage of goal scoring as well as a series of fun interactive quizzes to test visitors on Arsenal trivia. Club memorabilia aplenty should keep Arsenal addicts of all ages happy – there are photographs, autographed match strips and trophies galore – but (for the complete novice at any rate) the museum's lively displays offer an invaluable insight into football in general. Stadium tours also incorporate a visit to the museum but must be booked in advance.

Barnet Museum

- 31 Wood Street, Barnet, EN5 4BE
- ☎ 020 8440 8066
- www.barnetmuseum.co.uk
- High Barnet LU
- Tues-Thurs 14.30-16.30; Sat 10.30-12.30;14.00-16.00
- Admission free
- Shop

A local history museum covering the various 'Barnets' as well as Whetstone and Totteridge, Cockfosters and Hadley. Housed in a pretty early Georgian house, the museum collection was started back in 1927 and today includes an eclectic range of historical material from maps to household items, period costumes, photographs and archaeological remains. Barnet was the scene of one of the last battles in the Wars of the Roses in 1471 and today the museum is facing a fight of its own, namely to survive in the face of council cuts. The museum's doughty volunteer supporters are confident of success but keep an eye on the website for updates.

Brent Museum

- Willesden Green Library Centre, 95 High Road, Willesden Green, NW10 2SF
- ☎ 020 8937 3600
- www.brent.gov.uk/museum
- Willesden Green LU
- Mon 10.00-20.00, Tues-Thurs 9.00-20.00, Fri 9.00-18.00, Sat 9.00-17.00, Sun 12.00-17.00
- Admission free
- ♿ Wheelchair Access

This museum – newly opened in 2006 – is firmly rooted in its local community, one of the most multi-cultural in London. As if to prove the point a bust of Marcus Garvey, the founder of the pan African nationalism greets visitors as they arrive (he's buried in nearby Kensal Green Cemetary). The permanent displays tell the story of the borough from its pre-historic days submerged beneath a tropical sea to the present day, and include images of Brent past and present, a display about the evolution of shopping and industry in the district and a collection of Victorian household bits and bobs. Temporary exhibitions cover subjects as diverse as the art of 'the cat man' Louis Wain, and the history of Willesden Hospital.

Bruce Castle Museum

Lordship Lane, N17 8NU

☎ 020 8808 8772

🖰 www.haringey.gov.uk

🚌 Wood Green LU, then 243 bus

🕓 Wed-Sun 13.00-17.00 (and Summer Bank Holidays)

💷 Admission free

🛍 Shop

♿ Wheelchair access

Although 'castle' is rather too generous a soubriquet, this historic building is one of only two Grade I listed buildings in Haringey. Once the manor house of Tottenham, Bruce Castle is now home to the Haringey borough archive. Illustrating Haringey's evolution from rural idyll to sprawling suburb, the displays include Roman pottery as well as material relating to World War II. Postal history is the subject of a small display, reflecting the fact that Sir Rowland Hill, founder of the Penny Post, once lived at Bruce Castle. Early postmen's uniforms and letter-writing paraphernalia help illustrate the origins of the postal service. The museum also hosts changing exhibitions.

Fenton House

Hampstead Grove, NW3 6SP

☎ 020 7435 3471, 01494 755563 (recorded information)

🖰 www.nationaltrust.org.uk

🚌 Hampstead LU, Hampstead Heath Rail

🕓 Wed-Sun 11.00-17.00 (Mar-Oct)

💷 House and Garden £6.50 (adults), £3 (child), £16 (families), free (National Trust members); joint ticket with Willow Road £9 (adults); Garden only £2; Garden season ticket £10

♿ Disabled access (ground floor only)

Known primarily for its collection of early keyboard instruments, this National Trust property also contains an interesting array of furniture, textiles, art and 18th-century porcelain. Interior design students will be intrigued to learn that the house was 'done up' by renowned decorator John Fowler in 1973, and was one of his last commissions for the National Trust. The bold tangerine coloured decorative scheme by Fowler in the Dining Room forms a vivid backdrop to a group of no less delectable paintings by Sir William Nicholson, newly loaned by the Bacon family. A bequest of 55 paintings, drawings and watercolours from the collection of the late actor Peter Barkworth are an additional draw; now on permanent display in the house they include paintings by the Camden Town School and 18th and 19th centuries watercolours by the likes of Constable, Cox and Collier.

A late 17th-century merchant's house, Fenton House has clung onto a number of original features and is still surrounded by a large walled garden, with orchard, making it a pleasant haven from Hampstead's bustling shops. Classical concerts are put on here throughout the year but if you're lucky you might hear a music student playing on one of the old spinets or harpsichords during your visit. A costume exhibition is held annually, usually in the summer, with costumes from period film & TV productions.

Fenton House

The Freud Museum

- 20 Maresfield Gardens, NW3 5SX
- 020 7435 2002
- www.freud.org.uk
- Finchley Road LU
- Wed-Sun 12.00-17.00
- £6 (adults), £4.50 (Seniors), £3 (concs), free (under 12s)
- Shop
- Wheelchair access to ground floor,
 help available for access to first floor

The Freud Museum

A refugee escaping Nazi oppression, Sigmund Freud made this house his final home. Freud's study – an almost exact recreation of the one he vacated at his apartment in Vienna – remains as it was during his lifetime. Festooned with oriental rugs and lined with books, this room in particular offers a remarkable slice of *fin de siècle* Vienna. The centrepiece of the museum, the study, is home to *that* couch as well as to the many Egyptian, Greek, Roman and oriental antiquities Freud loved to collect. Preserved by a long period of burial, these objects from the past are worth seeing in their own right – for the founder of psychoanalysis they constituted the perfect analogy to his own archaeology of the unconscious.

On the landing hangs Salvador Dali's haunting portrait of the face that launched a thousand slips and upstairs there's another couch – this one belonged to Freud's psychoanalyst daughter Anna, who lived at the house and whose pioneering work is also celebrated here. A video shows footage from the Freud family home movies and the shop is well stocked with titles covering the A-Z of psychoanalysis, along with gifts and jewellery inspired by Freudian theories.

Hampstead Museum

🏠 Burgh House, New End Square, NW3 1LT
☎ 020 7431 0144
🖎 www.burghhouse.org.uk
🚌 Hampstead LU
🕐 Wed-Fri 12.00-17.00, Sun 12.00-17.00,
 Saturdays ground floor art gallery only
💷 Admission free
🛍 Shop
☕ Café

Just off Hampstead's busy, bijoux High Street, this recently refurbished local history museum is a useful first port of call for those doing the cultural pilgrimage bit around this part of London. Housed in a graceful Queen Anne building, the museum shows how Hampstead developed from Mesolithic hunting ground to 'small and lonesome village' to fashionable spa and affluent suburb. Hampstead has long since been a mecca for arty and literary types and exhibits at Burgh House include watercolours by Helen Allingham, Modernist furniture designed by Marcel Breuer and memorabilia from the High Hill Bookshop. The obligatory WWII display features evocative items such as a bed from the Belsize Park Deep Shelter while the wartime memories of Hampstead residents can be accessed via a Bakelite telephone. The small shop sells books, quality conserves and attractive gifts. Down in the basement the excellent Buttery serves good home-cooked food.

Islington Museum

- 245 St John Street EC1V 4NB
- 020 7527 2837 (gallery)
- www.islington.gov.uk
- Angel LU then 19 bus
- Daily 10.00-17.00 (closed Wed and Sun)
- Admission free
- Shop
- Wheelchair access

This local history museum opened in its new premises in May 2008. Its permanent exhibition gallery explores the history of Islington from Tudor times through different themes, such as childhood, fashion, poverty, food and drink. The collections include a beautiful 1838 day dress and a silver cup from 1797 – presented to the man who set up the Islington Volunteers in the face of the invasion threat by Napoleon. Fascinatingly the collections also contain a bust of Lenin, originally erected in WWII by the then Communist run Islington Council. Lenin himself lived and worked in Islington in the early part of the 20th century, working on a revolutionary newspaper. Over the years the bust became something of a focus for political protestors and vandals – the curator's hoping that perhaps its new home at the museum will prove more tranquil. The temporary exhibition gallery will host a programme of changing exhibitions and will showcase art as well as covering historical subjects.

The Iveagh Bequest, Kenwood House

- Hampstead Lane, NW3 7JR
- 020 8348 1286
- www.english-heritage.org.uk
- Archway LU, Golders Green LU (then 210 bus),
 Hampstead Heath Rail
- Daily 11.30-16.00
- Admission free
- Shop
- Café
- Wheelchair access (ground floor only)

With its serene neo-classical architecture, beautiful picture collection, landscaped gardens, extensive catering facilities and gift shop, Kenwood House is a favourite endpoint for many a Sunday afternoon walk on nearby Hampstead Heath.

Although its library is a good example of a lavishly-modelled interior by architect Robert Adam, Kenwood is not really one of those houses you visit for meticulously reconstructed period rooms. That said, the Music Room and Dining Room wings have both been refurbished, their

décor providing an elegant and sympathetic backdrop to the real draw: The Iveagh Bequest. Gems in this world-class picture collection include Rembrandt's late, rather melancholy, self portrait and Vermeer's *Guitar Player*. Works by British artists are plentiful and feature fine pieces by the stalwarts of 18th-century portraiture: Gainsborough, Reynolds and Romney. Adding some even older faces to the mix, Kenwood House is also now home to the Suffolk collection of Elizabethan portraits (formerly displayed at Ranger's House, p153).

The Iveagh Bequest, Kenwood House

The Jewish Museum

🖼 Raymond Burton House, 129-131 Albert Street, NW1
☎ 020 7284 7384
🖥 www.jewishmuseum.org.uk
🚇 Camden Town LU
🕐 Sun-Wed 10.00-17.0, Thurs 10.00-21.00, Fri 10.00-14.00
💷 £7 (adult), £3 (conc/under 16s)
🛍 Shop
☕ Café
♿ Wheelchair access

The Jewish Museum

A £10 million refurbishment has transformed the Jewish Museum, uniting under one roof collections that were previously divided between two sites, and making a much more coherent whole. The smart new permanent galleries follow three themes: an introduction to the Jewish faith, the social history of British Jewry, and the Holocaust, and there are friendly volunteers stationed throughout the museum to help visitors get the most from their visit. The Jewish Museum is part of a select group of London museums whose collections have been designated as outstanding – so prepare to be impressed.

On the ground floor, large audio visual screens introduce the visitor to a lively mix of Jewish people living in Britain today – from a smoked salmon manufacturer to a marathon running grandmother. A little further on, the reconstructed medieval *mikveh* (ritual bath), excavated from Milk street, acts as a nice counterpoint to these modern voices, underscoring the antiquity of the Jewish community in London.

In fact, as the *History: a British Story* gallery on the next floor shows, there's been a Jewish presence in London since the Norman invasion of 1066. Displays chart the fortunes of Jews in Britain since then, a cycle of tolerance and persecution that witnessed the expulsion of Jews by Edward I, their welcome back by Cromwell and the 'great Migration' of the 1880s, in which 150,000 Jews fled to Britain from the pogroms. The East End was the original Jewish heartland in London and there are evocative displays of the trades practiced there by these impoverished migrants – baking equipment, cigarette making tools and the ghoulish implements of the furrier. Friendly societies and trade unions were two of the mechanisms that evolved to alleviate suffering at the sharp end of the immigrant experience – a colourful bakers' trade union banner displayed on the ground floor urges 'workers of the world unite'.

Immigrant life was hard but not entirely devoid of fun – Yiddish theatres flourished and visitors with a dramatic bent will enjoy performing in the interactive 'Yiddish theatre karaoke' under the guidance of comic actor David Schneider. Interwar integration saw the start of another migration – this time to the suburbs of North London, as the Jewish community grew more affluent but this period also witnessed the traumatized arrival of 10,000 unaccompanied children on the Kindertransport. A tiny doll and a ferry ticket to Harwich are among the touching personal mementoes of that era-defining event. 'Talking head' interviews bring this period vividly to life with refugees from Nazism sharing their experiences and reflecting on their identity as Jews in Britain.

The museum's new Holocaust Education Gallery focuses around the story of Leon Greenman, a London-born survivor of no less than 6 concentration camps, fervent anti-racist campaigner and much

loved figure at the museum until his death in 2008. Mr Greenman's photographs and personal possessions are included in the display, some of the most poignant of which relate to his wife and young son, who were both killed within minutes of the family's arrival at Auschwitz.

Judaism: a living faith explores the festivals, ethics and rituals of Judaism, interpreted through the museum's collection of religious ceremonial objects. Items such as an intricately wrought pair of silver 18th-century *kiddush* cups, ornate *rimmonim* (Torah scroll finial), and a magnificent 17th-century Venetian synagogue ark embody the principle of *hiddut mitzvah* or 'beautifying the commandment' and showcase Jewish craftsmanship. Hannukah lamps from around the world reflect the breadth of the Jewish diaspora, allowing visitors to compare and contrast local variations on a theme. An interactive exhibit allows visitors to eavesdrop on a Jewish family's Sabbath meal.

A temporary exhibition gallery completes the displays; the inaugural exhibition showcased rare Hebrew manuscripts while future shows will look at Jews in entertainment and Jewish food. On the subject of which, perhaps the best interactive exhibit of all is the museum's café, which serves Kosher Jewish cuisine and drinks, with seasonal dishes reflecting Jewish festivals. The ground floor gift shop stocks a good selection of Jewish themed gifts and books – from harrowing Holocaust memoirs to light-hearted titles like 'How to raise a Jewish dog'.

Jewish Military Museum

Shield House, Harmony Way, Hendon, NW4 2BZ
020 8201 5656
www.thejmm.org.uk
Golders Green (then 183 or 240 bus to Bell Lane stop)
Mon-Thurs 10.00-16.00 (by appointment); Sun groups only (by appointment)
Admission Free
Small sales point
Wheelchair Access

Small it may be, but this museum, tucked away behind a North London shopping centre, certainly packs in the history. Its collection of uniforms, medals, photos, letters and memorabilia tells the little known (outside the Jewish community) story of the contribution made by British Jews to the British Army and its campaigns, from Sir Alexander Schomberg's role in the battle for Quebec under General Wolfe to today's engagement in Afghanistan.

The First World War displays include material on the Zion Mule Corps and the 'Judeans' (the two distinctly Jewish units created at this

time) as well as the poignant letters written home from the Western Front by Lt Marcus Stone. No less than five Jewish soldiers were awarded the VC in WWI and the museum recently acquired the first Jewish VC, that was awarded to Lt Frank De Pass for his action in the Battle of Festubert.

World War II saw the involvement of some 60,000 British Jewish service men and women and among the exhibits here are memorabilia belonging Jack Caplan, a Japanese POW, and a rare copy of the book of poems written at Buchenwald by Maurice Partschuk (aka Martin Perkins) – itself presented to the museum by famous British secret agent, Odette Hallowes-Churchill. A display tells the story of Norman Turgel, the British Jewish liberator of Belsen, while nearby is a stained glass memorial by the noted British graphic designer Abram Games. The story of Jewish personnel in the RAF and the Navy is also covered, as is the role of the clergy (Rabbis) in the military context. The grave marker of Pte Jason Burt, killed in the Falklands War, is a sad reminder that two world wars were not enough to 'end all wars'.

Jewish Military Museum

Keats House

🖃 Keats Grove, NW3 2RR
☎ 020 7332 3868
🖂 www.cityoflondon.gov.uk/keatshousehampstead
🚇 Belsize Park LU, Hampstead LU, Hampstead Heath Rail
🕐 Tues-Sun 13.00-17.00 (April-Oct); Fri-Sun 13.00-17.00,
 Tues-Thurs 10.00-17.00 (pre-booked groups only) (Nov-Mar)
💷 £5 (adults), £3 (concs), free (under 16s) – tickets valid for one year
🛍 Shop
♿ Wheelchair access (ground floor)

Romantic poet par excellence, John Keats lived in this pretty Regency villa from 1818-1820. Despite the onset of the TB that eventually killed him, Keats was at the height of his poetic powers during these years and it was in the garden of Wentworth Place that he penned his *Ode to a Nightingale*. It was here too that he met and fell in love with Fanny Brawne, the "beautiful, elegant, graceful, silly, fashionable and strange" girl next door. They became engaged but the relationship was tragically brief – in September 1820 the ailing poet left Hampstead for the warmer climate of Rome where he died the following February aged just 25. Poignant relics of the doomed love affair include the almandine and gold ring Keats gave Fanny, which she wore for the rest of her life.

Recently restored to its Regency elegance, complete with pretty wallpapers and harmonious colour schemes, the house also commemorates other important relationships in Keats' short life, with a rogues' gallery of literary folk such as Leigh Hunt, Charles Lamb and William Hazlitt. In Keats' day the house was semi-detached with Keats' half being something of a batchelor pad, shared with his friend and landlord Charles Brown. Although Keats clearly got the short straw when it came to the accommodation (his rooms are distinctly smaller than Brown's), the pair enjoyed a high old time here, hosting 'claret feasts' and card parties. When Keats fell ill, Brown's spacious parlour became Keats' sick room, with a sofa bed placed so he so could look out at the garden and observe the comings and goings of the house. Images of Keats are displayed around the house, including life and death masks and several romanticised posthumous portraits by his friend Joseph Severn, who devotedly nursed the poet in his last desperate months in Rome. The portrait bust of Keats by Anne Whitney in the Brawne Rooms is placed at Keats' actual head height and reveals his tiny stature – just a shade over 5 feet.

Visitors can walk around three floors of the house, from the basement kitchens and dining areas to the simply furnished bedrooms of Keats and Fanny Brawne (how tantalising for the young lovers to have been separated by so little distance!). A later resident, retired actress

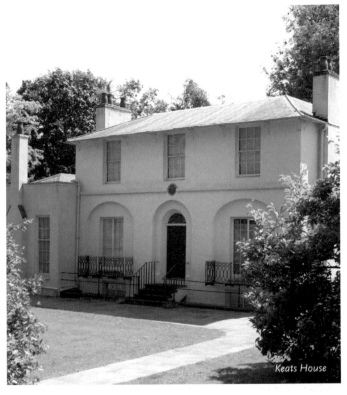

Keats House

Eliza Chester, turned Wentworth Place into a single dwelling and the large room she added to the side of the house is today named after her. Designed as a grand dining room, its theatrical red and gold colour scheme is a marked contrast to the restrained decor in the rest of house. The portraits of Miss Chester in her pomp were a feature of the room when she lived there, today they are joined by cartoons satirising her 'close friendship' with King George IV. Laminated guides are available for each room but a guided tour is the best way to get the most out of a visit, being filled with lots of lively detail and anecdotes about Keats, the history of the house and its inhabitants. The garden too has had a revamp and is a delightful place to have a picnic, read a poem or two or just listen to the birdsong that fills the air. Keats House runs an interesting events programme, as well as hosting a summer festival, featuring a poet in residence (Benjamin Zephaniah in 2011), poetry readings, writing workshops, art and music.

The London Canal Museum

⊞ 12-13 New Wharf Road, N1 9RT
☎ 020 7713 0836
✎ www.canalmuseum.org.uk
🚌 King's Cross St Pancras LU/Rail
◷ Tues-Sun and Bank Holidays 10.00-16.30 (last entry 16.00)
💷 £4 (adults), £3 (concessions), £2 (children); free (under 4s)
🛍 Shop
♿ Wheelchair access

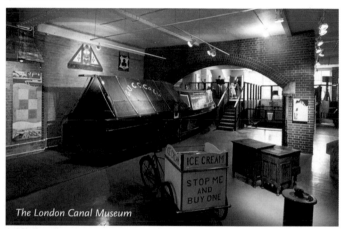

The London Canal Museum

Overlooking the murky waters of Regent's Canal, the LCM celebrates the history of London's 'silent highway' from its heyday as a bustling trade route to its more recent role as a tourist trail. Visitors can experience at first hand the cramped conditions endured by canal folk in part of a restored narrowboat, admire the distinctive 'roses and castles' artwork that decorated the narrowboats, and find out how canal locks work.

The building was once a Victorian ice house owned by ice-cream entrepreneur Carlo Gatti and a massive, still only partially excavated ice pit dominates the far end of the ground floor. Displays covering London's ice trade and the history of ice cream explain the pit's cavernous presence in this canalside warehouse, and upstairs in the former stables, visitors can sit back and enjoy a video trip along the canal. The museum's 'Bantam IV' tug is usually moored at the rear of the museum in the Battlebridge Basin, once a thriving industrial spot but now a haven of inner city tranquility. The shop is small but well-stocked with relevant, reasonably-priced souvenirs, including books about boats and canals and a range of colourful hand-painted canalware.

MCC Museum

⊡ Lord's Cricket Ground, St John's Wood Road, NW8 8QN

☎ 020 7616 8595

✎ www.lords.org

🚌 St John's Wood LU

🕓 Mon-Fr 10.00-17.00 (April-Oct); Mon-Thurs 11.30-17.00, Fri 11.30-16.00 (Nov-Mar); On match days entry to match spectators only; Tours of the ground (including museum) usually twice or three times daily throughout year except major match days, see website or telephone for times

⊛ £7.50 (adults), £5 (concessions)

🛍 Shop and tavern

♿ Partial wheelchair access

Based at Lord's, the home of cricket, Marylebone Cricket Club's museum is a haven for those who love the sound of leather against willow. For those less familiar with the game, displays chart over 400 years of cricketing history. Unwieldy curved-edge bats and two-stump wickets (which often let the ball straight through) date from the days when sheep kept the pitch in trim – more recent clobber includes the pads, blazers, boots and caps of Sir Donald Bradman and Sir Jack Hobbs. Special exhibitions are mounted to mark particular anniversaries and honour visiting teams, and highlights of some of the game's great matches and performances are screened in the Brian Johnston Film Theatre. A stuffed sparrow commemorates one of the game's smaller casualties (clean bowled in 1936) but pride of place undoubtedly goes to the Ashes Urn – a tiny but potent symbol of Anglo-Aussie rivalry and a permanent fixture in the museum regardless of whether Australia or England win. More paintings and memorabilia are displayed in the Long Room, the MCC's inner sanctum – the club commissions new portraits each year and in recent years has added the likenesses of Shane Warne and Sir Viv Richards to a collection that includes a portrait of cricketing legend WG Grace. This atmospheric club room can usually be viewed by visitors on the tour, along with the Players' Dressing Rooms, MCC Honours Board and the award-winning Media Centre – the striking aluminium 'pod' that floats above the 'nursery end' of the pitch. Cricket gear is stocked at the Lord's shop, along with a comprehensive selection of cricketing books and souvenirs ranging from floppy hats to cricket themed pencil sharpeners. Refreshments are available at the Lord's Tavern, the ground's on-site pub.

Royal Air Force Museum

Grahame Park Way, NW9 5LL

☏ 020 8205 2266

🖉 www.rafmuseum.org.uk

🚇 Colindale LU

🕓 Daily 10.00-18.00 (last entry 17.30)

💷 Admission free

🛍 Shop

🍴 Café, restaurant and picnic areas

♿ Wheelchair access

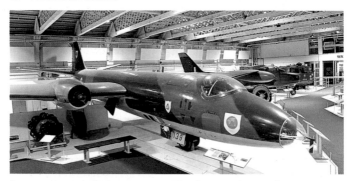

Set on 10 acres of what was once Hendon aerodrome, this is Britain's National Museum of Aviation. With over 100 historic aircraft from around the world on display, it's a plane-spotter's paradise as well as a must for those interested in 20th century history, and particularly the two world wars. The excellent Milestones of Flight exhibition was launched on 17 December 2003, the 100th anniversary of the first powered flight and makes a terrific opener to a visit. Its sleek barrel vaulted, stainless steel clad building houses a gleaming split level display of landmark flying machines from flimsy looking early pioneers like the Clarke Hang Glider of 1910 and Bleriot XI to muscular creations like the Harrier Jump Jet and a prototype Eurofighter Typhoon. Other beauties include an immaculately restored Fokker D.VII from 1917, resplendent in purple, green and black camouflage, a nippy Hawker Hart, a shiny silver American Mustang and that wooden wonder, the De Havilland Mosquito.

'Top Trumps' veterans will relish the technical specifications which can be accessed via the touchscreen computers dotted around, along with the history of each aircraft, its designers and pilots and film footage. On the ground floor level visitors can mingle with the machinery, and inspect the timeline wall with its year by year account of this century

of aviation. Up in the Control Tower there's a rolling programme of short 3D aviation films and more interactives let would be air traffic controllers try their hand at managing the airways.

From 'Milestones' a covered walkway leads into Bomber Command Hall where gargantuan aircraft like the Lancaster make planes such as the Spitfire look like gnats ("Wimpy", the museum's Wellington bomber has recently left the building to undergo major restoration that is likely to last several years). Prize for the spookiest exhibit goes to the ghostly, water-stained wreck of a Halifax bomber, dredged up from the Norwegian fjord where it had lain since the 1940s. The development of bombers and bombing is examined and a reconstruction of a bombed-out industrial plant offers a sobering reminder of the destructive capability of these giants of the air. The Hall also serves as a moving memorial to the 131,000 young men who lost their lives during the Allied bombing offensive of WWII.

The museum's Historic Hangers, – so called because they are in fact two original WWI hangers, – showcase a wider variety of aircraft and are divided into Jets, the RAF Overseas, Fighters, Wings over Water and Whirling Rotors. This latter display includes the chalk and cheese of helicopters – a cumbersome looking Wessex Belvedere and a sprightly Gazelle. Air-sea rescue and maritime reconnaissance are covered in 'Wings over Water' – look out for 'A Very Gallant Gentleman', the carrier pigeon which saved a 'downed' WWI flying crew. Raised walkways allow a look inside the cockpits of planes like the Supermarine Southampton flying boat, the 'touch and try' Provost lets wannabe aviators loose on the controls of a modern jet trainer while there's a Flight Simulator for confirmed thrill-seekers. A Tornado F.3 fighter is due to be added to the line up soon.

'Aeronauts Interactive' is an extensive hands-on area with exhibits demonstrating the underlying principles of aviation such as thrust, drag, and airspeed. Aimed at younger visitors, the fun activities include pilots' aptitude tests, flying a hang-glider, and landing supplies accurately on a drop zone. A 4-dimensional theatre is the museum's latest attraction, whose state of the art computer animation and environmental effects enables particpants to 'become' a B-17 bomber pilot or a crack jet pilot – for the princely sum of £4 for 4 minutes.

Over in the recently refurbished Battle of Britain Hall, a sequence of tableaux explain the background to the outbreak of World War II and a sound and light show portrays the stirring story of the Battle of Britain and 'Our Finest Hour'. Visitors can walk through a Sunderland flying boat and see the crew's quarters but many of the planes included in this hall are German models like the Junkers 88, and there's even an Italian Fiat plane. A fragment of Rudolph Hess's wrecked Messerschmitt

and Herman Goering's decorations and awards are among the more unusual exhibits here. Tribute is paid to the 'Few' and the uniforms and medals of distinguished airmen are also displayed as well as an exhibition of the art of the battle of Britain.

Amid all the hardware, the human element is never overlooked: throughout the museum are memorials and testaments to airmen and women from the Great War to the Gulf War. A quiet moment of contemplation can be sought in the prefab RAF chapel from the Falkland Islands or in front of medals won by WWI pilots. Other displays highlight the roles played by test pilots, ground staff, the WAAF, and that major contribution to air safety – the ejector seat.

Don't forget to leave time for another attraction, the Grahame-White Factory and Watch Office. These original aircraft factory buildings, dating from Hendon's early aviation days, have been restored and reconstructed at the Museum, where they make an appropriate setting for some of the earliest aircraft in the collection. Expect to see WWI 'crates' such as the lovable Sopwith 'Pup', the Vickers FB5 and the Sopwith Triplane.

There's a lot to see but the Wings Restaurant and Wessex Café are on standby all day to banish the inevitable hunger pangs and for those bringing packed lunches, there are pleasant picnic areas inside and out. The museum shop has more Airfix models than you can shake a joystick at, and a wide range of aviation books and videos.

The Stephens Collection

⌂ Avenue House, East End Road, N3 3QE
☎ 020 8346 7812
✐ www.london-northwest.com/sites/stephens
🚌 Finchley Central LU
🕓 Tues-Thurs 14.00-16.30
💷 Admission free
♿ Wheelchair access

Dr Henry Stephens was the inventor of the famous 'Blue-Black Writing Fluid' and went on to become something big in ink. His son Henry Charles ('Inky') Stephens developed the family business and brought Avenue House in 1874, adding a laboratory and planting the rare trees which can be seen in the landscaped grounds today. Stephens Jnr left the house to the people of Finchley and it is now run as a charitable trust, with a room dedicated to the Stephens Collection on the ground floor. Displays are changed every 6 months or so and explore the history of writing materials and the Stephens Ink Company. Hands-on writing sessions can be arranged for groups of up to 15.

2 Willow Road

Willow Road, NW3 1TH

020 7435 6166 / 01494 755570 (recorded information)

www.nationaltrust.org.uk

Belsize Park LU, Hampstead LU, Hampstead Heath Rail

Wed-Sun 11.00-17.00 (Mar-Oct); entry by timed tour only 11.00, 12.00, 13.00 & 14.00; non-guided viewing 15.00-17.00 with timed entry when busy

£5.80 (adults), £2.80 (child), £14.50 (family); joint ticket with Fenton House £9; free (National Trust members)

Wheelchair access (ground floor only)

A Modern Movement interpretation of a terraced house, 2 Willow Road is as about as far from the stereotype of a National Trust property as it's possible to get. Set in leafy Hampstead, it was built by architect Ernö Goldfinger in 1937 and remained his family home until 1994. The stylish modernist aesthetic of the building is matched by its contents – along with furniture and toys designed by Goldfinger are works of art by Henry Moore, Bridget Riley, Max Ernst and Marcel Duchamp. Goldfinger's uncompromising approach is not everyone's cup of tea – his Trellick Tower in North Kensington remains controversial although flats inside are still much sought after. An introductory video is shown at regular intervals.

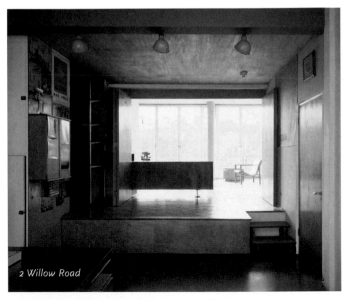

2 Willow Road

West

Carlyle's House

- 24 Cheyne Row, SW3 5HL
- ☎ 020 7352 7087
- ✎ www.nationaltrust.org.uk
- 🚌 Sloane Square LU
- ⏰ Wed-Sun 11.00-17.00 (Mar-Oct)
- 💷 £5.10 (adults), £2.60 (children), £12.80 (family),
 free (National Trust members)

This desirable Queen Anne residence was home to Victorian historian Thomas Carlyle and his wife Jane. Although Carlyle's star waned in the 20th century, he was a hugely influential writer in his day, and visited by the likes of Tennyson, Dickens, George Eliot and Chopin (who tinkled the ivories on Mrs Carlyle's piano). Today's visitors can follow in their footsteps, soaking up the atmosphere of intimate rooms that still contain their original furnishings, together with Carlyle's books and personal effects such as the non-slip horseshoe he invented for icy roads. All very cosy, but spare a thought for the Carlyles' maid – who had to sleep on the bottom shelf of the dresser in the spartan basement kitchen. The delightful restored walled Victorian garden is also open to visitors.

Centre for Performance History

- Royal College of Music, Prince Consort Road, SW7 2BS
- ☎ 020 7591 4340 (centre for Performance History)
 020 7591 4842 (Museum of Instruments)
- ✎ www.rcm.ac.uk / www.cph.rcm.ac.uk
- 🚌 South Kensington LU
- ⏰ Museum of Instruments: Tues-Fri 11.30-16.30 (closed Christmas & Easter vacations)
 Centre for Performance History: by appointment only
- 💷 Admission free
- 🍴 College cafeteria
- ♿ Wheelchair access to ground floor (by prior appointment)

The Centre brings together the RCM's museum of musical instruments and their collection of portraits of musicians, the most comprehensive in Great Britain. With examples dating from the 15th century onwards, the musical instrument collection is weighted in favour of European stringed, wind and keyboard instruments but does contain some Asian and African examples. Exhibits range from rare early creations like the clavicytherium right down to the humble recorder as well as instruments

touched by celebrity such as a spinet used by Handel and Haydn's clavichord. Lecture tours with live and recorded demonstrations are available and tours for groups can be made by appointment (at an extra charge).

The portrait collection is supplemented by extensive collections of general musical iconography (opera, concert hall and instrument design) and by an important history archive of more than 600,000 programmes.

The Chelsea Physic Garden

🖽 66 Royal Hospital Road, SW3 4HS

☎ 020 7352 5646

🖉 www.chelseaphysicgarden.co.uk

🚌 Sloane Square LU

🕓 Wed-Fri and Sun 12.00-17.00 (Wed until 22.00 July & August),
 bank holidays 12.00-18.00, closed winter

💰 £8 (adults including senior citizens), £5 (concessions);
 maximum of 2 children per accompanying adult

🛍 Shop

🍽 Café

♿ Wheelchair access

Despite the roar of traffic from the neighbouring Chelsea Embankment, this formal historic walled garden is a magical place. Founded in 1673 as a botanic garden to promote the study of medicinal plants, the Physic Garden continues the same role today and is filled with therapeutic flora from around the world. Most specimens, from traditional medicinal plants like verbena to medicinal plants popular today such as evening primrose, are clearly labelled with their botanical classification and place of natural origin, as well as what ailments they treat. The plant collections fall into four categories: the Garden of Ethnobotany (whose plant beds are arranged by culture, for example Maori medicine), the Pharmaceutical Garden (whose beds are arranged by branch of medicine, such as oncology and parasitology), perfumery and aromatherapy borders, and a vegetable plot. Enjoying a balmy micro-climate, the 3 1/2 acre garden also cultivates rare and tender plants and is home to the largest outdoor fruiting olive tree in the country as well one of the earliest rock gardens in England. A profusion of benches line the scrunchy gravel paths offering an ideal place to while away a sunny summer afternoon in the city. The shop is well-stocked with gardening goodies, own produced honey and homegrown plants and seeds. The café serves delicious homemade food and is one of the nicest places in London to enjoy a traditional afternoon tea.

Chiswick House

⬚ Burlington Lane, W4 2QN
☎ 020 8995 0508
✑ www.chgt.org.uk
🚇 Turnham Green LU
🕐 House: Sun-Wed 10.00-17.00 (April-Oct)
 Garden: Daily 7.00-dusk all year
🎟 £5.50 (adults), £5 (concessions), £3.30 (5-15yrs), free (under 5s,
 English Heritage members); admission to garden free
🛍 Shop
🍽 Refreshment kiosk
♿ Wheelchair access (telephone in advance)

The last word in classical chic when it was built in the 1720s, Chiswick House is still a sumptuously stylish pad by any standards. Owner-architect Lord Burlington was inspired by the architecture of Ancient Rome and Renaissance architect Andrea Palladio. An enthusiastic 'grand tourist', Burlington returned home from his travels with 878 trunks of art acquisitions and set about designing a building that would represent the different aspects of roman architecture: domestic, religious and civic. The result is his masterpiece – a villa that was intended not as a home, but rather as an art gallery and severely upmarket party pad. The interiors centre around the octagonal domed 'tribunal' and include the resplendent Red, Green and Blue Velvet Rooms – the latter being Burlington's study, whose royal blue and gold colour scheme makes Lady Burlington's perfectly pleasant bed chamber look rather dowdy in comparison. A pair of original 'Chiswick' tables designed by Burlington's artistic collaborator William Kent are among the treasures on display, along with a set of paintings of Chiswick House in the 18th century by Rysbrack. The historic gardens, designed by William Kent are often described as the birthplace of the English landscape movement, and are just as much of a draw as the house. A 2-year, £12.1 million restoration has returned their arcadian vistas more closely to their original appearance and garden features such as the Camellia House and the Ionic Temple have also been restored. A much loved resource for the local community, the gardens are a popular haunt for dog walkers, who even organize an annual dog show, complete with celebrity judges. Good quality, fairly priced refreshments for human visitors can be tracked down at the sleek new café, designed by award-winning architects Caruso St John (dog water bowls are also provided).

The Alexander Fleming Laboratory Museum

- 🖃 St Mary's Hospital, Praed St, W2 1NY
- ☎ 020 3312 6528
- ✐ www.imperial.nhs.uk/aboutus/museumsandarchives/index.htm
- 🚎 Paddington Rail/LU
- 🕓 Mon-Thurs 10.00-13.00, and by appointment; Guided tours available
- 💷 £4 (adults), £2 (concessions)
- 🛍 Shop

It was in this tiny, old-fashioned laboratory that Alexander Fleming discovered penicillin – a storm in a petri dish that transformed its discoverer into a national hero and earned him a Nobel Prize.

A very distant relation to today's pristine white boxes, the laboratory is an accurate reconstruction of Fleming's workplace (although his original penicillin culture plate is housed at the British Library). Volunteer guides, some of them retired medical staff who knew Fleming personally, talk visitors through the momentous – and accidental – discovery of penicillin. A concise, well-presented exhibition charts the development of penicillin from mystery mould to life-saving wonder drug and the impact of antibiotics on modern medicine. The displays also recount the details of Fleming's life and career – including reproductions of the bizarre 'germ' paintings he created. The museum has been designated an International Historic Chemical Landmark.

Gunnersbury Park Museum

- 🖃 Gunnersbury Park, Popes Lane, W3 8LQ
- ☎ 020 8992 1612
- ✐ www.hounslow.info
- 🚎 Acton Town LU
- 🕓 Daily 11.00-17.00 (until 16.00 Nov-Mar)
- 💷 Admission free
- 🍽 Café
- ♿ Wheelchair access

Local history museums don't come much grander than this. Once the home of the Rothschild family, the richly decorated rooms of Gunnersbury Mansion are now furnished with exhibitions about Ealing's and Hounslow's past. Period clothing is displayed (or can be seen by appointment when not on display), while the Rothschild's regal carriages take centre stage. A copious collection of domestic objects and the fully-restored Victorian kitchens give a 'below stairs' insight into the household. A lively and varied programme of changing exhibitions highlights particular aspects of local history. The house is surrounded by 160 acres of parkland with its café situated next to a pond.

Hogarth's House

Hogarth Lane, Great West Road, W4 2QN

020 8994 6757

www.hounslow.info/arts/hogarthshouse

Turnham Green LU

Tues-Sun 12.00-17.00

Admission free

Shop

Wheelchair access (ground floor only)

From the outside, it takes a leap of imagination to picture this quaint red brick house back in the 18th century when it was the home of the painter-engraver William Hogarth. Only one room deep, the house was described by Hogarth as his 'little country box by the Thames', a place where he and his family could enjoy a more relaxed pace of life away from his town house and studio in Leicester Fields (today better known as Leicester Square'). Today Hogarth's rural retreat looks out over the less than tranquil pastures of the A4 and the roundabout that bears his name but the charming walled garden remains and contains a craggy old mulberry tree that Hogarth would have known.

Often regarded as the founder of British painting, Hogarth's fame now rests on the detailed social observation and scathing moral commentaries of engravings such as *The Rake's Progress, Marriage à la Mode* and *Gin Lane* (see also Sir John Soane's Museum, p. 76). A selection of his prints are displayed throughout the house, along with personal items such as his palette and the portable chest where he kept his colours.

Hogarth's interests were wide-ranging and as well as setting up an art academy and being responsible for the first copyright legislation, he was a philanthrophist, instrumental in setting up the Foundling Hospital (see p. 33). The Hogarths fostered several children and in the summer had foundling children to stay with them at Chiswick, where Mrs Hogarth would apparently bake them mulberry pies from the tree in the garden.

Hogarth's House reopened in November 2011 after an extensive and sympathetic refurbishment (made more lengthy by a fire midway through). It is now much easier to envisage as a family home, with its reinstated Georgian colour scheme of muted greys and pinks, open fireplaces, exposed floorboards and replica 18th-century furniture. New displays explore not only Hogarth's artistic career and legacy but also the lives of the ladies in the family, and the colourful characters who lived at Hogarth House after them.

museums west

Kensington Palace State Apartments

⌷ Kensington, W8 4PX

☎ 0870 751 5170 (information line)

✐ www.hrp.org.uk

🚾 Bayswater LU, Gloucester Road LU, High Street Kensington LU,
 Notting Hill Gate LU, Queensway LU

🕓 Daily Nov-Feb 10.00-17.00, March-Oct 10.00-18.00;
 last admission 1 hour before closing

💷 £12 (adults), £10 (concessions), £6 (children 5-16 years); Audio guides

🛍 Shop

☕ Café

♿ Restricted wheelchair access

Kensington Palace was snapped up by monarchs William and Mary
in 1689 when it was still humble Nottingham House. Remodelled
by Sir Christopher Wren, this tidy red brick building (the birthplace of
Queen Victoria and erstwhile home of Diana, Princess of Wales) boasts
illusionistic ceilings and a staircase painted by William Kent, and a
clutch of Old Masters in the State Apartments. 'KP' is also home to
the Royal Ceremonial Dress Collection, which features court dress worn
by members of the Royal Family and courtiers from the 18th century to
the present and including outfits belonging to Diana, Princess of Wales.
At the time of going to press the Palace is undergoing a multi-million
pound refurbishment which will make it more accessible to visitors.
Four new exhibitions are planned which will introduce some of the very
different royals who have lived in the palace over the centuries but while
building work is ongoing only the State Apartments remain open to the
public, re-imagined as 'the enchanted palace' courtesy of cutting edge
modern art and fashion installations. The Palace gardens – originally
laid out by landscape architect Charles Bridgeman for George I - are also
being improved, and historic 18th-century views are being reinstated.

Leighton House Museum

⌷ 12 Holland Park Road, W14 8LZ

☎ 020 7602 3316

✐ www.rbkc.gov.uk/museums

🚾 High Street Kensington LU

🕓 Daily 10.00-17.30 (closed Tuesdays), last admission 17.00,
 free guided tour every Wed 15.00

💷 £5 (adults), £3 (concessions/children)

This evocative haute-bohemian pad was once home to Frederic, Lord
Leighton, the great classical painter of the Victorian age. Hung with
paintings by the man himself and his Pre-Raphaelite pals Millais and
Burne-Jones, and with ceramics by William de Morgan (see p. 142), the

house was designed as a palace devoted to art, and its opulent interiors are spellbinding. Leighton's vast studio dominates the upper floor but the domed Arab Hall is the centrepiece of the house: a Moorish fantasia complete with gilt mosaic frieze, antique Iznik tiles, lattice-work 'mashrabiyah' window and gently playing fountain. The house has recently been on the receiving end of an award-winning refurbishment and restoration that has returned Lord Leighton's interiors to their polychrome 19th-century glory, with specially commissioned wall coverings for the silk room and the dining room. A hugely successful artist in his day, Leighton entertained the great and good of the Victorian art world in his flamboyant home but it is instructive to compare and contrast the splendour of the 'public' rooms with the austere simplicity of Leighton's sparsely furnished bedroom.

Leighton House Museum

The Museum of Brands, Packaging & Advertising

Colville Mews, W11 2DA
020 7908 0880
www.museumofbrands.com
Notting Hill LU
Tues-Sat 10.00-18.00, Sun 11.00-17.00
£6.50 (adults), £2.25 (children 7-16), £15 (family), £4 (concessions)
Shop
Tea room
Disabled access

This delightfully eccentric museum opened at the end of 2005 and, if you haven't been yet, is well worth a visit. The brainchild of Robert Opie, the museum pays affectionate homage to 20th century consumerism or as the Wombles would have it the 'everyday things that folks leave behind'. Robert Opie's Damascene moment occurred at the age of 16 and involved, of all things, a Munchies wrapper and from this humble start the collection has grown to comprise thousands of items, including toys, games, magazines, food and drink packaging, postcards, and advertising artwork. Exhibits are laid out along a 'time line' from the 1890s to present day and provide plenty of Proustian moments for all ages, provoking delighted cries of recognition as the visitor re-encounters the toys, sweets and games of their childhood.

Nostalgia aside, the collection beautifully shows how consumerism reflects society, unerringly charting trends like our national obsessions with crisps, ready meals, DIY and washing whiter than white. Striking

a chord with current concerns about over-packaging, displays also examine the technology and materials of packaging itself and the rise of containers like Tetrapak and the increasing sophistication of fizzy drinks cans. Commercial artwork is a particular strength of the collection and the flowing Art Nouveau lines of an Edwardian biscuit tin, or the striking Art Deco cover of a 1920s *Radio Times* show how directly the art movements of the day affected the look of trivial everyday items. Displays of fashions through the decades – from flapper dress to mini skirts – reflect Opie's view of clothing as the ultimate human packaging and on my visit Mr Opie himself was in evidence, happily talking to visitors about his collection. The small shop stocks engagingly nostalgic products and there's a small tea room, should looking at all those sweet wrappers make you hungry.

The Museum of Fulham Palace

⌨ Bishops Avenue, SW6 6EA
☎ 020 7736 3233
🖱 www.fulhampalace.org
� Putney Bridge LU
🕓 Sat-Wed 13.00-16.00
 Grounds open daily dawn to dusk
♿ Admission free
🛍 Shop
☕ Café-Bar (open weekdays 10.00-16.00, weekends 9.00-17.00)
♿ Disabled access

New displays opened at this small museum in 2007, telling the story of this remarkable site from prehistory to the present. The life and times of the Bishops of London were sometimes bloody and the ghost of the Bishop Bonner is said to haunt the Tudor Courtyard. More tangible exhibits take the form of archaeological remains, a scale model of the palace, a mummified rat and Bishop Winnington-Ingram's bejewelled mitre and cope. Benjamin West's pious depictions of Thomas à Becket and Margaret of Anjou are among the paintings on display. Several Fulham bishops were keen gardeners and their botanizing legacy lives on today in the Palace grounds, which include an 18th-century walled garden, herb knot garden, woodland and lawns. Plans to improve the gardens are afoot and include reinstituting part of the moat, restoring the historic vinery and returning the walled garden to a productive state. *The Bishops' Tree* carving by sculptor Andrew Frost is a recent addition to the gardens and depicts various of Fulham's prelates, among them anti-slavery campaigner Bishop Porteus. Another welcome addition to the set up is a stylish café-bar, and a small gallery showing contemporary art and photography inspired by the Palace.

The National Army Museum

🏠 Royal Hospital Road, SW3 4HT
☎ 020 7730 0717
✎ www.nam.ac.uk
🚌 Sloane Square LU, bus 239
🕙 Daily 10.00-17.30
♿ Admission free
🛍 Shop
☕ Café
♿ Wheelchair access

If you've got a thing about men – or women – in uniform this is the place for you. Unlike the Imperial War Museum (see p.47), whose subject is 20th-century conflict, the NAM focuses on the life of ordinary British and Commonwealth soldiers and is appropriately situated next to the Royal Hospital, home of the Chelsea pensioners (see p. 125). But even if you're not barmy about the army, this imaginatively presented museum makes for a rewarding visit and the chances are you'll linger much longer than you anticipated. An ongoing refurbishment programme ensures displays don't get stale, but does mean possible disruption to some galleries. If you are planning a visit to see something specific, it's probably worth checking before you set out.

Permanent displays track the development of the modern soldier from early times right up to the Cold War and controversial present day conflicts. The 'Changing the World' gallery follows 'the road to Waterloo', taking in the Peninsula War en route, and bears witness to the British Army's transformation from Wellington's well-drilled 'Redcoats' to a khakhi clad fighting force, struggling to get the upper hand in the Boer War. As elsewhere in the museum, startlingly realistic full-size models of historic soldiers bring the Napoleonic campaign to life – right down to doughty camp-following army wives – and there are historical curiosities such as a model of the Battle of Waterloo with a cast of 75,000 tin soldiers, the skeleton of Napoleon's favourite charger, and the VC awarded to Corporal Schiess, the hero of Rourke's Drift.

The museum covers the two World Wars, with uniforms, equipment and vehicles, and a walk-through trench, and looks at key battles such as Gallipoli, as well as Rommel's 'duel in the desert' with Monty, and the Campaign in the Far East. The most destructive war in human history, the Second World War, left in its wake a fragmented world and a new display examines the Korean War – a conflict which technically is still ongoing since no peace treaty was ever signed. Examples of both sides' propaganda are displayed, along with clothing worn by soldiers to combat Korea's harsh weather conditions. Audio accounts of soldiers' experiences as POWs add a personal aspect to the visual content.

Licked into shaped by fierce sergeant-majors, Britain's National Service conscripts played an important role in the country's post-war campaigns. A new display evokes the extreme contrasts of a conscript's life – from mindless kit polishing to sudden danger and even death in theatres as various as Aden, Kenya, Malaya and Belize. Visitors can listen in on the reminiscences of National Servicemen and hear their often sharply contrasting experiences.

On Level 3, 'Conflicts of Interest' is a timely new exhibition that tackles over three decades of controversial conflicts with British involvement – from Northern Ireland to Afghanistan, via Bosnia, Iraq and the Falklands. It's fascinating to see recent history in a museum context and the eye-catching displays highlight the role of the media in our perceptions while also raising emotive issues, such as the difficulties experienced by soldiers returning from conflict – from PTS to homelessness, and the rights and wrongs of sending them there in the first place. A touchscreen computer lets visitors vote on the matter.

Also on the third floor, the art gallery shows off the museum's impressive collections of paintings – from portraits of soldiers such as the pub-loving Marquis of Granby, to guts'n'glory battle scenes. Historic scenes predominate but are accompanied by more modern pieces, such as John Dowling's painting of a patrol in Pristina in 2000.

Special exhibitions ensure this is a museum to return to even after you've seen the permanent collections. Recent displays have included 'The Road to Kabul' and 'Wives and Sweethearts'. A popular Kids' Zone with castles to defend, monkey bars to climb, and uniforms to try on, caters to visitors age 10 and under, while interactive 'action zones' in the permanent galleries focus young minds more closely on the museum's exhibits.

A comprehensive selection of military books and knick-knacks can be found in the shop – deck the kids out in some trendy camo gear, pick up a military survival kit or simply award yourself a miniature campaign medal. Recently refurbished and expanded, the café is strategically placed to let you regroup your forces before doing battle with the well-heeled hordes of Chelsea.

The Natural History Museum

📺 Cromwell Road, SW7 5BD
☎ 020 7942 5000
✎ www.nhm.ac.uk
🚇 South Kensington LU
🕐 Mon-Sat 10.00-17.50 (last admission 17.30)
💷 Admission free
🛍 Shops
🍽 Cafés & Restaurant
♿ Wheelchair access

The Natural History Museum

One of South Kensington's "Big Three" museums, the Natural History Museum has been a London landmark since 1881. Famed for its dinosaur and fossil collections, the museum has evolved into one of London's most popular attractions, welcoming over 4 million visitors a year as well as supporting a 300-strong team of research scientists behind the scenes.

Purpose built by Alfred Waterhouse, the original museum building on Cromwell Road is worth a visit in its own right. Its elegant Romanesque arches conceal an iron and steel framework - the last word in Victorian structural innovation – but it is Waterhouse's lavish use of terracotta that really distinguishes it. Beautifully detailed sculptures of plants and animals liberally adorn both the interior and exterior of the museum, carefully distinguishing between living and extinct species (which were originally segregated in west and east wings respectively).

The cathedral like Central Hall is dominated by an iconic diplodocus skeleton – a giant plant eater known to all as "Dippy". Dippy has been

shrewdly placed: I suspect that many make 'Dinosaurs' their first port of call. This perennially popular gallery is chock-a-block with overgrown skeletons, all of which look ready to sample some human prey. A raised walkway brings visitors eyeball to eyeball with 'fearful lizards' like Dromaeosaurus, Triceratops and the might Tyrannosaurus Rex. Vicious claws, teeth, horns and spines abound and the animatronic model of a grumpy T-Rex guarding its kill means you can even see, and hear, one of them in action. On ground level, interactive displays ask 'What is a Dinosaur?' and look at possible reasons for their eventual demise.

There's more animal magic, albeit of the stuffed variety, in 'Mammals'. Flying mammals and mammals with pouches put in an appearance alongside more familiar species. The life-size model of a blue whale, slung from the ceiling, makes even the dinosaurs look like small fry. Films and hands-on exhibits supplement the stuffed specimens and bring to life the various mammalian habits, life cycles and evolution. The 'Images of Nature' gallery is a new permanent gallery showing highlights from the Museum's collection of over 1/2 a million natural history artworks – from delicately nuanced drawings to ultra-close up images captured via electron microscopes.

Completed in 1977, the 'Human Biology' display contributed to the NHM being made Museum of the Year way back in 1980 – and it's still one of the most compelling things here. After all, what could be more interesting than us? The human life cycle and the vital roles played by our component parts are explored with lots of interactive exhibits to make the information accessible. Share a womb with a giant foetus (cheaper than a flotation tank!) or listen to a baby learn to speak.

'Primates' and 'Our Place in Evolution' put the whole process in a larger perspective, as does the cross section of a 1,300 year old giant sequoia at the top of the Central Hall. Date markers chart major events like the Battle of Hastings and the foundation of Islam against its numerous growth rings. Less cuddly creatures get a look in too - 'Creepy Crawlies' is fun, even for confirmed arachnophobes. In a highly interactive display, visitors can walk into a termite tower, see where our many-legged friends make themselves at home in our homes and find answers to tricky questions such as 'how do crabs mate' or 'why is a millipede like a Swiss roll?'

From rainforest to desert, 'Ecology' looks at our environment, how it works and how mankind is messing it up. The giant 'leaf factory' shows how plants convert solar energy into food and a huge video wall follows the life cycle of water. Here you can learn about webs, pyramids, and the cycles of life – and recycle a rabbit.

The Earth Galleries can be reached via the Waterhouse Building but also have their own entrance on Exhibition Road. These galleries reflect

the latest approach to museology: low on endless cases of sparsely labelled specimens, high on participatory displays, sound effects and video monitors. With its six bronze statues depicting man's changing perspectives of the planet and its musical escalator leading up into a giant globe, the introductory exhibit 'Visions of the Earth' treads a fine line between the visionary and the naff. Once reached however, permanent displays like 'The Power Within' and 'The Restless Surface' get down to the nitty gritty. Solid ground turns out to be anything but on a planet made from frisky tectonic plates and volcanoes. Visitors can get a tiny piece of the action here in South Kensington by standing under a 'volcano' or by shopping in a Japanese supermarket just as the 1995 Kobe earthquake hits. 'From the Beginning' takes the long view by exploring the 4,560 million year history of the planet while 'Earth's Treasury' offers a glittering presentation of the precious gems and minerals created out of all the geological jostling.

Over on the western flank of the museum, the Darwin Centre is a state of the art scientific research station that houses a mind-boggling 22 million specimens, as well as one or two scientists. Here visitors can embark on a Cocoon tour, following a gently sloping walkway around the outside of the vast storage 'cocoon', past beautifully displayed insect and plant specimens as well as a sequence of high-tech interactive displays. Pick up a NaturePlus card on arrival to collect content from exhibits as you go around which can be viewed later online. Led by an engaging group of 'virtual' curators, visitors are introduced to Sir Hans Sloane, the museum's founding father and invited to explore the fundamentals of the science of nature. Aimed at adults and older students, slick touch-screen interactives allow you to play at being a scientist, leaf through a herbarium and plan a field trip (hint: don't forget to pack your pooter). The real versions can be seen hard at work in the adjacent laboratories and some can be quizzed via intercom. Down on the ground floor, more scientists can be seen beavering away in the Angela Marmont Centre for UK Biodiversity, while the David Attenborough Studio hosts a daily programme of films and lectures.

An extensive programme of special exhibitions, events and educational activities support the permanent displays. Families with under 7s might want to pick up an 'Explorers!' activity backpack from the Information Desk while down in the basement 'Investigate' transforms children aged 7-14 into scientists for the day. More flora and fauna can be seen in the Wildlife Garden, which is open every year from April to October. Two cafés and a restaurant keep any hunger pangs at bay and there's also a picnic area in the basement. On the last Friday of every month (except December) the museum keeps its doors open until 22.00, with a late bar and live music.

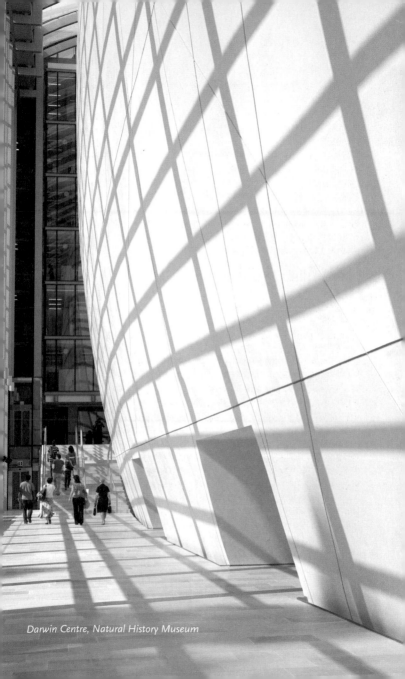

Darwin Centre, Natural History Museum

PM Gallery & House

🏠 Mattock Lane, W5 5EQ

☎ 020 8567 1227

🖱 www2.ealing.gov.uk/services/leisure/museums_galleries

🚌 Ealing Broadway LU

🕐 Tues-Fri 13.00-17.00, Sat 11.00-17.00

💷 Admission free

♿ Wheelchair access

Another example of Sir John Soane's inimitable architectural style (see also Bank of England Museum, p. 8, Dulwich Picture Gallery, p. 226, Sir John Soane's Museum, p. 76), Pitshanger Manor now functions as an historic house and contemporary arts venue with a lively programme of events and exhibitions. The Victorian Wing's extensive displays of Martinware pottery include a magnificent chimneypiece made for Buscot Park in Oxfordshire, and the Manor's elegant interiors are being restored to their original Regency style.

The Polish Institute and Sikorski Museum

🏠 20 Princes Gate, SW7 1PT

☎ 020 7589 9249

🖱 www.sikorskimuseum.co.uk

🚌 South Kensington LU, Knightsbridge LU

🕐 Tues-Fri 14.00-16.00, first sat of the month 10.30-16.00

💷 Admission free (donations appreciated)

Containing over 10,000 items, this extensive collection of Polish militaria is a valuable resource for students, particularly those of World War II. Friendly, knowledgeable volunteers guide visitors around – offering a trenchantly Polish take on events and an interactive experience in the best possible sense of the word. Each branch of the Polish armed forces is represented with memorabilia ranging from battle colours, regimental badges and weapons to photos, documents and personal effects. Exhibits include a Nazi Enigma machine, a submarine map drawn from memory by the crew of the Eagle when their original charts were confiscated, and the uniform in which Poland's war-time leader, General Wladyslaw Sikorski died. Military paintings and prints line the walls, among them Feliks Topolski's lively portrait of Sikorski and a dramatic depiction of the Battle of Monte Casino by Mezaj.

The Royal Hospital Chelsea Museum

⌕ Royal Hospital Road, SW3 4SR
☎ 020 7881 5203
✎ www.chelsea-pensioners.org.uk
🚌 Sloane Square LU
🕐 Daily 10.00-16.00 (closed 12.00-14.00);
 closed Sundays Oct to Mar
💰 Admission free
🛍 Shop

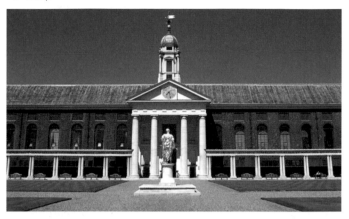

Founded in 1682 by Charles II as a retreat for army veterans, the Royal Hospital fulfils the same function today and Chelsea Pensioners, in their old-fashioned uniforms, are a much-loved sight along the King's Road. Pensioners' uniforms and medals are displayed in this small museum, as well as photos, original documents and artefacts illustrating the institution's history. Nosey parkers will enjoy peeking into the wooden 'berth' on display. These cabin like rooms are where the Pensioners live and were designed by the Hospital's architect, Sir Christopher Wren. Originally only 6 feet square, the 'berths' today have been enlarged to a palatial 9 feet square. Alongside the military memorabilia are 17th-century 'Wren' nails found during renovation work and a button made from the oak tree in which Charles II hid. The Wellington Hall houses a vast painting of the Battle of Waterloo. There is also an excellent shop, with post office, offering well-priced souvenirs. The Chapel and Great Hall are also open to visitors and, as they were also designed by Sir Christopher Wren, are well worth a look. Conducted tours, led by Chelsea Pensioner guides and for which a charge is made, are also available – telephone for details.

The Science Museum

⌨ Exhibition Road, SW7 2DD

☎ 0870 870 4868 (general booking and enquiries)

✎ www.sciencemuseum.org.uk

🚇 South Kensington LU

🕐 Daily 10.00-18.00

♿ Admission free

🛍 Shop

🍴 Cafés

♿ Wheelchair access

'See inside for inspiration' used to be the slogan here and although the tag line has been dropped, the sentiment remains just as true. In fact, since the 2000 opening of the £50-million Wellcome Wing there's more than ever to see and be inspired by at the Science Museum. Taking a broad view of historic and contemporary science, the museum encompasses technology, industry and medicine – everything from computing to chemistry, dentistry to deep sea diving, Foucault's Pendulum to Stephenson's Rocket.

With over 200,000 historic objects in its collections, the museum also prides itself on its interactive exhibits, many of which are geared towards children. If your kids favour the hands-on approach make a bee-line for the 'Launch Pad' on the third floor which contains over 50 interactive experiments from the world of physics. Aimed at 8-14 year olds, it's an incredibly popular destination, on my visit in the school holidays it was positively teeming with hyperactive boffins. Down in the basement 'The Garden' is a marginally more tranquil exploration and discovery area for 3-6 year olds while 'Things' offers demonstrations, workshops and special events for all ages. All these galleries are supervised by 'Explainers' – friendly museum staff who are on hand to answer questions, guide experiments and stage educational performances.

Also in the basement and accessible to everyone, 'The Secret Life of the Home' is an entertaining display charting man's struggle to conquer the domestic front. Given the technological wizardry on show elsewhere in the museum, what's really amazing here is just how long it has taken humans to work out an effective way of doing the housework. The evolution of the humble toilet is shown in all its glory – culminating in a frank, funny presentation of how a modern flush loo works.

On the ground floor the Energy Hall is filled with the steam driven hardware that powered the Industrial Revolution – giant beam engines such as 'Old Bess' – and also includes the reconstructed workshop of steam pioneer James Watt. 'Exploring Space' is a popular attraction on the same floor covering early rocketeers, men on the moon and modern satellite communications. The huge Black Arrow satellite launcher runs

practically the length of the gallery and there's also a look at life in space – only 50 miles away – complete with astronauts' undies and a Coke can specially adapted for gravity-free conditions. Leading on from here is 'Making the Modern World', a chronological display of some 1,800 icons of the industrial world, including 'Puffing Billy' (the oldest steam locomotive), a Model-T Ford, and the Apollo 10 command module, surprisingly compact and still bearing its re-entry scars.

The first floor is home to 'The Challenge of Materials', a funky display which takes a fresh look at the manufacture, use and disposal of materials. The exhibits incorporate examples of art, architecture and fashion to challenge our perceptions. While visitors can boggle at unusual items like a steel bomber jacket, interactive exhibits let you get to grips with how materials are developed and tested.

Recently opened on the 2nd floor, 'Atmosphere' is a highly interactive, immersive gallery dedicated to exploring the science behind climate change. Actual artefacts neatly complement the high-tech touch screen games: such as the 'climate change diary' of a copper beech tree and its human equivalent, the temperature notebooks of climate change pioneer Guy Callendar. Showing that climate change is not new is a 56 million year old example of global warming, in the form of a Hertfordshire 'pudding stone'.

Contained within a vast hangar-like space, 'Flight' takes off on the third floor. Flying machines of all descriptions hang from the ceiling like Airfix models – from papery biplanes to Britain's first jet plane – while ranged along one wall is a miscellany of gleaming aircraft engines. A high-level walkway gives a bird's-eye view of the planes which include several historic exhibits from the pioneering days of flight, such as the Vickers Vimy in which Alcock and Brown crossed the Atlantic in 1919 and Amy Johnson's de Havilland Moth 'Jason'. These all seem worlds away from the crowded skies of the 21st century and the paraphernalia of jet travel: a cross-section of a Boeing 747 and an air traffic control suite bristling with lights, switches and split-second, life or death decisions. Flight simulators – used to train pilots on the cheap – are a popular draw here, despite costing extra and promising a bumpy ride.

On a more down to earth note, 'Health Matters' looks at how medical technology affects our experience of medicine. Medical hardwear on show includes a 1950s iron lung, an MRI scanner and an artificial kidney. Other displays look at research into community health and genetics and medicine. The top two floors of the museum, 'The Science and Art of Medicine', and 'Veterinary History' continue the gore with no end of evil-looking instruments. There are also reconstructions in 'Glimpses of Medical History' – visit a 1930s dentist or (if you've got the bottle) 'drop in' on a 1980s open heart operation.

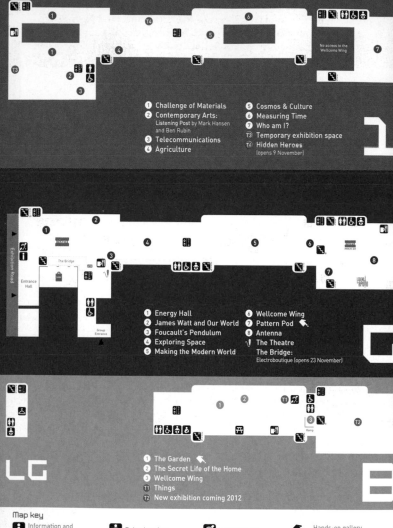

1

① Challenge of Materials
② Contemporary Arts:
 Listening Post by Mark Hansen and Ben Rubin
③ Telecommunications
④ Agriculture

⑤ Cosmos & Culture
⑥ Measuring Time
⑦ Who am I?
T3 Temporary exhibition space
T4 Hidden Heroes
 (opens 9 November)

No access to the Wellcome Wing

G

Exhibition Road

Entrance Hall

TICKETS

The Bridge

Group Entrance

① Energy Hall
② James Watt and Our World
③ Foucault's Pendulum
④ Exploring Space
⑤ Making the Modern World

⑥ Wellcome Wing
⑦ Pattern Pod
⑧ Antenna
✓ The Theatre
The Bridge:
Electroboutique (opens 23 November)

LG

B

Ramp

① The Garden
② The Secret Life of the Home
③ Wellcome Wing
T1 Things
T2 New exhibition coming 2012

Map key

🛈 Information and Membership desk	👶 Baby changing	🔁 Induction loop
☕ Café/restaurant	👨‍👩‍👧 Family room	🚻 Toilets
⛱ Picnic area	🧥 Cloakroom	♿ Accessible toilets

Hands-on gallery
see overleaf for details

Lifts
including floors accessible

Stairs
including number of steps up to
next floor, and floors accessible

5

1. The Wellcome Museum of the History of Medicine
2. The Science and Art of Medicine
3. Veterinary History

4

1. The Wellcome Museum of the History of Medicine
2. Glimpses of Medical History

3

1. Science in the 18th Century
2. Launchpad
3. Health Matters
4. Flight
5. Wellcome Wing
6. In Future

2

1. Public History:
 Oramics to Electronica
2. Energy
 – fuelling the future
3. Computing
4. Mathematics
5. Marine Engineering
6. Ships
7. Docks and Diving
8. Atmosphere
 ...exploring climate science
T5. Temporary exhibition space

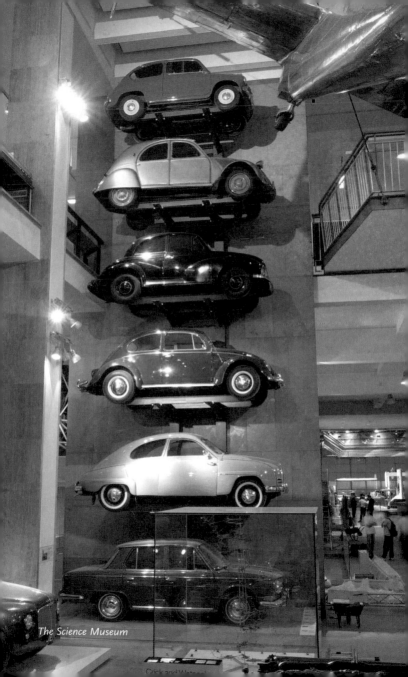

The Science Museum

Contemporary science is the name of the game in The Wellcome Wing. Its exhibitions handle the hottest topics in science today such as genetics, digital technology, and artificial intelligence. Billed as the world's fastest-moving science exhibition, 'Antenna' features constantly updated displays on the latest advances while 'Who am I?' is a bio-medical investigation into identity and brain science with a Live Science area with fun interactive 'bloids'. The under 8s haven't been forgotten either – the importance of patterns in science is the premise for 'Pattern Pod', a multi-sensory exhibit. Looming large on the third floor, the IMAX cinema shows science films such as 'Space Station 3D' and 'Seamonsters 3D' on its five storey-high screen.

This is just the tip of the iceberg – temporary exhibitions, events and contemporary artworks are some of the other attractions on offer – but don't discount the older style galleries; just because they aren't packed with touchscreen computers doesn't mean they aren't worth a good look around. While the newer galleries can get crowded and noisy, displays like 'Time Measurement' remain havens of traditional museum hush. For quiet contemplation try 'Agriculture' on the first floor. Ponder the development of the plough and admire the old-fashioned tableaux of the changing seasons complete with model tractors and farm machinery. 'Marine Engineering', 'Ships', 'Docks' and 'Diving' are other enjoyable older-style galleries on the second floor. Simple labels let the objects speak for themselves and there's a stunning selection of model ships from across continents and through the ages.

There's a lot to see and, as with all big museums, a little pre-planning will ensure you get the most from your visit. Guided tours of the most popular galleries and outstanding objects take place every day, the museum map provides a list of highlights for those going it alone, while leaflets like the 'world wonders trail' promote a more focused visit, centred around 7 top scientific and engineering achievements. For children who just can't tear themselves away, the Museum organises 'Science Night' – a sleep-over event with demonstrations, hands-on workshops and gallery trails.

If all that thinking makes you peckish, there are two on-site cafés and several picnic sites with seating dotted about the museum. Food for the mind can be found in the bookshop, which stocks a host of relevant publications for all ages, from activity books to heavy-weight scientific tomes; while in the museum's shop, gadgets, gizmos and games are the order of the day.

18 Stafford Terrace
(Linley Sambourne House)

⌖ 18 Stafford Terrace, W8 7BH

☏ 020 7602 3316 (info and bookings)

🖰 www.rbkc.gov.uk/museums

🚇 High Street Kensington LU

🕑 Mid Sept – Mid June (Visits are by guided tours only - advance booking recommended); Wed 11.15am, 2.15pm, Sat and Sun 11.15am, 1pm, 2.15pm, 3.30pm (weekend afternoon tours are costumed).

💰 £6 (adults), £4 (concs), £1 (children)

🛍 Shop

A hidden gem in the heart of London. Remarkably well-preserved and complete with its original interior decoration and contents, 18 Stafford Terrace is one of London's best kept secrets. From 1875, this time capsule of a terraced house was the home of Punch illustrator and cartoonist Edward Linley Sambourne, his wife Marion, their two children and live-in servants. Originally decorated by the Sambournes in keeping with fashionable Aesthetic principles, the interiors evolved into wonderfully eclectic artistic statements within the confines of a typical middle-class home. Jam-packed with pictures, ornaments and knick-knacks of all sorts.

18 Stafford Terrace

Victoria and Albert Museum

⬚ South Kensington, SW7
☏ 020 7942 2000
✎ www.vam.ac.uk
🚇 South Kensington LU
🕓 Daily 10.00-17.45 (Fri until 22.00, selected galleries only)
💰 Admission free (a separate charge applies to some exhibitions & events)
🛍 Shops
🍽 Café & Restaurant
♿ Wheelchair access

The V&A, the national museum for art and design, is one of my favourite museums. Founded in the great 19th century era of self-improvement, it is still a life enhancing experience. Packed with beautiful textiles and fashion, jewellery, ceramics, glass and furniture from across the centuries and around the globe, it has long been cherished by artists and designers, for whom it acts as a vast, inspirational source book. Although known for its decorative art, the museum also contains an impressive assembly of 'fine' art – paintings, prints, photography and sculpture.

A review of this size can't do justice to the V&A's diversity – and neither will a single visit. Little and often is the ideal approach – thank goodness that admission to this great institution is free. Free guided tours depart daily from the Information Desk at the Cromwell Road entrance and last an hour. Those venturing in without a guide – human or otherwise – shouldn't be dismayed by the odd wrong turn: the V&A is labyrinthine but unplanned detours are part of the fun and you are bound to stumble across something of interest. Wandering through **'Ironwork'** recently, I discovered the 'Melchett Fire Basket', a fabulously self-referential 1930 commission by socialites Henry and Gwen Mond, invoking the catty gossip the couple attracted after an involvement in a ménage à trois. 'Late Views' on Friday evenings are particularly lively time for a visit with regular exhibits supplemented by a programme of lectures and live music into the night.

A word of warning before you embark. If there is anything in particular you want to see, it's worth calling 020 7942 2211 (09.00-17.30 Mon-Fri) in advance to find out which galleries are closed. Only selected galleries stay open on Friday evenings and implementation of the V&A's 'FuturePlan' means that some galleries may be closed while they are redeveloped. This ambitious project of renewal and restoration began in 2001 and has been growing in momentum, steadily transforming the V&A into a 21st century shrine to design. New or refurbished galleries have been opening on a yearly basis and the programme is still ongoing, with a new entrance on Exhibition Road, new Europe 1600-1900 galleries

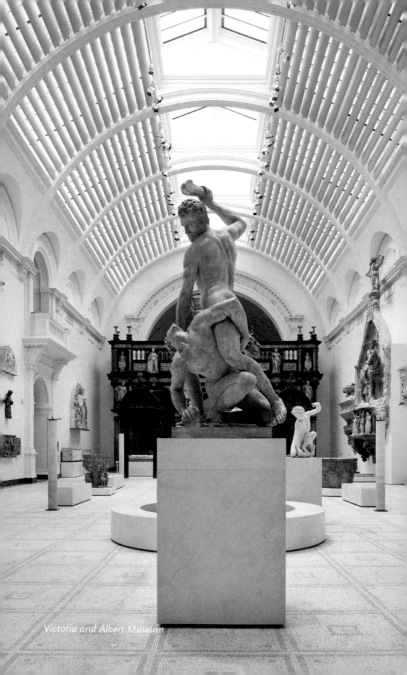

and a revamped fashion gallery among the upcoming developments.

The V&A's collections are grouped into five major themes: Asia, Europe, Materials and Techniques (like 'Ironwork' or 'Tapestries'), Modern and Exhibitions. The magnificent, refurbished **Raphael Gallery** on the ground floor makes a great starting point. This imposing space houses the seven enormous *cartoons* or preparatory designs for tapestries commissioned for the Sistine Chapel. With their vivid colours and serene compositions they are very much works of art in their own right. On the same floor, the **Far East Galleries** contain the finest collections of contemporary Chinese and Japanese art outside the countries themselves. The **Jameel Gallery** showcases the decorative arts of the Islamic Middle East, and features a vibrantly tiled 18th-century Turkish chimneypiece, Armenian church vestments and the vast 16th-century 'Ardabil Carpet' – one of the largest and finest Islamic carpets in existence. New suites of galleries for the **medieval and Renaissance** collections opened in 2009, their crisply presented exhibits revealing how large the church loomed in European life, with lavishly embroidered vestments, richly coloured stained glass, triptychs galore and the only Italian renaissance chapel outside Italy. On a secular note, don't miss the skeletal wooden façade of Sir Paul Pindar's London house.

Sculpture vultures are well-served on the ground floor with The re-vamped **sculpture galleries** and the vast and impressive **cast courts**. The latter are currently being restored to their Victorian pomp as part of FuturePlan and are populated with plaster reproductions of famous sculpture and architecture. Here, casts of the portal from *Santiago de Compostella* and *Trajan's Column* jostle for space with medieval knights and their ladies, and Michelangelo's *David*.

Up on the third floor, more modern sculpture includes a fine collection of marble and bronze works by Rodin (some given by the artist himself) such as his notorious *Age of Bronze*. The paintings in the refurbished **Paintings Galleries** also repay closer study. Look out for the first ever painting by Degas to enter a British public collection, landscapes by the Barbizon School and a glorious group of sketches by Constable including a study for *The Haywain* and some of his renowned cloud studies.

Touchscreen computers can be found in several galleries – such as the **Samsung Gallery of Korean Art** – and provide useful additional background information on the objects and the culture that formed them. The **Glass Gallery** on level 4 is a glittering celebration of a fragile yet durable substance. Artefacts range from ancient glass perfume jars to elaborate candelabra, from humble drinking glasses to the latest glass goods from Murano. A dramatic glass staircase and balcony, housing the study collection, supplies a fairy tale pièce de résistance.

Visitors with a magpie sensibility will enjoy the **Silver Galleries** on level 3, which house the largest public display of silver in the UK, albeit bizarrely displayed in the former ceramics galleries. As well as admiring lustrous silver from Britain and elsewhere, visitors can interactively explore fakes and forgeries, hallmarking and silversmithing techniques. There are more glittery goodies to ogle in the elegant new **Jewellery Gallery**, which opened in 2008. The ingenuity of jewelers seemingly knows no bounds with exhibits ranging from ancient amulets to the dazzling 'Londonderry Jewels', along with Edith Sitwell's boulder like aquamarine rings and Jan Yager's ultra-contemporary 'done deal' necklace, fashioned from crack cocaine vials. The **Gilbert Collection** continues the precious theme; relocated from Somerset House to the V&A in 2009, this amazing collection of gold and silver objects, micromosaics and enamel minatures is a tour de force of craftsmanship. Things get more earthy in the recently redeveloped **ceramics galleries**, whose displays chart mankind's love affair with clay: from ancient Egyptian artefacts, to the work of contemporary studio potters.

The **British Galleries** opened in 2001, after a £31 million refit. Comprising 15 galleries and 3,000 exhibits, the displays celebrate the best in British design 1500-1900 and examine how Britain rose from design non-entity to become the 'workshop of the world'. The displays feature five completely restored period rooms such as the 18th-century Norfolk Music Room as well as furniture, metalwork, ceramics, textiles, fine art and old favourites such as the 'Great Bed of Ware' and the 'Stoke Edith Hangings'. These new galleries include 'discovery areas' with hands-on exhibits and a Study Area. This latter comes equipped with interactive computers with all the gen on the many different styles in evidence as well as some dangerously comfy suede chairs and a selection of appropriately themed reference books. Just don't forget to look at the exhibits.

Another recent addition is the **Architecture Gallery** on level 4. Showcasing the V&A and the RIBA's collections of architectural drawings and models, displays guide visitors through the gamut of architectural styles from Classical to Modernist, via the more ornate Gothic and Spanish Islamic.

Contemporary style gurus will also want to check out the **20th Century Galleries** on level 3 which have their fair share of must-have designer furniture to lust after but also rejoice in a visual feast of graphic design and typography.

Major temporary exhibitions, as well as ever-changing smaller displays, keep things fresh while exploring topics as diverse as the Aesthetic Movement and the designs of Yoji Yamamoto. Visitors aged 5-12 might want to take advantage of the museum's award winning

'Back-Packs' (available on Saturdays) to take them through the collections with an innovative mix of jigsaws, stories, and puzzles.

Foodwise, the V&A offers two possibilities. The Garden Café occupies one corner of the John Madejski garden and offers light refreshments al-fresco. Enjoy the garden with its elegant, seasonally updated planting scheme and elliptical pond and see if you can spot the two small wall plaques commemorating 'Tycho' and 'Jim', two erstwhile museum dogs. The inside Café has returned to the museum's original suite of refreshment rooms, the wonderfully exuberant Morris, Gamble and Poynter rooms. The streets around South Kensington tube station offer plenty of alternatives, if you fancy a change of scene.

The museum shop is as tempting as ever and you may end up wishing you'd left your credit card at home. In addition to the usual postcards and posters, the stock includes a discerning selection of cutting edge jewellery, ceramics and textiles by top contemporary makers as well less expensive knick-knacks and art and design books.

William Morris Society – Kelmscott House Museum

⌗ Kelmscott House, 26 Upper Mall, W6 9TA

☏ 020 8741 3735

✍ www. society.org

🚌 Ravenscourt Park LU

🕓 Thurs and Sat 14.00-17.00

♨ Admission free

🛍 Shop

The basement and coach house of the riverside home of William Morris, now form a museum open to the public and serve as the HQ for the William Morris Society. Although by no means extensive, the displays here reflect Morris's dual role as doyen of the Arts & Crafts Movement and energetic pioneering socialist. Photographs of eminent early socialists in the coach house testify to its previous incarnation as the HQ of the Hammersmith Branch of the Socialist League. The original decorative designs by Morris and exquisite embroideries by his daughter, May, offer a glimpse of the man's influential style. See also William Morris Gallery p.171.

South

The Brunel Museum

🖬 Brunel Engine House, Railway Avenue, Rotherhithe, SE16 4LF

☎ 020 7231 3840

✎ www.brunel-museum.org.uk

🚃 Canada Water LU, Rotherhithe LU

🕓 Daily 10.00-17.00

💷 £2 (adults), £1 (concessions), free (children under 16)

🛍 Shop

☕ Café

♿ Wheelchair access

It took father-and-son team Marc and Isambard Brunel eighteen years to build the world's first under-river tunnel, linking Rotherhithe on the south side of the Thames to Wapping on the north. Located in the original Engine House, this award-winning museum tells the story of their achievement in the face of floods, financial losses and human disaster. 'The Great Bore' as the project was, without apparent irony, called, became known as the '8th wonder of the world' when it opened in 1843. It paved the way for modern mass urban transportation and is still used today by London Underground's East London Line. Displays explain the technological triumph of the tunnel, but also reveal the human side of the endeavour and the harsh lives endured by the tunnel's miners. The museum also commemorates Brunel's final project, the *Great Eastern* steamship, the world's first modern ocean liner which was launched just a few hundred yards down the river in 1858.

With its pedimented gable ends and dinky metal chimney, this modest brick building is a temple to Victorian self-belief and definitely punches above its weight. Not content with being a scheduled ancient monument and international landmark site, the Brunel Museum also runs an imaginative events programme as well as hosting community activities. Its garden features 3 of Isambard's most iconic bridges recreated as benches.

The Cinema Museum

The Master's House, 2 Dugard Way, SE11 4TH

020 7840 2200

www.cinemamuseum.org.uk

Kennington LU, Elephant & Castle LU

Admission by guided tour only £7 (adult)
£5 (children; conc) – advance booking essential

Disabled access

Appropriately housed in the workhouse building which once sheltered the impoverished young Charlie Chaplin, this characterful museum is a paeon to the days when 'going to the pictures' truly was a national pastime. The museum, co-founded by former projectionist and visionary collector Ronald Grant, embraces all aspects of the cinema from usherettes' uniforms, lobby cards and posters to swirling carpets, illuminated signs and hulking projectors. The advent of digital projection and the dead hand of the modern multiplex makes this collection a vitally important record of the way we once consumed the defining art form of the 20th century – in sumptuous 'picture palaces', surrounded by a fug of cigarette smoke, in thrall to the silver screen. A screening room, furnished with 36 salvaged vintage cinema seats, hosts regular screenings of material from the film archive and the museum also hosts film related lectures and collectors' bazaars.

The Crystal Palace Museum

Anerley Hill, Upper Norwood, SE19 2BA

020 8676 0700

www.crystalpalacemuseum.org.uk

Crystal Palace Rail

Sat, Sun and Bank Holidays 11.00-16.30 (last entry 16.00);
other times by prior appointment

Admission free

Shop

Hugely popular in its day, the Crystal Palace hosted everything from the Great Exhibition of 1851 to fun fairs and football cup finals before it burnt down in 1936. Dedicated to keeping its flame (as it were) alive, this museum is housed in the last surviving building constructed by the Crystal Palace Company. Numerous photos and artefacts tell the story of this glorified greenhouse and books and souvenirs relating to the palace are available from the museum's shop.

The Cuming Museum

Old Town Hall, 151 Walworth Road, SE17 1RY

020 7525 2332

www.southwark.gov.uk/cumingmuseum

Elephant and Castle LU/Rail

Tues-Sat 10.00-17.00

Admission free

Gift counter

Wheelchair Access

Hailed as a 'British Museum in miniature' when it opened in 1906, this museum is home to the extraordinary collections of father and son Richard and Henry Syer Cuming. Men of eclectic taste, their acquisitions were nothing if not diverse, encompassing natural history, ethnography, Egyptology, archaeology and the plain nutty. Now thoughtfully redisplayed in Southwark's former Town Hall, the museum manages to combine its original Victorian 'cabinet of curiosity' feel with the best of 21st century interpretation. Living in Southwark, the Cuming's were ideally placed to pick up all sorts of goodies from around the globe – from celebrity knick-knacks like King Alphonso of Spain's tooth to Egyptian mummies, and artefacts collected on Captain Cook's voyages. Other eye-catching curios include a stuffed bear, a cow's heart from Bethnal Green as well as 'medieval antiquities' forged by 'Billy' and 'Charley', two enterprising Victorian mudlarks. Every country in Africa

is represented but there are also objects from Asia, the Americas and Europe. Bizarre, bygone superstitions to ensure health and wealth are the focus of the Lovett Collection, whilst among the costumes there's a picturesque dentist's cap – trimmed with several mouthfuls of human teeth – and an Hawaiian feathered cape.

The local history displays include the obligatory hands-on element for young visitors, and cover the history of Southwark – from prehistory to the present day. Oral reminiscences and picture books tell the stories of Southwark's multicultural communities – and there are still more curios like the 'Camberwell Beauty' butterfly and a pearly king's jacket. A temporary exhibition gallery hosts shows on local themes.

Cutty Sark

　Cutty Sark Gardens, Greenwich, SE10 9HT
　020 8858 2698
　www.cuttysark.org.uk
　Cutty Sark DLR, Greenwich Rail/DLR

Launched in 1869, the *Cutty Sark* is one of the world's most historic ships – and the last remaining tea clipper. A famous speed merchant in her day she hauled not just tea but wool and on one famous occasion 'overhauled' a steam ship, the *Britannia*. The *Cutty Sark* went onto become one of London's best-loved sights – at least until May 2007 when a potentially devastating fire ripped through the vessel. Luckily much of the ship's fabric was not in situ as it was being conserved at the time and incredibly only less than 2% of *Cutty Sark*'s historic structure was lost. After 6 years, the conservation project is finally due to complete in Spring 2012. When she re-opens to the public, the *Cutty Sark* will be presented in a dramatic new way: raised 3 metres above her former position in dry dock and suspended in a glass canopy, an innovation which will create a new space underneath the ship where visitors will be able to appreciate her elegant lines and construction. At the time of going to press details about the new displays were yet to be finalized but the Silver Collection of Merchant Navy figureheads previously shown in the Lower Hold, are destined for a new exhibition area in the dry berth. After so long away from the limelight *Cutty Sark* is sure to set pulses racing when she resumes her rightful place at the centre of the UNESCO World Heritage Site of Maritime Greenwich. At time of going to press opening times were yet to be confirmed, please check their website for information.

The De Morgan Centre

📖 38 West Hill, SW18 1RX
☎ 020 8871 1144
🖋 www.demorgan.org.uk
🚇 Putney East LU, Putney Rail; bus 37, 170, 337, 776
🕐 Tues-Fri 13.00-17.00, Fri-Sat 10.00-17.00
💷 £4 (adults), free (children and Art Fund Members)
🛍 Shop
☕ Café
♿ Wheelchair access

A victim of local authority cuts, The De Morgan Centre closed in 2009 but re-opened in 2011 with a three year stay of execution in its old premises at the former Putney library (now also home to Wandsworth Museum, see p.156). Its collections of William de Morgan's ceramics and his wife Evelyn's paintings are the largest in the world and, freshly restored and re-hung, they offer a fascinating snapshot of a very particular moment in English aesthetics.

William De Morgan was a key player in the Arts and Crafts Movement and worked alongside William Morris while Evelyn was also something of a trailblazer, being one of the first women students at the Slade School of Art. A man of many parts De Morgan single-handedly rediscovered the lost art of lustre decoration, was involved in prison reform, the suffragette movement and in his last years enjoyed a second career as a novelist. It is for his pottery, though, that he is remembered today, and judging by the ceramics displayed here it's easy to see why. Islamic pottery was a major influence and his gorgeously coloured and intricately patterned vases, bowls and tiles, decorated with fish, peacocks, boats and flowers, show how well he absorbed the lessons of his Persian and Turkish inspiration.

With their abundance of mournful damsels with flowing hair and robes, Evelyn De Morgan's paintings fit squarely in the Pre-Raphaelite mould. They are also intensely personal creations, expressing her radical feminist, spiritualist and pacifist beliefs. Her Botticelli inspired depiction of *Flora* shows how well she adopted the techniques of the Italian Renaissance masters, while the bright, almost garish, colours she deployed in paintings such as *The Love Potion* are expressions of Evelyn's own unique style.

As well as showcasing the De Morgan's work, the Centre nurtures the Arts and Crafts tradition with a programme of temporary exhibitions. They feature the work of top contemporary craftspeople, who keep the skills advocated by William Morris alive, while also making things of very great beauty.

Eltham Palace & Gardens

Courtyard, off Court Road, Eltham, SE9 5QE

☎ 020 8294 2548

www.english-heritage.org.uk

Eltham Rail, Mottingham Rail

Sun-Wed 10.00-17.00 (Apr-Oct), 10.00-16.00 (Nov-March), closed January

House and gardens: £9.30 (adults), £8.40 (concessions), £5.60 (children), free (English Heritage members)

Shop

Café

Wheelchair access

A medieval royal palace with a twist. The twist being the 1930s house with stunning Art Deco interiors which is incorporated into the ruins of what was once Henry VIII's childhood home. Wealthy couple Stephen and Virginia Courtauld commissioned the house and they kitted it out in luxurious style: concealed electric lighting, a centralised vacuum cleaner and en suite bathrooms were some of the mod cons. Although most of the original artworks and furniture are no longer in place, the house has been restored to its Jazz Age opulence with replica furniture and Deco colour scheme. The Entrance Hall and Dining Room are particularly fine rooms – the former featuring marquetry panels of Italian and Scandinavian scenes (guarded by a pair of bellicose marquetry sentries), the latter with a series of black and silver doors depicting animals from London Zoo. Virginia Courtauld's onyx and gold mosaic bathroom is another essay in the Hollywood style, presided over by a classical statue of *Psyche*. In a bold juxtaposition of ancient and modern, the Great Hall of the medieval palace was rescued from picturesque decay to become the Courtaulds' Music Room, complete with underfloor heating. The relentless luxury even extended to the living quarters of 'Mah-Jongg', the Courtauld's pet lemur who, when not jet setting around the world with his owners, had use of a roomy heated cage, hand-painted with a tropical jungle scene. Old home movie footage of the Courtaulds at play with friends, family

and a succession of pets, show how much they enjoyed living at Eltham. Hospitality for today's visitors comes in the form of an excellent waitress service café, housed in the pea-green former servants quarters along with an imaginatively stocked shop (jaunty jazz soundtracks and Deco themed gifts). The Palace's 19 acres of gardens are being restored to their 1930s elegance and are perfect for a post cream tea stroll. Admire the stunning herbaceous border and see if you can spot the rogue goldfish among the monster carp in the moat.

The Fan Museum

⊞ 12 Crooms Hill, SE10 8ER
☎ 020 8305 1441
⌨ www.fan-museum.org
🚃 Cutty Sark DLR, Greenwich Rail/DLR
🕐 Tues-Sat 11.00-17.00, Sun 12.00-17.00
💰 £4 (adults), £3 (concessions), free (under 7s), Tues 14.00-16.30
 free entry for Seniors and disabled
🛍 Shop
☕ Teas served Tues & Sun
♿ Wheelchair access

Set in two immaculately-restored Georgian houses, this small museum oozes gentility from every pore – from its tasteful décor and charming volunteer staff to its award-winning lavatories.

As well as fans, painted fan leaves feature in the permanent display – a rare 17th-century example depicts a somewhat glum bunch of French royals at a birthday party – but the history and craft of fan-making are also explored. The fans themselves are crafted from an amazing range of materials from elaborately carved tortoiseshell, ivory and mother of pearl to Welsh slate. High profile recent acquisitions include a fan leaf painted with a landscape by Gauguin and one by Sickert featuring a music hall scene. Regularly-changing themed exhibitions are held in the upstairs gallery and showcase fans from the museum's 3,000 strong collection – past shows have included Victorian fans and ancient myths and legends. The museum also runs fan-making workshops and can even design and make fans to order for special occasions.

Fans appear in a variety of guises in the imaginatively stocked museum shop. Fan fayre on offer includes specially commissioned jewellery, as well as greetings cards, toiletries and tea cosies, plus a variety of fans. The shop also carries a range of specialist publications. Afternoon teas are served in the museum's pretty conservatory on Tuesday and Sunday afternoons; but this being Greenwich, there is no shortage of good eating opportunities within easy walking distance for those visiting on other days.

Firepower, The Royal Artillery Museum

Royal Arsenal, Woolwich, SE18 6ST

☏ 020 8855 7755

✎ www.firepower.org.uk

🚌 North Greenwich LU, then buses 161, 422 or 472 to Woolwich; Woolwich Arsenal Rail

🕓 Wed-Sun 10.30-1; (Daily during school holidays)

💰 £5.30 (adults), £2.50 (children), £4.60 (cons), £12.50 (family ticket), Free (serving Gunners)

🛍 Shop

☕ Café

♿ Wheelchair access

The first home of Arsenal Football Club (see p. 88), Woolwich was also the birthplace of the Royal Regiment of Artillery. Nearly 300 years after the regiment's founding in 1716, this museum tells the story of the original 'gunners' as well as exploring the history of artillery from slingshot to supergun. Firepower features an impressive battery of weaponry including coastal and air defence guns, anti-tank guns and rockets. Displays of military hardware range from a 16th-century glass hand grenade to a fully kitted out Command Post Saracen and are backed up by archive images, personal recollections and interactive exhibits to help visitors really get a flavour of life as a gunner in both war and peace. 'Field of Fire', a noisy, seat-shaking film presentation, shows some of the museum's big guns in action. There's plenty of science on offer here too – this is the place to discover the difference between direct and indirect fire, and why 'rifling' is crucial to spin stabilisation. More than just a museum, Firepower is also a memorial to those who served in the regiment and the Medals Gallery includes decorations from just about every campaign fought by the British Army over the past 200 years. Incidentally, the museum is home to the Victoria Cross Guns – metal from which continues to be used to make Britain's most prized military honour. A major new exhibition 'Gunners today' brings the Royal Artillery story right up to date with a look at recent/current campaigns in Iraq and Afghanistan. Personal equipment and accounts of the combat bring the human element into focus while displays also include a reconstruction 'FOB' (forward operating base) and, chillingly, a mock IED – the improvised explosives device that have claimed so many British soldiers. The lively museum café serves simple but good hot food and a decent cappuccino.

Greenwich Heritage Centre

- ▦ Artillery Square, Royal Arsenal, Woolwich SE18 4DX
- ☎ 020 8854 2452
- ✎ www.greenwich.gov.uk
- 🚃 Woolwich Arsenal Rail; North Greenwich LU then bus 161, 422 or 472
- 🕓 Tues-Sat 9.00-17.00
- ⏾ Admission free
- ✄ Shop
- ⬛ Refreshments
- ♿ Disabled access

What was once Greenwich Borough Museum has amalgamated with the local history archives to become the Greenwich Heritage Centre, in the process relocating to a striking 19th-century building in the heart of the Royal Arsenal. The Centre features a permanent exhibition on the history of the Royal Arsenal, charting its roles as Henry VIII's dockyard, munitions depot, stopping off place for convicts en route to Australia, and the birthplace of the Arsenal FC. For those brave souls delving into their family history, the 'Search Room' is packed with useful resources like old census returns, electoral registers and historic maps and prints. The Centre also offers guided visits around the exhibitions and collections and walking tours around the Royal Arsenal itself. A children's Saturday Club, lectures and workshops for adults are also on the cultural menu here.

The Horniman Museum & Gardens

- ▦ 100 London Road, Forest Hill, SE23 3PQ
- ☎ 020 8699 1872
- ✎ www.horniman.ac.uk
- 🚃 Forest Hill Rail, bus 176, 185, 197, 356, P4
- 🕓 Museum: Daily 10.30-17.30
 Gardens: Mon-Sat 7.30-dusk, Sun 8.00-dusk
- ⏾ Admission free
- ✄ Shop
- ⬛ Café
- ♿ Wheelchair access

Although firmly rooted in its South London community, the Horniman is much more than a purely 'local' museum. With displays embracing natural history, ethnography and a vast collection of musical instruments, this popular museum revels in its diversity – and its enthusiasm is catching.

The museum's in-house aquarium showcases a variety of endangered watery habitats, with the emphasis on conservation. Visitors can follow the journey of a river upstream from mouth to source, peer

The Horniman Museum & Gardens

into the dark waters of a flooded forest pool or wonder at the brilliance and fragility of a coral reef. In these aquatic stage sets the fish – flamboyantly costumed clown fish and stately seahorses – are consummate performers and usually have a captive audience.

A veritable menagerie of stuffed animals populate the Natural History section, centred around an enormous, somewhat elderly walrus. Old style (but none the worse for that) displays explore topics such as evolution as well as Forest Hill's own flora and fauna, making the Horniman a well-structured, local alternative to the Natural History Museum.

The Horniman is also the home of Britain's first permanent gallery dedicated to African cultures and the African-influenced cultures of the Caribbean and Brazil. 'African Worlds' brings together fine and decorative arts from as far afield as Mali and Ethiopia, Egypt and Zimbabwe, with exhibits such as Benin bronzes, huge Dogon, Nufansa and Bwa masks and religious altars from Haiti and Brazil. Beautifully presented, the artefacts are accompanied by clear, informative explanatory material. Changing exhibitions on a variety of themes are shown on the balcony gallery and there is a further gallery which displays more extensive, year-long temporary exhibitions.

147

The museum's centenary development opened in 2002 and has greatly enhanced the original building with better access and facilities, including a shop and a pleasant café overlooking the museum's elegant Victorian conservatory. Some of the treasures collected from around the world by the museum's founder, Victorian tea tycoon Frederick Horniman, can be seen in the Centenary Gallery. The gallery tracks the changing way ethnographic collections have been displayed in the museum and looks at the ongoing collecting work of the Horniman's curators with recent acquisitions from Nepal and the American Southwest. Visitors can handle some 4,000 objects from the museum's amazing collections in the 'Hands-On Base', which is open on Saturday mornings and Sunday afternoons as well as select days in school holidays for family groups (entry by ticketed session only). The Music Gallery also promises lots of hands-on action with the chance to play a selection of instruments from an African mbira to 'paddle panpipes' (played with a pair of flip-flops!). Thanks to interactive computers, visitors can also hear what some of the other instruments in this 2,000-strong collection sound like.

The Horniman's 16 acres of well-tended gardens are currently undergoing a major, multi-million pound makeover and are scheduled to re-open fully in 2012. The new gardens will boast greater diversity of plants, new activity areas and picnic spaces as well as a new Gardens Learning and community Centre.

London Sewing Machine Museum

⌨ 300 Balham High Road, SW17 7AA
☎ 020 8682 7916
✎ www.sewantique.com
🚌 Balham LU/Rail
🕓 First Sat of each month 14.00-17.00
💰 Admission free

Balham is not just the 'Gateway to the South' – since July 2000 it has also been home to this specialist museum. About 550 machines are lovingly displayed here, the focus being on domestic sewing machines dating from 1850-1885 and industrial sewing machines made between 1850-1950. Built up over 40 years by one man, Ray Rushton, the collection is one of the most extensive and best of its kind in the world. The centrepiece of the display is the unique sewing machine made for Queen Victoria's oldest daughter on the occasion of her wedding.

National Maritime Museum

- Romney Road, Greenwich, SE10 9NF
- 020 8858 4422
- www.nmm.ac.uk
- Cutty Sark DLR, Maze Hill Rail, Greenwich Rail/DLR
- Daily 10.00-17.00 (last admission 16.30); Thurs until 18.00 (Sammy Ofer wing only)
- Admission free (admission charge for some exhibitions)
- Shop
- Café & Restaurant
- Wheelchair access

National Maritime Museum

The largest maritime museum in the world, the NMM explores 500 years of salt-soaked British history, from the swashbuckling days of Drake and Raleigh through to the record-breaking yachtsmen and women of the 20th-and 21st centuries. The museum is split between two sites, with the adjacent Queen's House (see p. 152) given over to changing displays of the NMM's outstanding maritime art collection.

Attracting some 2 million visitors a year, this is one hard-working museum and its galleries are currently undergoing a major re-development that will usher in a more coherent and dynamic presentational style. The opening of the Sammy Ofer wing in summer 2011 heralded the start of the overhaul, which will see all of the museum's permanent galleries renewed or refreshed over the next five years. The sleek new wing functions as the museum's new main entrance, and houses the 'Voyagers' introductory gallery, as well as a temporary exhibition gallery, café, restaurant and shop. Dominated by a mesmerizing 'wave' sculpture onto which a loop of images and footage from the collection is projected, 'Voyagers' showcases 200 key objects to illustrate our relationship with the sea, from love tokens given by departing sailors to relics from the Titanic disaster. Visitors are also introduced to maritime personalities such as Admiral Nelson, Captain Cook, Sir John Franklin and that staple of seaside entertainment, Mr Punch. Interpretative panels have been kept deliberately skimpy here and visitors are encouraged to pick up a 'compass card' on arrival, which they can stamp at selected objects throughout the museum to retrieve follow up information in the Compass Lounge, or at home.

Moving into the 'old' museum building, on the ground floor, 'Explorers' asks what possessed people to sail off on dangerous voyages into unknown waters to all points of the compass. Spice, gold and glory is the short answer and the displays include relics from Sir John Franklin's ill-fated voyage to discover the North-West Passage in the 1840s. Another, smallish exhibition probes various aspects of 'Maritime London', such as shipping and shipbuilding, commerce and cargoes, and at the time of writing also contained a display about Nelson, which featured his blood stained, bullet-holed 'Trafalgar' coat and some of the avalanche of commemorative items which appeared after his death.

The Upper Deck overlooking the Neptune Court deploys over 400 objects from the NMM stores to represent a snapshot of the Museum's core collections. Ships' badges, ingenious navigational aides and curatorial curiosities are typical of the displays here. A small adjacent gallery – 'Your Ocean' – tackles topical sea-borne issues such as global warming, pollution and modern day piracy.

On the first floor, 'Atlantic worlds' looks at the migrations of people

and goods across this ocean between the 17th and 19th centuries, a story that includes the shameful 'triangular' trade of African slaves, West Indian sugar and American Cotton. A hippopotamus hide slave whip, neck irons, and whaling harpoons are among the grislier exhibits. The historic paintings include depictions of the Capture of Havana in 1762 and a portrait of three Elizabethan sea dogs, Cavendish, Drake and Hawkins. The Indian Ocean is the focus of 'Traders', a new permanent gallery opening on this floor in September 2011, exploring Britain's trade with Asia, through the lens of the East India company and the commodities it traded – opium and tea being the most notorious. Don't miss, tucked away in gallery 13, the stained glass windows from the Baltic Exchange, recently installed after a decade of restoration following the 1992 bomb blast which all but destroyed them. Fusing classical and religious imagery, the windows commemorate the men of the Baltic Exchange who died in WWI.

Moving up a floor, 'Oceans of Discovery' recounts the 4,000 year old story of man's endeavour to explore the sea. A replica Polynesian map using shells and sticks to denote ocean currents is one of the navigational aids shown, and considerable space is devoted to underwater exploration, from the early days of cumbersome diving suits to the snazzy remote control deep water submersibles of today.

Some of the NMM's vast model collection can be admired in 'Ships of War', which showcases beautiful model ships made in the 17^{tth} and 18th centuries. Often mind-bogglingly intricate, these miniatures are an important source of information about the ships of this period such as The *Royal George*, an 18th-century flagship, which inexplicably sank while at anchor in 1782.

The revamped 'All Hands' interactive children's area allows aspiring admirals to signal to each other using flags, morse code or two-way radio, learn what it's like to work deep underwater in total darkness or discover what Vikings ate on their 'cruises'. Equally interactive is 'The Bridge', where visitors can learn how to 'read' a hydrographic chart, bark instructions down a 'loudaphone' or attempt to bring a ferry into harbour.

Vistors over the coming years might encounter some disruption while the development plan is put into place. It should be worth it with a new permanent 'Royal Navy' exhibition, a new maritime London gallery and a new children's gallery on the cards. In the meantime, the temporary exhibition space in the Sammy Ofer wing ensures there's always something new for regular visitors – the basement space got off to a flying start with its inaugural high-tech, conceptual show 'High Arctic'. The new Brasserie, café and shop also aim to please, the latter stocking a good variety of gifts, including timepieces, telescopes and any amount of pirate paraphernalia.

The Queen's House

⊡ Greenwich, SE10 9NF

☎ 020 8858 4422

✐ www.nmm.ac.uk

🚌 Cutty Sark DLR, Maze Hill Rail, Greenwich Rail/DLR

🕒 Daily 10.00-17.00 (last entry 16.30)

💷 Admission free

♿ Wheelchair access

Built by Inigo Jones for James I's wife, Anne of Denmark, this gracious residence holds the double distinction of being the first classical building in England and the first to boast a flight of cantilevered stairs. The Queen's House now serves as an art gallery having been redesignated as the National Maritime Museum's Fine and Decorative Arts Centre. Even without their historic furnishings the rooms are impressive – the balconied Great Hall and 'tulip stairs' are the must sees here – and the NNM's art collection of mainly maritime art is also top of its league with paintings by Sir Joshua Reynolds, William Hogarth, Boudin and Turner. On the ground floor the Orangery is flanked by two galleries showing 17th and 18th century marine art by the likes of the Van de Veldes and the aptly named Isaac Sailmaker. The friendly room staff willingly share their knowledge and go out of their way to engage the visitor – a refreshing alternative to the increasingly ubiquitous audio guide.

The Queen's House

Ranger's House

⌖ Chesterfield Walk, SE10 8QX

☎ 020 8853 0035

✎ www.english-heritage.org.uk

🚌 Blackheath Rail, Cutty Sark DLR, Greenwich Rail/DLR

🕐 Sun-Wed 11.30-16.00 (April-Sept) entry by guided tours only at
 11.30 and 14.30 (pre-booking advisable)
 (Oct-Mar see website for opening hours)

💷 £6.30 (adults), £5.70 (concessions), £3.80 (under 16s),
 free (under 5s/English Heritage members)

🛍 Shop

♿ Wheelchair access to ground floor

This imposing Georgian house has recently been on the receiving end of an extensive refurbishment courtesy of English Heritage. Its once again gracious interiors have also become home to the 'Wernher Collection' – an opulent assembly of objets d'art put together by self made millionaire Sir Julius Wernher. Wernher made it big in the South African gold and diamond industries and you can certainly see where he spent his cash – the suite of 12 display rooms are stuffed with bronze statuary, medieval ivories, Old Master pictures, Renaissance jewellery, Sèvres porcelain and maiolica ceramics.

The Red Room has been kitted out as it would have been at Bath House (the Wernher's Mayfair residence). The rich ox-blood red walls are hung with Old Masters such as Memling's *Mother & Child* and *Rest on the Flight to Egypt* by Filippino Lippi, while its displays of Renaissance ivories and medallions are densely packed in 19th century connoisseur style. No labels intrude on the ambience in this room – if you want to know what you're looking at, you can refer to information sheets, housed in smart leather bound folders. If the Red Room is an exercise in masculine self-expression, the Pink Drawing Room downstairs bespeaks an altogether more feminine sensibility. This was Lady Wernher's domain and it's characterised by deeply pink wallpaper, pretty portraits of 18th-century beauties by the likes of Hoppner, Romney and Reynolds, sugary Sèvres porcelain and curvaceous French furniture.

Reminiscent of the Wallace Collection (see p. 220), albeit on a smaller scale, the collection offers a similarly revealing insight into what makes a collector tick. Its highlights include the jewellery closet which contains beautifully crafted Renaissance and Antique pieces, the 'private devotion room' (mainly Medieval items), the Limoges room (painted enamels and fine metal work) and the Green Silk Room (Dutch and English landscape paintings). The collection concludes in The Gallery, hung with 17th century French tapestries and overseen at the far end by a dazzling white marble sculpture of angels by Bergonzolli.

Royal Observatory Greenwich and Peter Harrison Planetarium

🖂 Blackheath Avenue, Greenwich, SE10 8XJ

☎ 020 8858 4422

✐ www.nmm.ac.uk

� Cutty Sark DLR, Maze Hill Rail, Greenwich Rail/DLR

🕓 Daily 10.00-17.00 (last admission 16.30)

💰 Admission free; charge applies for Flamsteed House and Meridian Courtyard: £10 (adults), £7.50 (concs), free (under 15s)

🛍 Shop

☕ Café (at the Planetarium)

♿ Wheelchair access (ring 020 8312 6608 for details)

Royal Observatory and Planetarium

A short sharp walk up the hill from the Queen's House and Maritime Museum brings you to a cluster of buildings which look more like a stable block than an observatory (although the big green 'onion' dome is a bit of a giveaway).

Straddling the meridian line (at 0 degrees longitude) and home to Greenwich Mean Time, the Observatory can claim to be 'the centre of time and space'. Visitors line up to photograph each other with one foot in the East, the other in the West. The 'Camera Obscura' is much more entertaining: a revolving panorama of Greenwich projected live

onto a table in the middle of the room. Next door, Flamsteed House contains the spartan apartments of the Astronomers Royal and the Octagon Room, a rare example of an interior by Sir Christopher Wren. Instruments for measuring time and space are also on display and include the watch that solved the navigators' problem of assessing longitude. If you get to the Observatory before 1pm, look out for the 'Time Ball' which drops at that exact time each day to enable ships on the Thames to set their chronometers.

Over in the Weller Astronomy Galleries at the Planetarium, there's no need to wish for the moon, when you can have the stars as well. Crammed with high-tech interactive gizmos, these engaging displays aim to unravel the secrets of the universe, revealing, amongst other things, why telescopes are like time machines and giving visitors the chance to build their own virtual space probe. It's mind-boggling stuff so it's good to see included among all the highfaluting quotes by Plato, Newton and their ilk, Douglas Adams' laconic observation, 'Space is big'. If you want to feel really insignificant, buy a ticket (£6.50 adults, £4.50 children) to one of highly enjoyable shows in the Planetarium to follow the birth and life of a star and for guidance from a real astronomer on what to see in the sky that night.

Southside House

3-4 Woodhayes Road, Wimbledon Common, SW19 4RJ
020 8946 7643
www.southsidehouse.com
Wimbledon LU/Rail
Visits by guided tour only: Wed, Sat, Sun and Bank Holidays 14.00, 15.00, 16.00 (Easter to Oct)
£5 (adults), £2.50 (children), £10 (family), £4 (student))
Wheelchair access – please phone in advance

Anybody who is anybody seems to have featured in the colourful history of Southside House: Lord Byron, Emma Hamilton, and Axel Munthe are just some of the names associated with the house, built in the Dutch Baroque style by Robert Pennington in 1687. Its contents are equally well-connected and include souvenirs of two beheaded queens (Anne Boleyn's vanity case and Marie Antoinette's pearl necklace) as well as portraits by Van Dyck, Hogarth and Angelica Kauffmann. Following a potentially disastrous fire in November 2010, Southside House has undergone a major restoration and conservation project and reopened to the public in November 2011. One unexpected consequence of the fire was the discovery of a secret basement room and a cache of WWII weapons, hidden there by war hero and SOE operative, Malcolm Munthe.

Wandsworth Museum

🖼 38 West Hill, SW18 1RZ
☎ 020 8870 6060
✎ www.wandsworthmuseum.co.uk
🚌 Wandsworth Town Rail (then 10 min walk);
 East Putney LU (then 10 min walk)
🕐 Tues-Sun 10.00-17.00
🕐 £4 (adults), £3 (concs), free (under 5's)
☕ Café
♿ Wheelchair access

William Brodrick of Wandsworth

Once a museum has closed, it's not often that it reopens but Wandsworth Museum is a refreshing exception to the rule. This popular council-run local institution closed in 2007 due to lack of funds but has risen, phoenix like from the ashes, reopening in 2010 thanks to a £2million donation from Wandsworth resident (and hedge fund boss) Michael Hintze.

Now run as a private charity, the museum occupies the former West Hill library/De Morgan Centre site and its newly kitted out permanent gallery reveals the 'undiscovered country' of Wandsworth, its landscape and cultural development, as well as its human story. The borough has seemingly long been a magnet for the movers and shakers of this world – from the Celtic chieftan who chucked his best shield into the Thames as a gift to the river god to William Brodrick, the nattily dressed 'Court Embroiderer to James I' and poet-novelist Thomas Hardy, who lived in the area in the 1870s. Even the wildlife was upscale around these parts, if the woolly rhino skull and mammoth tooth on display are anything to go by.

Invigorating temporary exhibitions complement the permanent displays while refreshment of a different sort can be located in the Longstaff Café, which itself houses a fully fitted out 1900's chemist's shop. The new incarnation of Wandsworth Museum has already made a positive impact – the first museum in the world to be lit entirely by LEDs, it was the recipient of a Green Tourism Award in 2011.

The Wimbledon Lawn Tennis Museum

Museum Building, The All England Lawn Tennis Club,
Church Road, SW19 5AE

020 8946 2244

http://aeltc.wimbledon.com

Wimbledon LU/Rail then bus 493, Southfields LU then 15mins
walk or bus 493

Daily 10.00-17.00 (last entry 16.30) (during the Championships
open only to those visiting the tournament)

£11 (adults), £9.50 (concessions), £6.75 (children)

Shop

Café

Wheelchair access

It's hard to believe it now, but lawn tennis was once just a glorified garden party game, rejoicing in the preposterous brand name of 'Sphairistiké'. This museum, based at the famous All England Lawn Tennis Club, follows the development of the sport from its monastic origins to genteel Edwardian pastime to mega-bucks international industry – all thanks to the invention of the lawn mower and the bouncy rubber ball. Naturally the museum also celebrates the unique sporting event that is the Wimbledon Championships and, thanks to a recent relocation and redesign, displays are top-notch with plenty to enjoy, whether you're a die-hard tennis nut or a casual armchair aficionado.

Tableaux recreate the early days of tennis – from the quaint 1920's Gentlemen's Dressing room to a 1930's racquet makers' workshop complete with woodshavings – while comprehensive displays of tennis equipment show how the game evolved into today's hi-speed, hi-tech sport. Interactive consoles allow visitors to test their response time in the face of a 150 mph serve, interview the head groundsman or try their hand at a traditional Wimbledon pastime – pulling the rain covers over the court. Touchscreens show footage of tennis stars past and present in action, providing the opportunity to see just how leisurely the game seemed in the days of René Lacoste, 'Bunny' Austen and Fred Perry – the last British player to win the men's singles. Footage of Wimbledon television coverage over the decades is also nostalgic fun with no shortage of net-leaping, trophy-kissing finals action.

Tennis has always been about looking the part and the on-court fashions shown here range from full-length white cotton dresses to a gold lamé micro-mini worn by our very own Sue Barker, Roger Federer's natty white blazer kit and a bodyhugging Lycra 'corset' dress designed for Venus Williams. One of the highlights of the museum is the 'Pepper's Ghost' illusion of John McEnroe, talking about the heroes of men's tennis and his Wimbledon years in a recreation of the 1980's locker room he once

used. The pressures and rewards of today's 'Circuit' are also explored while the science of playing tennis is explained in the 200° Cinema.

Wimbledon's glittering prizes – the Ladies' Singles salver and Mens' Singles cup – are among the closing exhibits, along with a display about the most recent Championships. Tennis themed souvenirs and equipment are the order of the day in the shop and the well-appointed Wingfield café serves light lunches and traditional cream teas.

The Wimbledon Society Museum of Local History

⌕ 22 Ridgway, SW19 4QN
☎ 020 8296 9914
✐ www.wimbledonmuseum.org.uk
🚆 Wimbledon LU/Rail
🕓 Sat and Sun 14.30-17.00 (at other times by appointment)
💰 Admission free
🛍 Shop

Famous today for its international tennis tournament (see previous page), Wimbledon has not always been the haunt of white clad tennis pros. Neanderthal hunters once prowled its open spaces and in Victorian times Wimbledon became the venue for popular rifle shooting competitions. There must be something competitive in the air because it was here too in 1798 that the Prime Minister William Pitt fought a pistol duel. These and other aspects of Wimbledon's 3,000 year long history are recounted at this small local museum, which boasts an extensive archive of paintings, prints, objects, maps and manuscripts.

Wimbledon Windmill Museum

⌕ Windmill Road, Wimbledon Common, SW19
☎ 020 8947 2825
✐ www.wimbledonwindmill.museum.org
🚆 Putney LU (then bus); Wimbledon LU/Rail
🕓 Sat 14.00-17.00, Sun and Bank Holidays 11.00-17.00 (April-Oct)
💰 £1 (adults), 50p (children/concessions)
🛍 Shop
🍴 Café
♿ Wheelchair access (ground floor only)

What better place to tell the story of windmills and windmilling than in a windmill itself? Working models, original machinery as well as films, bring the narrative to life, revealing the development of windmills from ancient Persia to modern wind farms. There are hands-on activities for young millers but if it's all too much of a grind, the café's just next door.

East

Dennis Severs House

- 18 Folgate Street, E1 6BX
- 020 7247 4013
- www.dennissevershouse.co.uk
- Liverpool Street LU
- 18.00-21.00 every Monday evening, by candlelight, booking required; Sun 12.00-16.00 No booking required; Mon (on Mons following the 1st and 3rd Suns) 12.00-14.00, no Booking required
- £12 (Mon evening openings), £8 (Sun openings), £5 (Mon openings)
- No disabled access

Dennis Severs House

Dennis Severs House is a real one-off – neither museum nor historic house it is perhaps best approached as piece of unique installation art. Created by Dennis Severs, an Anglophile Californian who died in 1999, the house is an 18th-century terraced dwelling whose candlelit rooms have been furnished and arranged as a series of atmospheric period 'still-life dramas', in which the visitor travels through the picture frame into the painting itself. Mr Severs had strong views about how his creation should be experienced, reminders of which are dotted around the house; visitors are expected to be seen but not heard and a very museum-like approach to looking but not *touching* is enforced. Talkative, tactile folk may find this constricting but restraint is worthwhile – it's hard for the magic to come alive if all you can hear is inane chatter. In the old days Mr Severs would summarily eject visitors who transgressed in this way.

The conceit is that the house is still lived in by a family of Huguenot silk weavers, and going around the house the visitor continually enters rooms they have apparently just left. Subtle recorded sound effects and authentic touches such as brimming bedside chamber pots, unmade beds and half-eaten meals help create the Marie Celeste effect but the house remains an engagingly leaky time capsule. Period pedants may disapprove but playful anachronisms abound, including poignant reminders of Mr Severs' own occupancy – a NY Yankees baseball jacket draped over the back of a chair, a pair of highly polished English gent's shoes tucked away in a bedroom. The house evokes several time periods, following successive generations of the Jervis family on a picaresque journey from genteel Hanoverian prosperity to the Dickensian hard times evoked by the squalid top floor garret. Taking the idea of painterly drama even further the 'smoking room' recreates the debauched interior of Hogarth's painting *A Midnight Modern Conversation* – x marks the spot on the floor where the visitor is invited to stand to become part of the painting.

Severs' motto was 'You either see it or you don't', and for those willing to suspend disbelief the experience he created is captivating – but don't forget to keep the noise down ...

The Geffrye Museum

⌖ Kingsland Road, E2 8EA

☎ 020 7739 9893

☎ 020 7739 8543 (recorded information)

✎ www.geffrye-museum.org.uk

🚌 Hoxton London Overground; Dalston Kingsland Rail; Liverpool Street LU/BR, then 149 or 242 bus; Old Street LU, then 243 bus or 15 mins walk

🕓 Museum open Tues-Sat 10.00-17.00, Sun & Bank Holidays 12.00-17.00; Almshouse (visit by guided tour only) see website for details

💷 Admission to museum free; Admission to almshouse £2.50 (adults)

🛍 Shop

🍽 Restaurant

♿ Wheelchair access

Set in 18th-century almshouses, the Geffrye is one of London's most charismatic museums, offering visitors a chance to 'go through the keyhole' to explore the changing face of English middle-class interior decoration. From the oak-panelled simplicity of the 17th-century hall to the coolly elegant early Georgian parlour, from the oppressively cluttered Victorian sitting room to the jazzy art deco apartment and funky contemporary warehouse 'loft', the museum's fully furnished period rooms present a walk-through source book of past taste. Preliminary overviews put the rooms in the context of the whole house and show not just how they looked but how people lived in them, revealing for example how 18th-century 'politeness' determined not just your decor but also how you behaved, walked and dressed.

In December the period rooms are decorated in appropriately festive fig, while in the summer months the walled herb garden and period garden 'rooms' are an added attraction, neatly echoing the aesthetics of their indoor counterparts. If you get the chance, don't miss a guided tour of Almshouse 14, which features two restored and furnished period rooms showing how alms people lived there in 1780 and 1880 respectively. These small but pleasantly proportioned rooms

make a telling contrast to the museum's resolute focus on the lives of the 'middling sort' and the simple wooden bed in the 18th-century room is a rare example of the cheaply made chattels of the poor. The good quality brass bedstead of the 1880s room meanwhile reflects the rising status of the folk living at the almshouse, which by this period catered to the 'genteel poor' such as governesses, who were often left homeless when they retired.

The story of the founding of the almshouse is fascinating too – the result of a bequest to the Ironmongers' Company by Sir Robert Geffrye, a Cornishman who made good in the City and ended up mayor of London. It's hard to imagine that when the almshouses were built, Shoreditch was famous for its market gardens and salubrious fresh air. By the time the residents were moved out to new quarters in the early 20th century the area had become part of the overcrowded inner city, with furniture being the pre-eminent local industry (hence the museum's focus on furnishings).

A smart extension to the museum opened in 1998 and incorporates a venue for temporary exhibitions, as well as housing a well-stocked shop, stylish café and a Design Centre for contemporary design and craft. A gem.

Hackney Museum

Technology & Learning Centre, 1 Reading Lane, E8 1GQ
020 8356 3500
www.hackney.gov.uk
Hackney Central Rail
Tues, Wed, Fri 9.30-17.30; Thurs 9.30-20.00, Sat 10.00-17.00
Admission free
Shop
Wheelchair access

This community museum explores the reasons why people have flocked to Hackney over the last 1,000 years. Its permanent displays include a very rare Anglo-Saxon log boat, a Victorian nursery-cum-contemporary flat and oral histories from people living in the area, interspersed with sculptures by local schoolchildren. Regularly changing temporary displays explore aspects of local history and the museum also runs a vibrant programme of events and activities. Installed in the smart modern premises of the Technology and Learning Centre, the museum has attracted rave reviews from the museum press and has proved a real hit with families, older visitors and those notoriously difficult to please folk, teenagers.

Museum of London Docklands

⌦ No. 1 Warehouse, West India Quay, Hertsmere Road, E14 4AL

☏ 020 7001 9844

✐ www.museumoflondon.org.uk/docklands

🚌 West India Quay DLR, Canary Wharf LU;
Bus 227, D3, D6, D7, D8, 115

🕓 Daily 10.00-18.00 (last admission 17.30)

🎫 Admission Free

🛍 Shop

☕ Café

♿ Wheelchair access

Woefully underused today, the river Thames permeates almost every aspect of London's history. This museum tells the story of London's river, ports and people and their role in shaping the city. An outpost of the Museum of London (p. 58) the setting for this enterprise couldn't be more appropriate: an early 19th century warehouse at West India Quay, in the heart of Docklands and in the shadow of the glittering skyscrapers that dominate Canary Wharf.

Visits start on the third floor and work down but before you get stuck in, a word of warning. The museum tackles a huge subject and is packed with things to see and enjoy – archaeological finds, historical documents, model ships (such as the remarkably difficult to launch *HMS Northumberland*) and artworks. You'll certainly need to pace yourself if you want to do it in one go, but free admission means you can return as often as you like and explore at your leisure.

London was a successful port from the word go and the museum's opening display charts the relentless comings and goings on 'the Thames Highway'. Roman *Londinium* became Anglo Saxon *Lundenwic* which in turn gave way to the 3rd century port of *Lundenburgh* and not even Boudicca or Viking marauders could dent London's pre-eminence. An audio visual presentation by Time Team's Tony Robinson sets out the whole sequence of events very clearly and boasts some neat interactives encouraging younger visitors to 'dig deeper' and find out what archaeologists really get up to. Archaeology has been crucial in shaping our understanding of London's long lost early ports and discoveries such as Roman pottery, Anglo Saxon loom weights and a Viking battle axe bring this history to life. Another highlight is a magnificent double sided model of old London Bridge showing the bridge in Medieval and Tudor times respectively. Other displays look at trade expansion and the rise of the merchant class and there's the first of the reconstructed interiors which are such a feature of the museum, this one being of a 'legal quay' from the 1790's, complete with a human treadmill crane, a counting house and a gibbet.

Still on the third floor, a new gallery (opened 2007) tells the ignoble story of London's part in the slave trade and the sugar industry from the 1700s onwards. The museum's location in the West India Docks – the construction of which was financed by London's sugar barons and which were used by slave trading ships – brings the subject painfully home. Portraits of wealthy merchants such as George Hibbert are displayed alongside the brutal instruments of slavery as well as the product which drove the trade: a sugar loaf. Slavery in Britain was finally abolished in 1833 but the repercussions continue to be felt, and the gallery brings the story up to date with contemporary artworks exploring the subject while headphones allow visitors to listen to the stories of colonial subjects in postwar London.

Moving down a floor, 'City and River' looks at the Thames in the Regency period and its role as a whaling and coal port, and the emergence of the docks. It wasn't all hard graft though as the displays highlighting the colourful rituals associated with the river show – watermen's races and barge processions involving opulent City Barges.

'Sailor Town' is an enjoyable, faintly spooky, reconstruction of the East End in the 19th century. Visitors walk down dimly lit cobbled alleyways flanked by a pub, a lodging house and shops dealing in everything from prints to wild animals. Other reconstructed interiors such as the bottling vault and tobacco weighing station recall when London truly was 'the Warehouse of the World' – the goods once handled at North Quay's warehouses ranged from almonds to tulipwood, along with pepper, rice, rum, tea, tin and teak.

All this relentless trading was fuelled by raw manpower – as the number of ship builders', dockers', stevedores' and porters' tools on display powerfully demonstrate. Not for nothing was the quayside outside the museum known as 'Blood Alley' from the damaged hands and backs of dockers who lugged commodities from dockside to warehouse. Life in the docks was tough and there's a section devoted to the 1889 Dock Strike in which visitors can 'interview' participants on both sides of this bitter dispute.

Things got even tougher during the Second World War when the Docklands became a target for Nazi bombers. Film footage showing the devastation wreaked on 'black Saturday' still has the power to move and shock, as do a series of original canvases by war artist William Ware. The wartime exhibits include a claustrophobic 'consul' air raid shelter and a mobile canteen and reveal some of the secret work carried out in Docklands, such as the development of 'Pluto' – the pipeline which carried fuel under the Channel to Allied troops in France. An area of quiet contemplation with stained glass panels by artist John Patsalides is a reminder that for some people this perilous time is not just history, it is part of their lives.

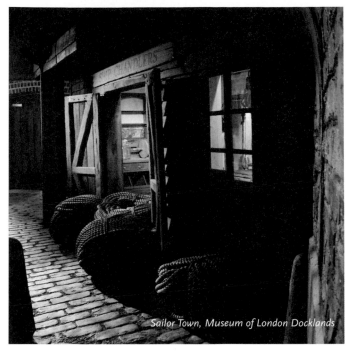

Sailor Town, Museum of London Docklands

Before you get too carried away on a high tide of nostalgia the museum turns its scrutiny to the recent regeneration of the docklands after years of what seemed terminal decline. This chapter of London's history was not without its turbulent moments either and features the controversial London Docklands Development Corporation, yuppies, the Wapping newspaper dispute, as well as major engineering feats such as the Millennium Bridge and the Jubilee line extension.

On your way down to the ground floor, the mezzanine 'Sainsbury Study Centre', contains the Museum in Docklands and the PLA Archives as well as the Sainsbury Archive. On display are photographs of early Sainsbury stores and examples of Sainsbury's own brand packaging. The 'Mudlarks Gallery' on the ground floor lets the under 12s engage in educational fun activities such as 'tipping the clipper', tying nautical knots, and getting to grips with block and tackle technology. There's plenty of nick-nacks in the museum shop as well as books about London and the Thames. The café serves a simple menu and a decent cappuccino while the new bar-restaurant 'Rum and Sugar' offers classic British dishes in heritage styled surroundings.

Museum of Immigration and Diversity

- 19 Princelet Street, E1 6QH
- 020 7247 5352
- www.19princeletstreet.org.uk
- Liverpool Street LU/Rail, Aldgate East LU
- Scheduled days only – see website or phone for details; for group visits, book in advance
- Admission free (donations appreciated)
- Wheelchair Access – ground floor only

Based in a battered, unaltered 18th-century house, this multicultural museum celebrates diversity and is the first of its kind in Europe. From Huguenot silk weavers' (whose garrets can still be glimpsed on the top floor) to 19th-century Jewish settlers from Eastern Europe who built their own synagogue in the garden, the house is a witness to the waves of immigrants who have made their home in this part of London. A site specific exhibition 'Suitcases and Sanctuary' explores the continuing history of immigration to Spitalfields to the present day, through the eyes of children living in the area today. The fragile condition of the house means that the museum can currently only open a few days a year. Despite the limited opening hours, a shortage of funding and the fact that it is run by volunteers, thousands of people every year visit 19 Princelet Street – an indication of the resounding relevance and popularity of this 'museum of conscience'.

The Ragged School Museum

- 46-50 Copperfield Road, E3 4RR
- 020 8980 6405
- www.raggedschoolmuseum.org.uk
- Mile End LU
- Wed and Thurs 10.00-17.00, first Sunday of the month 14.00-17.00
- Admission free (donations appreciated)
- Shop
- Wheelchair access (ground floor only)

Staffed by enthusiastic, friendly volunteers and set in an old canalside warehouse, this is a charismatic little museum. The site of London's largest Ragged (free) School, the museum focuses on the work of Dr Barnardo and education in London but its displays also explore the lives and history of East Enders over the last two centuries. Many of the volunteers are locals and they help to bring the past to life in a memorable way.

Decked out in the cream and maroon livery specified by Dr Barnardo and furnished with wooden desks, writing slates, abacus and 'butterfly' blackboard, the reconstructed 1880s schoolroom makes

an atmospheric centre piece. Each year thousands of primary school children take part in the popular re-enacted 'Victorian' lessons held here. On the first Sunday of the month lessons are open to everyone, whatever their age. There is also a reconstructed domestic kitchen, kitted out as it would have been in 1900, and complete with utensils for visitors to handle. The museum shop stocks local history publications as well as a selection of traditional-style toys and games.

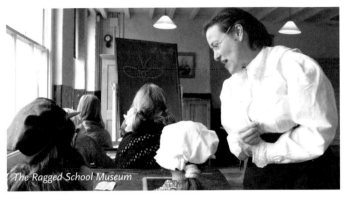
The Ragged School Museum

Royal London Hospital Museum

- St Philip's Church, Newark Street, E1 2AA
- 020 7377 7608
- www.bartsandthelondon.nhs.uk
- Whitechapel LU
- Tues-Fri 10.00-16.30
- Admission free (donations welcome)
- Shop
- Wheelchair access

Located in the crypt of the former Hospital Church, this museum has an interesting selection of historic documents, medical equipment and nurses' uniforms as well as original artworks by William Hogarth and Sir John Lavery. The displays recount the history of the hospital from its founding in 1740 and highlight some of the medical developments it has witnessed like x-rays and keyhole surgery, and the work of pioneers like Frederick Treves and Edith Cavell. There's also a small display about the hospital's most famous resident, Joseph Merrick (the 'Elephant Man') and a showcase on forensic medicine which includes original material relating to the Jack the Ripper murders and the London Hospital surgeon who helped investigate the case. Books and cards are sold at the shop and a digital video facility is available to visitors.

Sutton House

2 and 4 Homerton High Street, (corner of Isabella Road), E9 6JQ

☎ 020 8986 2264

🖉 www.nationaltrust.org.uk

🚌 Hackney Central Rail, Homerton Rail

🕐 See website as opening times vary according to season

💷 £3 (adults), £1 (children), £6.90 (family ticket), free (NT members)

🛍 Shop

☕ Café

♿ Disabled access ground floor only

Tudor houses aren't exactly ten a penny in the capital these days and Sutton House is a rare survivor. Built in 1535, it is in fact the oldest domestic building in the East End and its occupants have included Henry VIII's Secretary of State, Sir Ralph Sadleir, squatters in the 1980s, and its current owners, the National Trust. Although on the receiving end of later additions and alterations, the house still contains early features like linenfold panelling, stone fireplaces and 17th-century wall paintings. Hinged panels dotted throughout the house enable visitors to literally peel back the layers of history and see changes made to the fabric of the house for themselves. Located in Hackney, one of London's most arty boroughs, the house also has a gallery which hosts exhibitions of work by local artists. But if contemporary art isn't your bag, the small gift shop sells the usual array of National Trust tea towels, mugs and preserves as well as a selection of books about London history. The licensed café serves delicious light lunches and teas.

V&A Museum of Childhood

Cambridge Heath Road, E2 9PA

☎ 020 8983 5200 (switchboard)

🖉 www.vam.ac.uk/moc

🚌 Bethnal Green LU, bus D6, 106, 253, 309, 388

🕐 Daily 10.00-17.45 (last admission 17.30)

💷 Admission free

🛍 Shop

☕ Café

♿ Wheelchair access

You don't have to have a sprog in tow to enjoy this museum. If anything, its vast hoard of toys from different eras makes it just as appealing for nostalgic adults. With a fine collection of children's clothes and paraphernalia like high-chairs and prams, the museum also illustrates the social history of childhood – but few will be able to resist embarking on a quest to rediscover the toys and games of their youth.

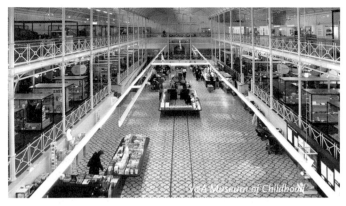

V&A Museum of Childhood

The museum re-opened in 2006 after a major redevelopment which saw its airy Victorian cast iron interior restored and a welcome upgrade to visitor facilities, including a chunky new entrance lobby and better toilets. Once inside, the permanent displays are divided into three main galleries: moving Toys, Creativity and Childhood but there's no particular route to follow – just start with whatever takes your fancy and follow the 'road signs' that point the way. If you are visiting with youngsters, there are ample opportunities for participation – be it messing around in the sandpit or a ride on the ever popular rocking horses.

Up on the first floor the Childhood Galleries get off to a positive start with 'Good Times' – party games like pin the tail on the donkey, an authentic 'Punch and Judy' booth and seaside accoutrements from saggy hand-knitted bathing costumes to vintage buckets and spades. More toys and games follow – the plethora of scaled down tool kits, lawnmowers and kitchens richly bearing out Roland Barthes' assertion that toys are a microcosm of the adult world.

The collection of children's clothing begins in the 18th century, when children were dressed as mini adults, and runs right up to the present day, on the way revealing how 'Lucy Locket,' of nursery rhyme fame, could have lost her pocket. Pride of place on this floor though must go to the dolls houses, executed in every possible permutation of architectural style and degree of grandeur: from the lavishly furnished Nuremburg House of 1673 (the oldest in the museum) to Betty Pinney's House, complete with lift and roof garden. The multicoloured 2001 Kaleidoscope House brings this section right up to date – perfect for today's brand-savvy youngsters.

Plenty of space too has been given over the museum's extensive collection of puppets from around the world, the centrepiece of which is an 18th-century marionette theatre and its *commedia dell'arte* puppets.

The theme of animation continues with the display of 'moving toys'. Every form of propulsion is represented here from simple pull-along toys (although this category does include an avant garde beach buggy by Modernist designer Gerrit Thomas Rietveld), wind powered yachts, battery driven cars, wind-up tin toys, and self propelled items like rocking horses and space hoppers. The extensive Hornby train layout however is powered exclusively by 20p pieces. A large collection of eye-bending optical toys completes this section – from zoetropes to space invaders.

As you might expect, the museum is very child-friendly. The open plan galleries are spacious and well laid out and a team of activity assistants run daily drop in art and craft, story telling, games and puppet sessions for children. Temporary exhibitions – often with a visual arts theme – add an extra layer of enticement, with past shows exploring the 'Stuff of Nightmares' and the work of 'Mog' creator Judith Kerr. The toilets are equipped for nappy-changing and the new lobby incorporates a capacious buggy park. The centrally placed ground floor café offers a kids' menu as well as tempting coffee and cakes – if you don't mind being surrounded by wailing infants. Over by the entrance the shop sells a selection of reasonably priced toys and books, many with a retro flavour and a sure hit with visitors of all ages.

Vestry House Museum

- 🏛 Vestry Road, E17 9NH
- ☎ 020 8496 4291
- 🖰 www.walthamforest.gov.uk
- 🚇 Walthamstow Central LU/Rail
- ◷ Wed-Sun 10.00-17.00
- 🐸 Admission free (donations welcomed)
- 🛍 Shop
- ♿ Wheelchair access (ground floor, garden and toilets only)

An exploration of the history of Waltham Forest and its people. Locally-made produce on show ranges from tin plate toys to the star exhibit, the Bremer car of 1894 – the first petrol driven British automobile. The Victorian parlour may be a reconstruction, but the police cell is the real thing and although built in 1840, still has its original privy intact. Examples of clothing from the 18th to the 20th-century can be seen in the Costume Gallery, which also contains some fine 16th-century panelling from the now demolished Essex Hall. Outside, the large garden is inspired by Vestry House's earlier role as a workhouse and is stocked with plants that would have been known to its inmates. The museum also houses Waltham Forest Archives, Local Studies Library and Photographic Collection (access by prior appointment only). The community room in the garden can be hired for functions.

William Morris Gallery

Lloyd Park, Forest Road, E17 4PP

020 8496 4290

www.walthamforest.gov.uk

Walthamstow Central LU or Blackhorse Road LU then bus 123; the museum is closed for redevelopment until July 2012

Admission free

Shop

Wheelchair access (ground floor)

Tea Room

Designer, craftsman, writer, socialist and entrepreneur, William Morris is revered today as the founding father of the Arts and Crafts Movement. He lived in this gracious Georgian house from his teens to his early twenties and since 1950 it has been a gallery housing a world-class collection of Morris' work – everything from glowing stained glass panels to stoutly rustic furniture and his signature nature-themed textiles and wallpapers. Among the treasures is a copy of the Kelmscott Chaucer, the crowning achievement of the Kelmscott Press (see entry for the Kelmscott House Museum, p. 137) and personal artefacts such as the canvas satchel in which Morris carried socialist literature to political rallies around the country.

The William Morris Gallery is currently closed while it undergoes a major development project, and is scheduled to re-open in July 2012. When the new gallery opens it will be able to show more of the collection, and will feature displays exploring Morris' early life in Walthamstow and university days at Oxford and a new gallery devoted to the diverse influences that inspired his work as a poet. Hands-on interactives will be a feature of the displays, introducing visitors to the labour-intensive, traditional craft techniques used by Morris and Co. Temporary exhibitions and changing displays of items from the Gallery's Arts and Crafts Collection will supplement the permanent displays. There will also be regularly updated displays of paintings and prints from the Gallery's collection of works by Sir Frank Brangwyn RA, who started his career working at Morris & Co.

Outskirts

Bethlem Royal Hospital Archives & Museum

⌖ Monks Orchard Road, Beckenham BR3 3BX

☏ 020 3228 4307 / 4227

✎ www.bethlemheritage.org.uk

🚃 Eden Park Rail, East Croydon Rail

🕑 Mon-Fri 09.30-16.30 (and selected Saturdays in the summer – see website)

♨ Admission free (donations welcome)

♿ Wheelchair access

This museum houses a distinguished collection of paintings and drawings by artists who have suffered from mental disorder. Space limitations mean that the display is small but well chosen and includes work by Richard Dadd (some of whose work is also at Tate Britain, see p. 214) and 'the man who drew cats', Louis Wain. The museum holds one of the best, and still growing, collections of Richard Dadd's watercolours as well as the only substantial collection of work by Jonathan Martin (who tried to burn down York Minster in 1829). The famous statues of *Raving and Melancholy Madness* from the gates of 17th-century Bedlam are part of the museum's historical collections. The archives document the history of Bethlem Royal, the Maudsley and Warlingham Park Hospitals and are open by appointment only. The complete art collection (see Bethlem Gallery p.232) and the archives catalogue can now be viewed on line.

Bourne Hall Museum

⌖ Spring Street, Ewell, Surrey KT17 1UF

☏ 020 8394 1734

✎ www.epsom.townpage.co.uk

🚃 Ewell West Rail

🕑 Mon-Sat 9.00-17.00

♨ Admission free

🛍 Shop

☕ Café

♿ Wheelchair access

Bourne Hall is the local history museum for the Borough of Epsom and Ewell, and is housed, not as its rather grand name suggests in an old mansion, but a circular 1960s building, topped by a transparent dome. There's plenty of local history for the museum to explore – Henry VIII's 'Nonsuch Palace' was nearby and Epsom Common was the site of the first English spa. Perhaps Epsom's greatest claim to fame though is

as the venue for the Derby, held here since 1780 and one of the world's most famous horse races. The museum duly obliges with changing displays of Derby memorabilia, jockeys' silks and lightweight racing saddles. Larger exhibits include a hansom cab used by Prime Minister, Lord Roseby, and a primitive fire engine. Displays are continually changing, and there is always an art exhibition on show.-

The Crossness Engines

🏛 The Old Works, Crossness S.T.W.,
 Belvedere Road, Abbey Wood, SE2 9AQ

☎ 020 8311 3711

🖱 www.crossness.org.uk

🚌 Abbey Wood LU (2 miles)

🕒 Selected 'Steaming' days only while restoration work is ongoing
 – see website for details

💷 £5 (adults), free (under 16s), £5 (steam days)

🛍 Shop

♿ Wheelchair access (limited)

You name it – somewhere, somehow there's a museum about it. This Victorian sewage pumping station, built by Sir Joseph Bazalgette in the 1860s, is no exception. Part of the vast sewer system that bought sanitation to London in the last century, the works contain four massive beam engines, capable in their day of raising 6,237 litres of effluent at a stroke. One of these monsters has been completely restored by a team of dedicated volunteers and can be seen 'in steam' about 5 times a year. If you think that's impressive, the building itself is a rare example of a Grade I listed industrial building that features some exuberant Romanesque style cast-iron work. The in-house Museum of Sanitation Engineering History contains decorative examples of Victorian and Edwardian toilet pans.

Following a Heritage Lottery Award, the Trust is now embarking on a major programme of work that will see the creation of a new access road; repair of the fabric of the core buildings and the creation of new visitor and exhibition facilities. The site is scheduled to reopen officially to the public in 2012.

Danson House

museums | outskirts

- Danson Park, Danson Road, Bexley, Kent, DA6 8HL
- 01322 526574
- www.dansonhouse.org.uk
- Bexleyheath Station (then 15 minutes walk)
- Wed, Thurs, Sun & Bank Hols 11.00-17.00 (April-October); also Tues in June, July and Aug
- £6 (adults), £5 (concs), free (accompanied children in family groups)
- Wheelchair access (principle floor & bedroom level)
- Shop
- Café

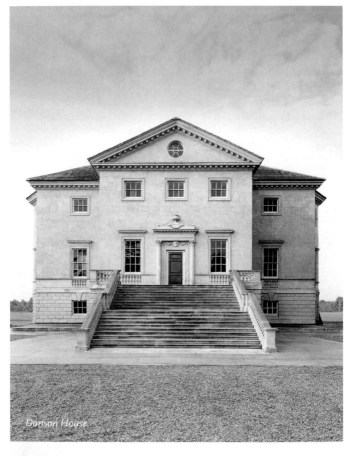

Danson House.

A 'gorgeous Georgian' gem of a villa , Danson House was built for city merchant Sir John Boyd in 1766, and designed by architect Sir Robert Taylor, with later alterations by Sir William Chambers. Its beautiful Palladian proportions and fine interiors however were not proof against the neglect of subsequent generations and by the 1990s the house was seriously 'at risk'. It was rescued from ruin by English Heritage, who purchased the lease and implemented an award winning restoration project. Danson House re-opened to the public in 2005 and today is managed by the Bexley Heritage Trust (who also run nearby Hall Place, see p.178).

Arranged around a central, sinuous elliptical staircase, Danson's principle rooms were purpose built for entertaining with a suite of stylish rooms in a décor that enthusiastically referenced classical antiquity. The dining room has been re-hung with its restored 18th-century wall paintings while the library retains its original George England organ – still working and used for recitals. The bedroom floor contains displays relating to the house and its inhabitants over the years, while the lower floor contains a licensed tea room.

Dorich House Museum

Kingston Vale, SW15 3RN

020 8417 5515

www.dorichhousemuseum.org.uk

Kingston Rail then bus 85, K3

Monthly Open Days 11.00-17.00 (see website for details)

£4 (adults), £3 (cons)

This imposing Modernist house was the home of Russian sculptress Dora Nadine and her diplomat/collector husband The Hon. Richard Hare. Designed by the couple in 1936, the house and its collections were bequeathed to Kingston University on Nadine's death in 1991, and a major restoration programme was undertaken to bring the house back from dereliction. Now restored to its former glory and open on selected days, the house holds an important collection of Dora Nadine's sculpture and associated drawings, as well as the collection of Russian Imperial art (including paintings, icons, porcelain, glass, lacquer work, metal work and furniture) amassed by the couple. Austere on the outside, the house has elegant, often Chinese influenced interiors and includes Dora Nadine's sculpture studio, a light-filled gallery as well as living space.

Down House

- Luxted Road, Down, Kent, BR6 7JT
- 01689 859119
- www.english-heritage.org.uk
- Orpington Rail, Bromley South Rail
- Gardens: Wed-Sun 10.00-17.00 (April-June), Daily 10.00-18.00 (July-Aug)
 House: Wed-Sun 11.00-17.00 (April-June), Daily 11.00-17.00 (July/Aug) – check website or telephone for admission times as these change yearly
- £9.90 (adult), £8.90 (concessions), £5.90 (children), £25.70 (family), free (under 5s/English Heritage members)
- Shop
- Café
- Wheelchair access

Darwin's Study

Originally built as a farmhouse in the 18th century, Down House became the home of scientist Charles Darwin in 1842. It was here that he wrote *On the Origin of Species by Means of Natural Selection*, a controversial book which became one of the defining documents of the Victorian era.

The house remains much as it did in Darwin's day and the ground floor rooms, including Darwin's book-filled study, have been returned to their 1870s appearance. One of the key exhibits is Darwin's huge journal of his epic 5-year voyage on *HMS Beagle* and a replica of his cabin on the ship; other treasures include his data-gathering instruments and mementos from his travels. Evidently a man able to take a joke against himself, Darwin kept the *Punch* cartoons and *Vanity Fair* caricatures which mocked his ideas and are also on display.

An interactive exhibition helps visitors get to grips with the theory of evolution while out in the restored Victorian gardens they can literally follow in the great man's footsteps by walking along the 'thinking path' he trod daily.

Forty Hall Museum

Forty Hill, Enfield EN2 9HA

020 8363 8196

www.enfield.gov.uk/fortyhall

Gordon Hill Rail, Turkey Street Rail

re-opening 2012 – see website for opening times

Admission free

Café

Wheelchair access (ground floor only)

This handsome, red brick, grade 1 listed mansion was built in the 17th century for Sir Nicholas Rainton, haberdasher, puritan, philanthropist and Lord Mayor of London. Today it is owned by Enfield Council and, courtesy of a Heritage Lottery fund award, is currently being refurbished. When it re-opens in 2012 its historic interiors will have been restored and will play host to exhibitions, events and 'activities', along with displays interpreting the hall's history.

The hall is surrounded by pleasant informal and formal gardens and a 264-acre estate composed of parkland and a working farm. The grounds are notable for containing the archaeological remains of Elsyng Palace – a one time hunting lodge frequented by various members of the Tudor royal family.

Garrick's Temple and Lawn

Hampton Court Road, Hampton TW12

020 8831 6000

www.garrickstemple.org.uk

Hampton Court Rail (then bus), Hampton (then bus)

Temple open Sun 14.00-17.00 April-Oct, Lawn open daily dawn-dusk

Admission free (to arrange special visits for small parties/schools contact Orleans House Gallery tel: 020 8831 6000)

Hero-worship doesn't come much more picturesque – or literal – than this, a dinky classical temple built by actor-manager David Garrick in 1756 to honour his idol, William Shakespeare. The pleasure garden that surrounds it was originally laid out with advice from landscape designer Lancelot 'Capability' Brown. Both temple and lawn have been the subject of restoration in recent years and the temple is now home to a replica of the life-size statue of Shakespeare by Roubiliac that was commissioned by Garrick for the temple. Regular events such as concerts and poetry readings enliven proceedings during the summer months and visitors wishing to arrive by waterborne transport can catch the Hampton Ferry from Molesey Hurst.

Hall Place and Gardens

⌧ Bourne Road, Bexley, DA5 1PQ

☎ 01322 526574

✎ www.hallplace.org.uk

🚃 Bexley Rail (then 15 minute walk)

🕓 Historic House: Mon-Sat 10.00-16.30, Sun & Bank Hols 11.00-16.30 (April-Oct), Mon-Sat 10.00-16.00, Sun & Bank Hols 11.00-16.00 (Nov-March)

 Gardens & parkland: Daily 9.00-dusk

❀ Admission Free

🛍 Shop

☕ Café

♿ Wheelchair access

Now in the tender care of the Bexley Historical Trust, Hall Place was built in 1537 for Sir John Champneys, City merchant and one time Mayor of London. Its grandeur and original owner, make it an interesting south London counterpart to Forty Hall in Enfield, built for a later Lord Mayor, Sir Nicholas Rainton (see p. 177). Architecturally the house falls into two distinct periods – the Tudor flint and rubble hall was joined in the 17th century by the addition of a smart symmetrically arranged, red brick mansion. The two parts make a very pleasant whole, which is set in 65 hectares of well-tended parkland and formal gardens, complete with a heraldic themed topiary lawn, a rose garden, 'model' gardens (including a 'really useful' Tudor herb garden) and a sub-tropical planthouse.

Oozing history from every brick, this mayorial status symbol has also in its time served as a boy's school and, rather more dashingly, as an Enigma code-breaking station in WWII. Today its historic rooms (which include a capacious Great Hall and minstrels' gallery), also contain a well-presented local history museum charting Bexley from pre-history to the present day. Displays of stone and flint weaponry alongside a woolly mammoth tooth certainly cast suburban Bexley in a different light. By Roman times the area had clearly come up in the world – if the upmarket grave goods on show here are anything to go by. An interactive 'Tudor' gallery looks at everything from Tudor fashions to the tribulations of the Reformation. Although clearly aimed at children it was on my visit being enjoyed by a group of history loving pensioners. Other permanent displays cover the Victorian and interwar years and there is a programme of temporary exhibitions and art shows ensuring that regular visitors won't get bored. A gift shop and an excellent café, with riverside terrace, completes the visitor experience nicely.

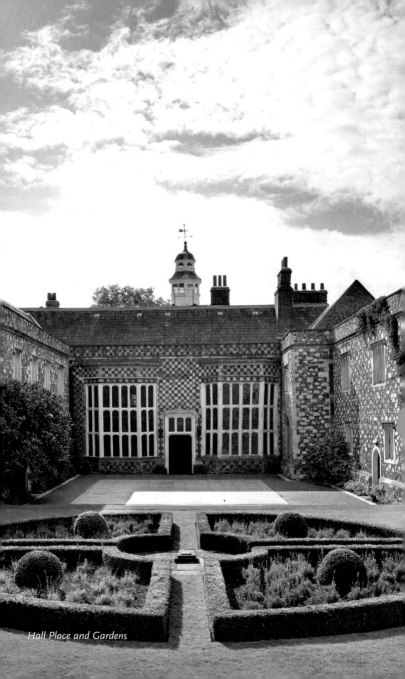

Hall Place and Gardens

Ham House

⊞ Ham, Richmond, TW10 7RS

☎ 020 8940 1950

🖉 www.nationaltrust.org.uk

🚌 Richmond LU/Rail

🕓 House Sat-Wed 12.00-16.00 (Mar-Nov); Garden 11.00-18.00 (all year)

💷 House & Garden: £9.90 (adults), £5.50 (children), £25.30 (families), free (National Trust members)
Garden only: £.30 (adults), £2.20 (children), £8.85 (families), free (National Trust members)

🛍 Shop

☕ Café

A 17th-century house on the banks of the River Thames. Built in 1610 and extended in 1670, Ham House is a unique example of Jacobean architecture and its imposing, perfectly symmetrical, south front makes an implacable statement about the power and taste of its occupants. Much of the Duchess of Lauderdale's extravagant 1670s redecoration is still in place and the lush interiors include fine textiles, furniture and paintings. The Duchess – a famous political schemer in her day – is said to haunt the house and ghost tours are held regularly (booking essential). The 17th-century gardens are currently being restored and feature a maze-like wilderness and formal lavender parterres as well as intriguing outbuildings such as an ice-house, dairy and the earliest known still-house.

Hampton Court Palace

⊞ East Molesey, Surrey, KT8 9AU

☎ 0870 752 7777 (general information)

🖉 www.hrp.org.uk

🚌 Hampton Court Rail, Richmond LU/Rail (then bus) or by river launch from Kingston, Richmond, and Westminster

🕓 Daily 10.00-18.00 (Mar-Oct, last admission 17.00), Daily 10.00-16.30 (Oct-Mar, last admission 15.30)

💷 £15.95 (adults), £13.20 (concessions), £8 (under 16s)

🛍 Shops

☕ Cafés

♿ Disabled facilities

So vast is Henry VIII's Thameside palace that visitors are advised to allow 3 hours to do it justice. Architecturally speaking, the palace has something of a split personality. On one hand its expansive red brick sprawl is a stunning example of Tudor architecture with all the crenellations and turrets you'd expect from a royal palace. On the other, it's a stately Baroque masterpiece designed (but never completed) by Christopher Wren. Inside it's not so bad either – from the State

Apartments and Renaissance picture gallery (featuring important works from the Royal Collection) right down to the enormous Tudor kitchens. Costumed guides and audio tours help interpret life in the royal household over the centuries while a permanent exhibition explores the myths surrounding the young Henry VIII and reveals the reality behind them.

The gardens – all 60 acres of them – are as famous as the palace and include a wilderness, the restored 18th-century Privy Garden, the Great Fountain Garden and the Maze (you may need to allow extra time to negotiate this latter feature). The palace is also home to The Great Vine which, planted in around 1768, is the oldest and largest known vine in the world. Although there are two cafés for hungry history hunters to choose from, picnickers are welcome and can use any of the benches around the palace courtyards or the gardens.

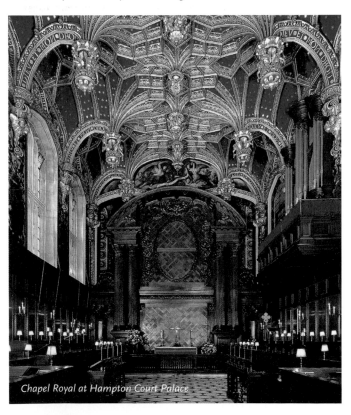

Chapel Royal at Hampton Court Palace

Harrow Museum

- Headstone Manor, Pinner View, Harrow HA2 6PX
- ☎ 020 8861 2626
- www.harrow.gov.uk
- 🕓 Mon, Wed, Thurs, Fri 12.00-17.00, Sat & Sun 10.30-17.00 (April-Oct), Mon, Wed, Thurs, Fri 12.00-16.00, Sat & Sun 10.30-16.00 (Nov-Mar)
- Harrow & Wealdstone LU/Rail then walk or bus H9
- Admission free
- Café
- Shop

This local history museum is based in a group of historic buildings, centred around Headstone Manor. Partially restored, the manor house dates from the early 14th century, comes complete with water (and duck) filled moat and is the earliest surviving timber building in Middlesex. Its bare but historically interesting interiors can be seen by guided tour every weekend during the summer. The handsome 16th-century 'tithe' barn that once used to store grain and stable horses now accommodates the museum's temporary exhibitions, events, children's activities, café and shop. Aptly named, the diminutive 'Small Barn' dates, like the manor, back to the 14th century and houses a permanent display about the history of the site, on which prehistoric and Roman remains have also been found. Permanent exhibitions about Harrow's rural and industrial past can be found in the 18th-century Granary, with a collection of old agricultural equipment and displays reflecting local industry: Whitefriars glass, Kodak cameras as well as a giant paintbrush from Hamilton's brush factory.

Kew Bridge Steam Museum

- Green Dragon Lane, Brentford, Middlesex, TW8 0EN
- ☎ 020 8568 4757
- www.kbsm.org
- Gunnersbury LU then 237 or 267 bus, Kew Bridge Rail
- 🕓 Tues-Sun & Bank Hol Mon 11.00-16.00 (last admission 15.30)
- Admission-weekday: £9.50 (adults), £8.50 (concessions), £3.50
- Shop
- Café (open weekends only), Picnic area
- Wheelchair access

Opposing elements they may be, but fire and water are inextricably linked in this magnificent Victorian pumping station, which once supplied water to the west of London. The gargantuan Cornish beam engines are still in situ in their original pump houses and can be seen 'in steam' on selected weekends. Other, lovingly maintained rotative

engines fill the Steam Hall and are in steam most weekends. More modern engines can be admired in the evocatively scented Diesel House, and train buffs young and old can enjoy a ride on the resident 'Wren' type steam locomotive every Sunday from March to November. Special events are regularly held throughout the year.

The 'Water for Life' gallery takes a close, sometimes microscopic, look at the history of London's water supply and doesn't fight shy of talking dirty. With the emphasis on interactivity and fun, visitors are invited to sift through a cesspit and walk through part of the Thames Water Ring Main. As well as the ubiquitous rat, London's sewers have supported a colourful range of wildlife from eels to red-eared terrapins as well as succession of different professions – from medieval 'gongfermors' to Victorian 'flushers' and 'toshers'. Other exhibits include Roman toilet spoons, medieval ice skates and a modern sewage worker's protective clothing. One of the best exhibits is the 'wall collage' of domestic appliances showing our ever-increasing demand for water.

The engines here may be steam driven but this dynamic museum itself runs on volunteer power – and a dedicated bunch they are too, maintaining the engines to a meticulous standard and even finding time to develop a lovely garden, complete with wildlife area, benches and wartime allotment. The café is only open at weekends but for weekday visitors in need of a cuppa, the Musical Museum (see p. 188) is just a short walk away and has a very pleasant tea room.

Kew Palace

- Royal Botanic Gardens, Kew, TW9 3AA
- 0844 482 7777
- 020 3166 6311 (information line)
- www.hrp.org.uk
- Kew Gardens LU, Kew Bridge Rail
- Daily Mar-Sept 10.00-17.00 (Mons 11.00-17.00); see website for opening times, as these change yearly
- £5.30 (adult), £4.50 (concs), £2.50 (child), tickets only available with tickets to the Royal Botanic Gardens, Kew
- Shop (at Welcome Centre)
- Cafés (Kew Gardens Orangery, Pavilion)
- Wheelchair Access

This red brick, Dutch style 17th-century house was the family home of King George III and his family, and a place of sanctuary for the king during his 'madness'. The smallest royal palace, it recently underwent a major restoration and reopened to the public in 2006. Visitors can admire the ornately decorated and furnished rooms and see family artefacts such as the elaborate dolls house made by George III's

daughters. The unrestored second floor is open to the public for the first time in its history. Entrance is only possible as part of a visit to Kew Gardens, so you'll need to pace yourself if you want to combine horticulture with history. At the weekends from June to September Queen Charlotte's Cottage is open, too (see p. 190).

Kingston Museum

Wheatfield Way, Kingston upon Thames, KT 12PS

020 8547 5006

www.kingston.gov.uk/museum

Kingston Rail

Daily 10.00-17.00 (closed Wed and Sun)

Admission free

Shop

Wheelchair access

As befits a royal borough, Kingston's museum is a pretty classy affair: a Grade II listed property, built with money donated by American benefactor Andrew Carnegie. Refurbished in recent years, the museum tells the story of the 'town of kings' from ancient times and also has a gallery dedicated to the photographic pioneer Eadweard Muybridge. The art gallery hosts national and local exhibitions.

Marble Hill House

Richmond Road, Twickenham TW1 2NL

020 8892 5115

www.english-heritage.org.uk

St Margaret's Rail, Twickenham Rail, Richmond LU/Rail

Sat 10.00-14.00, Sun & Bank Hols 10.00-17.00 (April-Oct), entry by guided tour only; see website for winter opening times and tour times

£5.30 (adults), £4.80 (concessions), £3.20 (children), free (under 5s/English Heritage members)

Shop

Café

Wheelchair access (ground floor)

The serene symmetry and perfect proportions of its façade give Marble Hill House the appearance of a scaled-up doll's house. In fact this elegant building, set by the Thames in 66 acres of parkland, was built by George II as a rural hideaway for his mistress, Henrietta Howard. The Great Room is regally decorated with lavish gilding and the house contains early Georgian paintings and furniture along with architectural paintings by Panini and a collection of chinoiserie.

Merton Heritage Centre

⊞ The Canons, Madeira Road, Mitcham, CR4 4HD

☎ 020 8545 3239

✎ www.merton.gov.uk/leisure

🚌 Mitcham Tramlink, Morden LU (then bus), Wimbledon LU (then bus); bus 118, 127, 152, 200, 201, 264, 270, 280, 355

🕓 Tues-Wed 10.00-16.00, Fri and Sat 10.00-16.30

💷 Admission free

🛍 Shop

♿ Wheelchair access

A programme of temporary exhibitions at this 17th-century house tells the story of Merton and its people. With the emphasis on making local history accessible to all ages the centre also organises lectures, craft workshops and reminiscence sessions. Exhibitions regularly feature hands-on displays. The Canons history extends back to Norman times and visitors can still see the carp pond and dovecote that were part of the grange farm complex that previously occupied the site. The small sales point offers local history publications and assorted gifts.

The Museum of Domestic Design & Architecture

⊞ Beaufort Park, Colindale

✎ www.moda.mdx.ac.uk

🕓 Open by appointment only

💷 Admission free

MoDA has an extensive holding of British domestic design from 1850-1960. Its six core collections include the famous Silver Studio Collection, which alone features some 40,000 designs, 5,000 wallpaper samples and 5,000 textile samples, dating from the 1880s-1960s. There's also an archive relating to the work of typographer and designer Charles Hasler and the contents of the London studio of artist and designer Peggy Angus. The museum moved from its home on the Middlesex Cat Hill campus in April 2011 and is now based at Beaufort Park, close to the University's Hendon Campus. Its collections will now be available 'online, on tour and on request' (ie by appointment).

Museum No. 1

- Royal Botanic Gardens, Kew, TW9 3AB
- 020 8332 5655 (24-hour information)
- www.kew.org
- Kew Gardens LU, Kew Bridge Rail
- Daily 09.30 onwards (closing time varies according to season: see website or telephone for details)
- Admission included in entrance to Kew Gardens: £13.90 (adults), £11.90 concessions, free (under 17s)
- Shop
- Cafés & Restaurant
- Wheelchair access

It doesn't have to be lilac time to make a trip to Kew worthwhile – with over 30,000 different types of plants in the Gardens, it's always horticultural heaven. Museum No.1 is an extra incentive for going. Its fun and interactive 'Plants and People' exhibition shows how reliant humans are on plants for food, medicine, clothing and even personal hygiene! Intriguing exhibits include a cannibal fork and dish, a deadly bamboo blowpipe and gramophone needles made from cactus.

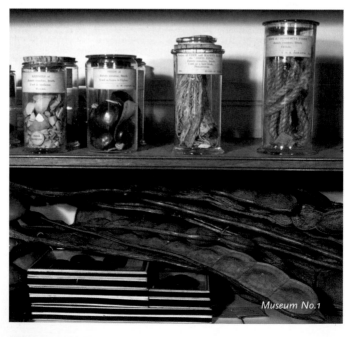

Museum No.1

Museum of Croydon

⬜ Croydon Clocktower, Katharine Street, Croydon, CR9 1ET

☎ 020 8253 1030 (box office)

☎ 020 8253 1022

✎ www.museumofcroydon.com

🚊 East Croydon Rail, West Croydon Rail, George Street Tramlink

🕓 Museum of Croydon: Mon-Sat 10.30-17.00; Exhibitions gallery and Riesco Gallery: Mon-Sat 11.00-17.00

💲 Admission free

☕ Café

♿ Wheelchair access

Formerly the Lifetimes Interactive Museum, the Museum of Croydon reopened in 2006 with a name change and a new, award winning design. With the focus on the objects and memories of local people, the displays explore Croydon's history from 1800 to the present day. Touchscreen kiosks allow visitors to listen to the reminiscences of residents as varied as a Sikh WWII fighter pilot, and a local Chinese food store owner. A 3-wheel 'Trojan' bubble car is one of the most popular exhibits – a genuine 1960s icon, made in Croydon. The Riesco Gallery houses a unique collection of Chinese ceramics dating from prehistory to the 19th century. Collected and donated by local business man Raymond Riesco, the exhibits include Tang Dynasty models and Ming dynasty bowls. The museum also hosts a varied programme of temporary exhibitions (both touring and self-developed) as well as events for all ages. Some exhibitions and events may carry an admission charge, although there are often 'happy hour' slots when entry is free.

Museum of Richmond

⬜ Old Town Hall, Whittaker Avenue, Richmond, TW9 1TP

☎ 020 8332 1141

✎ www.museumofrichmond.com

🚊 Richmond LU/Rail

🕓 Tues-Sat 11.00-17.00

💲 Admission free

🛍 Shop

♿ Wheelchair access

This local history museum celebrates Richmond's heritage as well as hosting regular exhibitions. The varied collection spans from prehistoric times to present day and includes such highlights as Regency actor Edmund Kean's snuff box and a 'Mickey Mouse' gas mask from 1939. The first part of a two-phase renovation project, to renew and modernise the displays, was completed in July 2011, with part two (new fibre optic lighting) to follow when funds allow.

The Musical Museum

- 399 High Street, Brentford, TW8 ODU
- 020 8560 8108
- www.musicalmuseum.co.uk
- Gunnersbury LU (then 237 or 267 bus), South Ealing LU (then 65 bus), Kew Bridge Rail
- Tues-Sun 11.00-17.30 (last admission 16.30)
- £8 (adults), £6.50 (concessions), free (children under 16)
- Shop
- Café
- Wheelchair access

The Wurlitzer Organ

In these days of iPods, downloads and radio it is hard to imagine life without wall to wall recorded music. With its world class collection of self-playing musical instruments the Musical Museum recaptures that far off era, when a pianola in a pub or a humble street barrel organ were how people accessed the popular music of the time. The huge variety of instruments ranges from vast ornate pipe organs to sophisticated reproducing pianos and tiny music boxes to more recently fangled contraptions such as an electronic organs and juke boxes. Regular demonstrations allow visitors to hear the instruments in action, and – as in the case of the 1813 pipe organ – literally listen to the sound of history. Guided tours of the collection take place at weekends and there are special 'Monkey Trails' for children to follow. Housed in a smart purpose

built venue the museum offers not only an excellent tea room with river views, but also a concert hall complete with a 1920s 'Mighty Wurlitzer' organ, which rises majestically from the floor for concerts and silent film screenings. The imaginatively stocked shop sells music themed gifts such as 'Chopin' boards as well as vintage sheet music and music rolls.

Old Speech Room Gallery, Harrow School

▫️ Church Hill, Harrow on the Hill, HA1 3HP
☏ 020 8872 8021
🖉 www.harrowschool.org.uk
🚌 Harrow on the Hill LU
🕐 Term-time daily (except Wed & exeat days) 14.30-17.00
💷 Admission free
🛍 Salespoint

Once a chamber for public speaking, the Old Speech Room was converted into a gallery in 1976 and now houses Harrow School's varied collection of Egyptian, Roman and Greek antiquities, and British watercolours and paintings. The school policy is to show its collection via themed exhibitions but works by Romney, David Jones and Old Harrovian Winston Churchill are among the works that visitors are likely to see here.

Osterley Park

▫️ Jersey Road, Isleworth, Middlesex, TW7 4RB
☏ 020 8232 5050
🖉 www.nationaltrust.org.uk
🚌 Osterley LU
🕐 Wed-Sun 13.00-16.30 (March-Nov), Sat-Sun 12.30-15.30 (Dec), (check website as these times may change yearly)
💷 House & Garden: £8.25 (adult), £4.15 (child), £20.70 (family)
☕ Café
🛍 Shop

A fine red brick Tudor manor house built by Sir Thomas Gresham and remodelled inside and out for the upwardly mobile Child family in the 18th century by John Adam. Stunning Georgian interiors include the austere Entrance Hall of 1767 and the tapestry room, hung with crimson coloured Boucher medallion tapestries specially commissioned from the Gobelin factory in Paris and lovingly tended over the years by the owners and family retainers. Clocking in at 130 feet, the 'Long Gallery' is aptly named and is now hung with an assemblage of 17th and 18th-century Venetian paintings. The house is set in 357 acres of parkland and gardens with lakes and featuring a collection of various species of oak tree.

Queen Charlotte's Cottage

▭ Royal Botanical Gardens, Kew, TW9 3AB
☎ 0844 483 7777
✐ www.hrp.org.uk
�489 Kew Gardens LU, Kew Bridge Rail
🕓 Weekends & Bank Holidays 10.30-16.30 (June-Sept)
🍽 Admission free with ticket to Royal Botanical Gardens
☐ Café

Queen Charlotte's whimsical thatched cottage provided a scenic spot for the Hanoverian royal family's picnics as well as a convenient place from which to admire the exotic inhabitants of their menagerie. Set in the southwest corner of the Botanic Gardens, the Cottage is at its best in springtime, when it is surrounded by a sea of bluebells. Kew Palace, George III and Queen Charlotte's official home, is nearby and is also open to the public (see p. 183).

Redbridge Museum

▭ Central Library, Clements Road, Ilford, IG1 1EA
☎ 020 8708 2317
✐ www.redbridge.gov.uk
🕓 Tues-Fri 10.00-17.00, Sat 10.00-16.00
�489 Ilford Rail then 10 mins walk
🍽 Admission free
🛍 Shop
♿ Wheelchair access

This local museum celebrated its 10th anniversary in 2010 and takes a multi-sensory approach to the history of the London borough of Redbridge. Visitors can inhale the heady smells of the borough (from farmyard fragrance to freshly baked fruitcake) and listen to a WWII air raid siren and the reminiscences of local residents such as Irish dancer Kathleen Maguire and children from Ilford Jewish primary school. A small display commemorates local MP Winston Churchill while the presence of mammoth remains found in the neighbourhood attests to the long history of the area. Room displays such as an early 1930s kitchen and a 1901 living room bring daily life of the past to life, aided by a 'video wall' and hi-tech touch screen computers covering different areas of the borough. Regularly changing temporary exhibitions on local subjects are held on the 1st floor, complemented by an events programme for children and families.

Red House

- Red House Lane, Bexleyheath, Kent DA6 8JF
- 020 8304 9878
- www.nationaltrust.org.uk
- Bexleyheath Rail (3/4 mile)
- Wed-Sun 11.00-17.00 (Mar-Oct), Fri-Sun (Nov-Dec)
 Visit by tour only. Guided tours 11.00, 11.30, 12.00, 12.30 and
 13.00 (booking essential); self-guided tours from 13.30 (no booking
 required)
- £7.20 (adults), £3.60 (child), £18 (family)
- Café
- Shop

A must for William Morris fans, Red House is the only house to have been created by the great designer and he moved here as a young man in 1860, with his new wife Jane Burden. Built for Morris by his friend Philip Webb, the house is a romantic essay in mediaeval -Gothic style, complete with steep red tiled roofs, higgledy piggledy layout, tiled fireplaces and, yes, a lot of red brick. The interiors are not fully furnished but the original Arts & Crafts features, together with the odd piece of furniture by Webb and Morris and wall-paintings by Burne-Jones help to compensate. It was at Red House that Morris began to work as a designer and examples of his famous wallpaper designs, like 'Trellis' and 'Daisy' are also displayed ('Trellis' was his first ever wallpaper and was used at Red House before Morris moved out in 1865). The garden, which wraps around the property, was a source of inspiration for Morris and today is something of a green oasis in suburban Bexleyheath, with its lovely old espaliered pears against the house, ancient apple orchard, croquet lawn and a productive vegetable garden. The tea-room, second-hand bookshop and Morris-themed merchandise mean visitors will leave neither hungry nor empty handed.

The Royal Military School of Music Museum

- ⌂ Kneller Hall, Kneller Road, Twickenham, TW2 7DU
- ☎ 020 8744 8679
- ✐ www.armymuseums.org.uk
- 🚌 Whitton Rail, Twickenham Rail
- ⊕ By appointment only
- ⓩ £4 (guided tours only)
- ☕ Café
- ✂ Shop
- ♿ Wheelchair access (limited)

A private collection of musical instruments, uniforms, medals and other objects with a military connection. Noteworthy exhibits include a bugle boy's book of music, found beside his body at the Battle of Waterloo, and a battle-scarred trumpet that was used in the 'Charge of the Light Brigade'. The collection also features a large variety of antique military musical instruments and is housed in a handsome 17th-century building, once the country home of the celebrated court painter Sir Godfrey Kneller.

Tithe Barn Museum of Nostalgia

- ⌂ Hall Lane, Upminster, RM14 1AU
- ☎ 01708 500600 (Ian Whaley)
- ✐ www.upminstertithebarn.co.uk
- 🚌 Upminster LU and Rail; bus 248 (from Upminster town centre, direction Cranham)
- ⊕ See website for opening days; guided tours of barn, inside and out, available by appointment
- ⓩ Admission free

A 15th-century thatched barn is the unlikely but rather charming venue for this collection of domestic and agricultural artefacts dating from Roman to more recent times, amassed by the local history society. Some 14-15,000 items are crammed in beneath the barn's mighty eaves, and range from lightbulbs to signposts to old delivery bikes.

The Twickenham Museum

- ⌂ 25, The Embankment, TW1 3DU
- ☎ 020 8408 0070
- ✐ www.twickenham-museum.org.uk
- 🚌 Twickenham Rail (then 10 mins walk); Richmond Rail/LU then bus H22, R68, R70, 290, 490
- ⊕ Tues & Sat 11.00-15.00, Sun 14.00-16.00
- ⓩ Admission free

Housed in a pretty 18th-century house overlooking the Thames and Eel Pie Island, this museum is the history centre for Twickenham, Whitton, Teddington and the Hamptons. These Thames-side villages once formed the Borough of Twickenham and their story is told through an ongoing programme of exhibitions at the museum and on the museum's excellent website.

The Wandle Industrial Museum

🖼 The Vestry Hall Annexe, London Road, Mitcham CR4 3UD

☎ 020 8648 0127

🖎 www.wandle.org

🚌 Mitcham Tramlink

🕓 Wed 13.00-16.00, Sun 14.00-17.00

💷 50p (adults), 20p (concessions)

🛍 Shop

♿ Disabled access by arrangement

The ultimate goal of this museum is to establish a riverside site at Ravensbury Mill in which to explore the Wandle Valley's industrial heritage. In the meantime, exhibitions at their current venue explore some of the area's better-known industries including snuff, tobacco and textiles as well as local figures such as William Morris and Arthur Liberty.

White Lodge Museum & Ballet Resource Centre

🖼 Richmond Park, TW10 5HR

☎ 020 8392 8440

🖎 www.royal-ballet-school.org.uk

🕓 Tues & Thurs 13.30-15.30 during term time
 All visits must be booked in advance
 Access to the museum is only via a free Park and Ride service,
 from the Sheen Gate entrance of Richmond Park (nearest rail Mortlake,
 then 15 min walk)

💷 Admission Free

♿ Wheelchair access

If your knowledge of ballet is limited to The Red Shoes and Billy Elliot, a visit to this, Britain's first dedicated ballet museum, is a must. The museum opened in 2009 and is housed, appropriately enough, in a former royal hunting lodge and the home of the Royal Ballet Lower School since 1954. As parallel timelines show, the story of ballet finds an elegant echo in the beauty, harmony and symmetry of White Lodge's Palladian architecture. Its date of design coincides almost exactly with the stage debut of Marie Camargo, the 'first' ballerina in 1726.

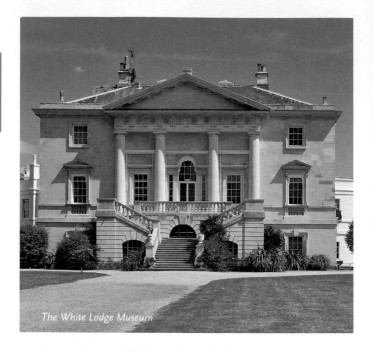

The White Lodge Museum

Past occupants of White Lodge include the Queen's parents and assorted other royals, but the real genius of the place remains the influential figure of Dame Ninette de Valois, the Irish-born dancer and choreographer who founded the Royal Ballet School, as well as the Royal Ballet and the Birmingham Royal Ballet. 'Madam', as de Valois was known, enjoyed a remarkable career (which included dancing with the Ballets Russes) and this is imaginatively celebrated in a wall of 'picture postcards' – some containing film footage of her at work. Displays recall the careers of other great ballerinas such as Marie Taglioni, the pioneering exponent of dancing en pointe who inspired such devotion that a pair of her pointe shoes were cooked and eaten by her admirers. The death mask of Anna Pavlova pays sombre tribute to another legendary ballerina, who unlike the long-lived de Valois, died before her time, aged just 49 (although at least Pavlova had a dessert named after her).

Archive material such as Margot Fonteyn's scrapbook of her triumphant post-war tour of America and displays of costumes from famous productions evoke the glamour of ballet, as well as the dedication it demands. The iconic components of the 'ballerina uniform' – ballet pumps and tutus – each get

a display to themselves, and twinkle-toed visitors can have a go bending their feet into the '5 positions', the foundation movements of ballet. Ballet is not just about dancers however and displays celebrating the careers of Sir Frederick Ashton and Kenneth MacMillan reveal the significance of the Royal Ballet's choreographic heritage.

Other exhibits de-mystify the day-to-day life of "White Lodgers", covering everything from what these student-athletes eat to the correct height of the barre. Royal Ballet School students receive a normal academic education alongside their ballet classes. While they labour, out of sight, at their lessons or practise their pliés, visitors can peruse the school reports of their distinguished predecessors, such as dancers Darcey Bussell and Lauren Cuthbertson. A 'family tree' of ballet pedagogy from the 17th century to the present day underscores the importance of teaching in the development of classical ballet, and the role of White Lodge in it.

World Rugby Museum

⊡ Twickenham Stadium, Rugby Road, Twickenham, TW11DZ
☎ 020 8892 8877
✐ www.rfu.com/microsites/museum
🚃 Twickenham Rail
🕐 Tues-Sat 10.00-17.00, Sun 11.00-17.00 (closed match & post match days)
💰 Museum only £6 (adults), £4 (concessions) Museum & Stadium Tour £14 (adults), £8 (concessions), £40 (family) (advance booking recommended)
🛍 Shop
♿ Wheelchair access

Situated in the East Stand of Twickenham Stadium, this museum charts the history of Rugby Football from a schoolboy game into an international sport. Many exhibits were donated by ex-rugby players and visiting teams – personal mementos include a mascot belonging to Robert Dibble who played for England between 1906 and 1911. More recent exhibits include one of the rugby balls kicked by Jonny Wilkinson in the 2003 World Cup final, and a replica of the World Cup trophy. Visitors can also admire reconstructed period rooms, trophies such as the Calcutta Cup (made from melted-down silver rupees), pictures and rugby memorabilia. Test your strength on the scrum machine or sit back and enjoy some great moments from the game in the audio-visual theatre. The guided tour take visitors around the home of English Rugby and includes a look at the England changing room and a walk through the players' tunnel to admire the hallowed turf.

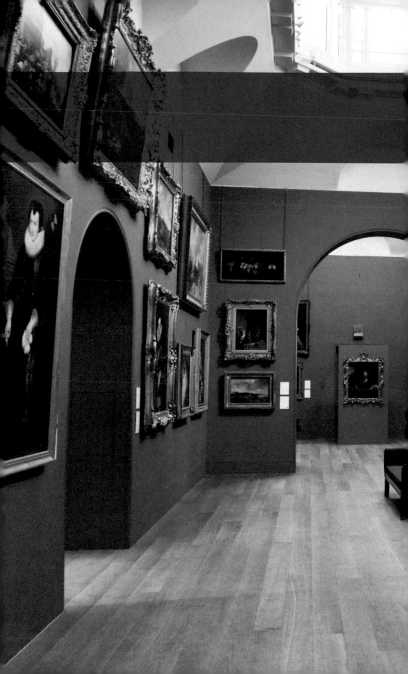

Galleries

Dulwich Picture Gallery

Central

Barbican Art Gallery

⬚ Gallery Floor, Level 3, Barbican Centre, Silk Street, EC2Y 8DS

☎ 020 7638 8891 (Box Office)

✎ www.barbican.org.uk

🚌 Barbican LU, Moorgate LU

🕐 Gallery. Daily 11.00-20.00 (except Wed 11.00-18.00)
1st Thurs until 22.00
The Curve: Daily 11.00-20.00, Thurs until 22.00

💷 £12 (adults), £8 (concessions)

🛍 Shop

🍴 Cafés & restaurants

♿ Disabled access

Set in the heart of the Barbican maze (Europe's largest multi-art venue), the Barbican Art Gallery hosts an eclectic range of photography, design and contemporary art exhibitions. The Centre's concourse, known as 'The Curve', is the venue for free exhibitions of contemporary art, specially commissioned for the site.

The British Library

⬚ 96 Euston Road, NW1 2DB

☎ 01937 546546 (Box Office)

✎ www.bl.uk

🚌 Euston LU/Rail, King's Cross St Pancras LU/Rail

🕐 Mon, Wed-Fri 09.30-18.00; Tues 09.30-20.00; Sat 09.30-17.00;
Sun and Bank Holidays 11.00-17.00

💷 Admission free (charge for some exhibitions)

🛍 Shop

🍴 Café & Restaurant

♿ Wheelchair access

Nestling in the shadow of a revitalised St Pancras, the British Library is a remarkable achievement – the largest UK public building of the 20th century. Housing millions of books, the Sound Archive and a large daily influx of readers, this is now indisputably the UK's national library. As well as its superb research facilities, the library has several exhibition galleries, and regular tours of the building itself, as well as the recently opened Centre for Conservation.

'Treasures of the British Library', the permanent exhibition in 'The John Ritblat Gallery', is a bibliographic tour de force. With books and manuscripts spanning some three thousand years, this is the place to

pore over historic documents like the Magna Carta, Shakespeare's First Folio or Captain Scott's last polar diary. Early maps offer insights into our ancestors' world view and there is a copious selection of sacred texts such as the *Golden Haggadah* and the *Luttrell Psaltar*. The Literature section includes some rare manuscripts, Lewis Carroll's meticulously handwritten copy of *Alice in Wonderland* and James Joyce's manuscript of *Finnegans Wake* among them. A Leonardo da Vinci notebook, written in his signature 'mirror writing', is one of the gems in the small Science section while over in Music, Beatles' pop songs share the limelight with Handel's *Messiah*.

Unsurprisingly, given the priceless nature of the exhibits the lighting is low and items are kept safely behind glass. Ingeniously interactive, 'Turning the Pages' gets around the restrictions of display – its touchscreen computers let you leaf through four of the library's most distinguished manuscripts at your leisure. A programme of special exhibitions in the Pearson Gallery and the Folio Society Gallery completes the picture.

For those with ambitions to build a library of their own, the bookshop on the ground floor is well stocked with books, books about books, mugs about books, bags for carrying books, and bookish gifts and games. And if intellectual stimulation just isn't enough, the library also has an in-house café and restaurant.

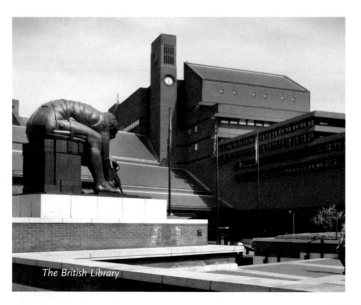

The British Library

The Courtauld Gallery

⬚ Somerset House, Strand WC2R 0RN

☎ 020 7848 2526

✎ www.courtauld.ac.uk

🚌 Covent Garden LU, Holborn LU, Temple LU (not Sundays)

🕐 Daily 10.00-18.00 (last admission 17.30)

💷 £6 adults, £4.50 concessions, (free under 18s,
students, unemployed & on Mondays 10.00-14.00)

👐 Shop

🍽 Café

♿ Wheelchair access

Vincent van Gogh, Self Portrait

Comprising a series of 11 different bequests, the Courtauld is that rare creature: a display of world-class art with the intimate feel of a private gallery. Its collections include those of Austrian aristo Count Seilern and of Samuel Courtauld, textile impresario and the man who gave his name to the Institute of Art. Recently re-displayed to show its works in chronological order, the Courtauld Gallery has the distinct advantage of being the ideal size to while away a morning or afternoon without having to resort to military-style route planning. Free entrance on Mondays 10am until 2pm makes the whole experience even more satisfying.

It doesn't take long to see why the collection is so renowned. Works by early masters Bernardo Daddi, Borghese di Piero and Nicola di Maestro Antonio d'Ancona are among the gleaming gold 'n' gesso treasures displayed in the ground floor gallery. The medieval enamels, ivory carvings and ceramics that share this gallery are less immediately eye-catching but just as rewarding.

The first floor galleries contain some of the finest 18th-century interiors in London, courtesy of Somerset House's architect, Sir William Chambers. His work provides atmospheric surroundings for a sequence of treasures of European art from the Renaissance onwards. Look out for Cranach's sublime take on the Adam and Eve story (in which a slow-on-the-uptake-Adam scratches his head in bemusement as Eve hands

over the fateful apple) and an outstanding altarpiece depicting the Holy Trinity by Botticelli. Moving on to the Baroque period, the gallery boasts a stunning roll call of works by Rubens. Popularly known for his lardy ladies, what is striking here is the sheer emotional and physical force of works like *The Descent from the Cross* and *The Conversion of St. Paul*. In contrast *Landscape by Moonlight* reveals Rubens in more tranquil mood whilst his affectionate portrait of *The Family of Jan Breughel the Elder* shows the artist in yet another light. The graciously proportioned rooms of Somerset House also prove the perfect foil for 18th-century portraits by the likes of Gainsborough and Goya as well as a series of light as cappuccino froth sketches by Venetian painter Tiepolo and a display of elegant 18th-century silverware by Augustin Courtauld.

For many, the Courtauld's collection of Impressionist and Post-Impressionist works will be the highlight of their visit and it's difficult not to reduce this to a litany of famous names and iconic works: Van Gogh's *Self Portrait with Bandaged Ear*, Manet's enigmatic *Bar at the Folies-Bergères* and Gauguin's melancholic, mystical masterpiece *Nevermore* are a few of the highlights. The Courtauld is also home to the largest collection of Cézanne's work in Britain, a group which includes *The Card Players*, *Montagne Sainte-Victoire* and the sublime *Lac d'Annecy*. Landscapes in a more purely impressionistic vein can also be found by Monet, Pissarro and Sisley, as well as by their Barbizon school precursors Corot and Daubigny and their fauvist and pointillist successors Signac and Seurat.

The second floor galleries are given over to the 20th Century with important long term loans from various private collections and works by modern masters such as Alexej von Jawlensky and Raoul Dufy, Derain and Vlaminck. Britain's answer to Post Impressionism and Modernism can be found on this floor – in changing displays that feature works by Ben Nicholson, Ivon Hitchens and 'Bloomsberries' like Vanessa Bell and Duncan Grant. Room 15 on this floor provides the venue for a programme of small scale, temporary exhibitions, often accompanied by a complementary display of prints and drawings.

For those in search of refreshment after their exertions, the Courtauld has a café looking out upon the fine courtyard of Somerset House. At the building's entrance is the gift shop which offers a selection of books and gifts relating to the collection and the exhibition of the moment.

Guildhall Art Gallery

🖵 Guildhall Yard, EC2V 5AE

☎ 020 7332 3700

🖉 www.guildhallartgallery.cityoflondon.gov.uk/gag

🚇 Bank LU, Mansion House LU, Moorgate LU, St Paul's LU

🕐 Mon-Sat 10.00-17.00, (last admission 16.30), Sun 12.00-16.00 (last admission 15.30), NB ceremonial events at Guildhall may require occasional closure of the gallery, telephone for details

💷 Admission free (entrance charge for some exhibitions)

🛍 Shop

♿ Wheelchair access

The Guildhall Art Gallery is home to the Corporation of London's collection of paintings and sculpture, begun in the 17th century and still growing today. Its posh City premises, designed by Richard Gilbert Scott, were officially opened to the public in 1999 by the Queen and host changing displays of the permanent collection, as well as a programme of temporary exhibitions. In 1987 it was discovered that the building was sited on top of London's Roman amphitheatre, the extent of which is marked out in the paved area outside the Guildhall; remains of the arena can be admired in situ in a basement gallery.

Portraits of Royalty and Lord Mayors of London include that of Alderman John Boydell whose magnificent full-length portrait by William Beechey respectfully reflects the sitter's civic clout. A dashing portrait of old sea dog Horatio Nelson is among the 18th-century paintings presented to the Corporation by the good alderman, while the highlight of the Copley room is a vast painting of the Siege of Gibraltar by American artist John Singleton Copley. The remarkable story of the restoration of this huge canvas and its gargantuan frame is told in a nearby display.

Returning to home ground, the Gallery's eclectic collection of London paintings captures the city in all its guises and at different points in its history, from the Great Fire of London after Waggoner to W L Wyllie's The Opening of Tower Bridge. London's famous pageantry is recorded for posterity in William Logsail's atmospheric depiction of the Lord Mayor's Procession in 1888 while, nearly a century later, Sharon Beavan distills the city's down to earth, mercantile energy in her 1984 depiction of Smithfield Market.

The collection also contains a knock-out selection of Victorian paintings and sculpture. Newly displayed in 19th-century style as you enter the Gallery, these include gloriously over the top evocations of the ancient world by artists such as Alma-Tadema and Lord Leighton as well as famous Pre-Raphaelite paintings like Holman Hunt's The Eve of Saint Agnes. J J Tissot's acutely observations of 19th-century society and

Tuke's evocative trio of swimmers, *Ruby, Gold and Malachite* are other treasures worth seeking out here, along with a powerfully expressionistic full-size oil sketch of Salisbury Cathedral by John Constable.

Splendid as the galleries are, they can only hold a small proportion of the whole collection but it is possible to view the entire collection on COLLAGE, the Corporation's data base which contains thousands of images of works of art in the collection and which may be accessed either using the gallery's own terminals or on the internet (http://collage.cityoflondon.gov.uk).

Hayward Gallery

🔲 South Bank Centre, SE1 8XX
☎ 0844 875 0073 (ticket Office)
✐ www.ticketing.southbankcentre.co.uk
🚌 Embankment LU, Waterloo LU/Rail
🕐 Daily 10.00-18.00 (Thurs & Fri until 22.00)
💷 Admission charge
👓 Shop
☕ Café
♿ Disabled access

Squatting snugly in the concrete cultural complex that is the South Bank Centre, the Hayward is not the most alluring exhibition space in town despite its love-it-or-loathe-it Brutalist bulk having acquired a glass fronted entrance foyer in recent years. Nevertheless, it puts on a quality show – recent ones have featured Tracey Emin and Swiss artist Pipilotti Rist. For regular visitors, full membership of the Southbank Centre's Membership costs £45 and offers a range of perks, including free Hayward Gallery entry.

Hayward Gallery

Institute of Contemporary Arts

- The Mall, SW1Y 5AH
- 020 7930 3647 (tickets and information)
- www.ica.org.uk
- Charing Cross LU/Rail, Piccadilly Circus LU
- Wed 12.00-23.00, Thurs-Sat 12.00-01.00, Sun 12.00-21.00
- Exhibitions free
- Bookshop
- Café, Bar
- Limited wheelchair access

For those who prefer their culture right slap bang up-to-the-minute, the ICA provides a potent programme of art exhibitions, literary events, cinema and live events from gigs to theatre. Membership starts at £25 and buys access to member-only special events, film previews and private views as well as discounts on tickets, books, food and drink. The bookshop does a nice line in trendy art mags, while the café-bar offers more readily digestible fodder.

Jerwood Space

- Jerwood Space, 171 Union Street, SE1 0LN
- 020 7654 0171
- www.jerwoodspace.co.uk
- Borough LU, Southwark LU
- Mon-Fri 10.00-17.00, Sat & Sun 10.00-15.00
- Admission free
- Café
- Wheelchair Access

Set in a beautifully refurbished Victorian school building, this exhibition space hosts a year-round programme of contemporary fine art shows, including the renowned Jerwood Contemporary Painters and the Jerwood Artists Platform. The acclaimed Café 171 offers good value, seasonal food in a relaxed environment. Ring ahead or view website to check exhibition programme.

The National Gallery

🖵 Trafalgar Square, WC2N 5DN

☎ 020 7747 2885

✎ www.nationalgallery.org.uk

🚌 Charing Cross LU/Rail, Embankment LU, Leicester Square LU

🕐 Daily 10.00-18.00, Fri 10.00-21.00

💷 Admission free (a charge is made for some exhibitions)

🛍 Shops

☕ Café & Restaurant

♿ Wheelchair access

Frequented by pigeons, rollerskaters and New Year revellers, Trafalgar Square is also a favourite haunt of art lovers, being home to Britain's National Gallery. A top-notch permanent collection of over 2,300 paintings spanning 700 years of Western European art history (from 1260-1900), the NG is the jewel in London's cultural crown. Some of the world's most famous paintings are housed here, among them van Gogh's *Sunflowers*, van Eyck's *The Arnolfini Marriage*, Leonardo da Vinci's *Virgin of the Rocks* and the ever-popular *Haywain* by Constable.

The paintings (no wacky installations or performance art here – unless you count your fellow visitors) are arranged chronologically, the earliest paintings (1260-1510) being shown in the Sainsbury Wing, the sleekest part of the gallery. Designed by American architect Robert Venturi, it opened in 1991 and its calm, monochrome interior provides an ideally neutral backdrop for the glistening gold leaf and vivid pigments of early Renaissance works like the *Wilton Diptych*. Christian iconography predominates but alongside the Annunciations, Nativities and Crucifixions are beautifully-observed portraits like Albrecht Dürer's *The Painter's Father* and Giovanni Bellini's *The Doge Leonardo Loredan*. Scenes from secular life include Uccello's *The Battle of San Romano* whose composition reflects the artist's struggle with the laws of perspective while Botticelli's languid *Venus and Mars* epitomises the Renaissance love affair with the classical past.

Moving back into the main building, the West Wing (coloured maroon on the gallery plan) displays painting from 1500-1600 and includes works by Cranach, Bronzino, Titian and El Greco along with Michelangelo's unfinished '*Entombment*' and Veronese's flamboyant set piece '*The Family of Darius before Alexander*'. Holbein's recently restored '*The Ambassadors*' is one of the highlights here, its ultra-realism managing to accommodate a smattering of symbolism and hidden meanings (stand to the side of the painting to view the death's head – an effect achieved by distorting perspective).

Northern European artists 1600-1700 dominate the North Wing (orange on the gallery map) which is home to Vermeer's enigmatic

Young Woman Standing at a Virginals. The gallery's Rembrandts are concentrated here and, looking at his self-portraits, it's hard not to be moved by the artist's searing self-analysis and his descent from cocksure, successful thirty-something to dissolute, world-weary 60 year-old. Among the works by Southern European artists, visitors can admire the curvaceous *Rokeby Venus*, Velasquez's 17th-century pin-up, the darkly passionate fervour of Zurbarán's meditating St Francis or enjoy the gothic frisson of Caravaggio's *Boy Bitten by a Lizard.*

The East Wing (green on the plan) brings the collection up to 1900. Hugely popular, the Impressionist and Post-Impressionist galleries always seem to be crowded – among the show-stoppers are a late Monet, *The Water Lily Pond,* Seurat's *Bathers at Asnières,* and Renoir's *Parapluies.* Escape the crush in Room 42, an intimate space hung with small, loosely painted *'plein-air'* sketches by the likes of Boudin, Corot and Degas. The wing's less fashionable galleries have treasures equally worth exploring – from frothy creations by Fragonard to landscapes by Constable and Turner to the Neo-Classicism of Ingres and David and the Romanticism of Delacroix.

Space restrictions ensure this review can only be a sketch – time restrictions will probably dictate how you tackle the NG. Regular visitors can take advantage of free admission to just drop in from time to time, savouring individual wings, rooms or even paintings. Those with limited time in the capital may likewise want to target particular areas of the collection – easily arranged thanks to the Gallery's nifty interactive multimedia system. Head for the ArtStart rooms on Levels 0 and 1 to print off a free personalised or a themed tour – find out who's behaving badly on the 'Drunkenness and Debauchery' tour or get the kids to track some beautifully painted Creepy Crawlies. Audio Guides are available by donation and feature a highlights tour of 30 masterpieces, but can also spoonfeed you a complete tour with commentaries on individual rooms, paintings and artists as well as on subject matter and techniques. Live guided tours set off daily and are supported by an excellent programme of temporary exhibitions, films, short talks and lectures – ask for details at the desk on arrival or pick up a copy of the Gallery's 'What's On' guide. The Gallery also recently launched its 'Love Art' i-phone App which allows users to explore 250 of the gallery's best loved paintings, accompanied by commentary and interviews with experts and artists.

Easy on the eye, the NG can be hard on the feet. Benches and squishy leather sofas offer some respite for weary art pilgrims but for hungry culture vultures the gallery has two in-house options. The ultra civilized 'National Dining Rooms' in the Sainsbury Wing has waitress service, seasonal menus using British produce and a mural by Paula

Hans Holbein, *The Ambassadors*

Rego. The Gallery's East Wing facilities (accessed via the street level Getty Entrance on Trafalgar Square) include a large, bustling café for less formal food opportunities as well as a very decent Espresso bar housed near the ArtStart computer terminals.

For those with the creative urge, sketching is permitted throughout the gallery – just bring your own materials and a stool. Thwarted artistic ambitions can be consoled in the gallery's shops, which are abundantly stocked with postcards, mugs and exclusive gifts inspired by the works in the collection. A print on demand service means that you can take home a reproduction of any painting in the collection from a neat A4 size, right up to a giant A0 mega poster. The well-ordered main shop in the Sainsbury Wing also stocks a comprehensive range of art books.

National Portrait Gallery

National Portrait Gallery

- 🏠 St Martin's Place, WC2H 0HE
- ☎ 020 7306 0055 (general ticket enquiries)
- ☎ 020 7312 2463 (recorded information)
- 🖰 www.npg.org.uk
- 🚇 Charing Cross LU/Rail, Leicester Square LU
- 🕐 Daily 10.00-18.00, Thurs and Fri until 21.00
- 💲 Admission free (charge for some special exhibitions)
- 🛍 Gift Shop & Bookshop
- ☕ Café & Restaurant
- ♿ Wheelchair access

Specialising in likenesses of famous British men and women through history, the NPG is perfect for people-watching. With a display of some 1,000 portraits in all media and more celebs than *Hello!*, here at least, it would be rude not to stare. The recent development programme means there's now even more to look at, with more exhibition space and better facilities – including not one but two places to have a coffee afterwards.

For a chronological view of Britain's finest, take the fast-track escalator to the second floor where the collection kicks off with the Plantagenet and Tudor monarchs. Beautifully displayed in an understated gallery (all deep-grey walls and fibreoptic lighting) the works here include Holbein's cartoon for his portrait of a bullish Henry VIII. Wall labels explain the niceties of his family tree, dramatised, if not entirely accurately, by one William Shakespeare – whose portrait by John Taylor was the first to be acquired by the Gallery. As you work your way downstairs, encounter a succession of monarchs, mistresses, men of letters and public figures and characters like the 18th-century Duchess of Queensberry, who 'still beautiful at 76, died of a surfeit of cherries'.

The Weldon Galleries on the second floor are home to the movers and shakers of Regency Britain – everyone from proto-feminist Mary Wollstonecraft to road surface pioneer John McAdam with a section devoted to 'Royalty, Celebrity and Scandal' thrown in for good measure. Founded in 1856, the gallery is a testament to the achievements and preoccupations of the 19th century and, unsurprisingly, most of the first floor is dedicated to Queen Victoria's great and good. The 'Statesmen's Gallery' is filled with the busts and portraits of stern, bewhiskered dignitaries. Empire builders (a jaunty Lord Baden-Powell among them), artists and scientists populate the anterooms. Writers get a look in too: a tousle-haired Lord Tennyson and a trio of Brontës.

The Early 20th Century galleries are prefaced by Sir James Guthrie's enormous *Some Statesmen of the Great War* out of which a centrally placed Winston Churchill stares knowingly. The 1918-1960 holdings are suspended in a series of glass screens and include personalities such as Lord Reith and Alexander Fleming although the arts are still represented by the likes of L.S. Lowry, Kingsley Amis and a curiously Mrs Tiggywinkle-like Beatrix Potter among others.

The Balcony Gallery looks at Britain 1960-1990 and offers a heady mix of pop culture and politics. On the ground floor, the Britain since 1990 rooms underline how the nature of fame has changed. Stand-up comedians, fashion designers, sports 'personalities' and models join the usual suspects from British public life pleading 'I'm a Celebrity, Get Me in Here!'. The Emmanuel Kaye Gallery attempts to redress the gallery's perceived bias towards the arts, with portraits of worthies from the worlds of science and technology.

The collection provides a gloriously voyeuristic tour through history, documenting changing attitudes and fashions more vividly than any history book. In an almost perverse reversal of the usual art gallery ethos, the celebrity of the subject holds sway over artistic merit – although that said there are works by big names like Kneller, Gainsborough and David Hockney. Although photography was cold-

shouldered by the gallery until the 1960s it now features much more heavily in the more contemporary displays with works by photographers such as Johnny Shand Kydd and Tom Miller.

Visitors in search of a particular face in the crowd should investigate the 'Portrait Explorer' in the new IT gallery where touchscreens offer access to high-resolution images of the gallery's entire Primary Collection as well as parts of its Archive Collections. Users can also listen to interviews with artists and sitters, as well as print out a personalised tour of 12 works of art. For those with larger ambitions the gallery's Audio Guide provides commentaries on over 300 famous portraits while a recently launched i-phone App offers the option of various themed tours plus commentaries and videos.

Late night openings on Thursdays and Fridays have proved a popular innovation at the NPG – with lectures, films, and live music. Information on these events and the temporary exhibition programme can be obtained from the Information Desk.

Down in the basement, the glass-roofed Portrait Café does a good line in coffee, tea and light snacks while up on third floor the Portrait Restaurant serves a more sophisticated menu at higher prices and offers stunning views of Trafalgar Square, Whitehall and the London Eye thrown in for free. The NPG's bookshop stocks titles ranging from biography to costume and those on a gift buying mission will find an eclectic selection in the shop.

The Photographers' Gallery

⬚ 16-18 Ramillies Street, W1F 7LW
☎ 0845 262 1618
✍ www.photonet.org.uk
🚌 Oxford Circus LU
🕓 Daily (check website for details)
💷 Admission free
📚 Bookshop
☕ Café
♿ Wheelchair access

Opened in 1971, The Photographers' Gallery was the first independent gallery in Britain to be devoted to photography, and runs an energetic exhibition programme, showcasing new talent as well as holding retrospectives of established names. Its Print Sales Gallery offers vintage, modern and contemporary prints for sale, while an extensive selection of photography publications can be found in the bookshop. The gallery has recently been redeveloped and re-opened in Autumn 2011, with new galleries, an education space and a public lift.

Queen's Gallery

🖼 Buckingham Palace, SW1A 1AA

☎ 020 7766 7301

✎ www.royalcollection.org.uk

🚌 Green Park LU, St James's Park LU, Victoria LU/Rail

🕐 Daily (during exhibitions) 10.00-17.30 (last entry 16.30)

💷 £9 (adults), £8.20 (concs), £4.50 (under 17s), free (under 5s)

🛍 Shop

♿ Wheelchair access

Even the Queen's Gallery wasn't immune from the refurb fever which swept through the city's museums at the turn of the millennium. The £20 million expansion of the Gallery's premises at Buckingham Palace has created an imposing new Doric portico, lofty double height entrance hall and staircase, and new galleries.

The gallery hosts a programme of changing exhibitions, showcasing different aspect of the extensive holdings of the Royal Collection. Held in trust by The Queen for her successors and the nation, the Royal Collection dates from the Restoration in 1660 and includes art in every medium from paintings and works on paper to textiles.

As you might expect, security is tight at the gallery, and airport style checks are in operation but the staff are courteous and helpful. The Gallery's shop sells scholarly publications about aspects of the collection as well as an assortment of right royal knick-knacks – from limited edition crockery to cuddly toys.

Rivington Place

🖼 Shoreditch, EC2A 3BA

☎ 020 7749 1240

✎ www.rivingtonplace.org

🚌 Old Street LU; Liverpool Street LU/Rail; Shoreditch High Street London Overground

🕐 Tues, Wed, Fri 11.00-18.00

💷 Admission Free

🍽 Café

♿ Disabled Access

A permanent public space dedicated to culturally diverse visual arts and photography. The award-winning complex, designed by leading architect David Adjaye, opened in 2007 and includes an array of exhibition and installation spaces, as well as a photography archive, research library and café.

Royal Academy of Arts

⌷ Burlington House, Piccadilly, W1J 0BD
☎ 020 7300 8000
☎ 0844 2090051 (Ticket booking line)
✎ www.royalacademy.org.uk
🚇 Green Park LU, Piccadilly Circus LU, bus 9, 14, 19, 22, 38
🕐 Daily 10.00-18.00 (Fri until 22.00)
💷 Admission free (Guided tour only) to the John Madesjki Fine
 Rooms; Admission charge for some exhibitions
🛍 Shop
☕ Café & Restaurant
♿ Wheelchair access

Perhaps George III wasn't so mad – after all he did found this august institution (the oldest fine arts academy in Britain) in 1768. Today the Royal Academy is known for organising crowd-pleasing blockbuster exhibitions like 'The Real Van Gogh' 'Treasures from Budapest', and 'Sargent and the Sea'. Punters flock to the RA's annual Summer Exhibition which, with over 1,000 exhibits, is the world's largest, and longest

running, open submission art exhibition. Offering a mind-bogglingly diffuse vision of contemporary British art, the show attracts as much critical disdain as it does popular acclaim. The RA's 'Friends' scheme rewards members with free entry to exhibitions, a separate 'Friends' room and a glossy mag amongst other perks.

A statue of Sir Joshua Reynolds, the Academy's first president, greets visitors as they enter the courtyard of Burlington House. Works by Academicians, past and present, can be seen free of charge in the John Madejski Fine Rooms. This suite of 7 elegant 18th-century state rooms displays selected works from the RA's collection, which includes works by Turner, Constable and Hockney. The RA's café and restaurant offer good light meals and the chance to see (and hear) the chattering classes in action – but like the exhibitions and indeed the ladies' loos, they can get crowded. Piccadilly and surrounding area offers a range of alternatives on all counts if the queues are too daunting.

The Saatchi Gallery

🖺 Duke of York's HQ, King's Road, SW3 4RY
☎ 020 7811 3085
🖎 www.saatchi-gallery.co.uk
🚌 Sloane Square LU
🕐 Daily 10.00-18.00
⅔ Admission free
🕮 Bookshop
☐ Café
♿ Disabled access

Housed in elegantly renovated ex-army premises, the latest incarnation of the Saatchi Gallery opened in October 2008. With 70,000 square feet of white-walled and wooden-floored gallery space there's plenty of room for Charles Saatchi to show off his famous and ever-developing contemporary art collection in a series of snappily titled temporary exhibitions. Controversial Brit-Art may be what the Saatchi is best known for in the popular imagination but the collection is truly international in scope and recent shows have looked at the latest in Chinese, Indian, Middle Eastern and American art. Richard Wilson's uncanny 1987 site specific 'oil installation' 20:50 is also on permanent display

The extensive main suite of galleries is given over to major 'survey' shows. For all the conspicuous consumption on display, the gallery has a surprisingly egalitarian stance with free entry for all and an extensive virtual online gallery. The site offers, amongst other things, a commission-free sales service complete with a 'Showdown' where visitors vote weekly for their favourite online work, which are then exhibited at the Gallery.

Tate Britain

⌖ Millbank, SW1P 4RG
☎ 020 7887 8888
✎ www.tate.org.uk
🚌 Pimlico LU
🕐 Daily 10.00-17.50 (until 22.00 first Friday of the month)
💷 Admission free (admission charges apply for major loan exhibitions)
🛍 Shops
🍽 Café & Restaurant
♿ Disabled access (via the Manton Entrance)

What was once simply known as 'the Tate' has been rationalised and rebranded for the 21st century as Tate Britain and Tate Modern. With its collection of modern international art happily installed downstream at Bankside (see p216), the Millbank branch of the Tate empire can concentrate on being the national gallery of British art – as founder Henry Tate intended back in the 19th century. It's got plenty of material to work with too – the permanent collection of native art spans some 600 years from the Renaissance to the present day and features works by the lynchpins of British art including Hogarth, Gainsborough, Stubbs, Turner, Constable, the Blakes (William and Peter), Bacon and Moore.

And thanks to its Centenary Project, Tate Britain has more space in which to show off the goodies. Four new galleries, five refurbished galleries on the main floor and six new temporary exhibition rooms (the Linbury Galleries) on the lower floor, help to make this the largest display of British art in the world. The building work has also resulted in a crisp, rather antiseptic, entrance and lobby (with shop and coffee bar) on Atterbury Street. Tate die hards will probably still want to head for the high ground of the old Millbank entrance overlooking the Thames to meet friends.

In contrast to the thematic approach adopted at Tate Modern, Tate Britain has plumped for a broadly chronological presentation,

straightforwardly entitled 'Collections 1500-present'. Keeping things fresh – but making life difficult for the guidebook compiler - displays change annually and within the narrative sweep individual rooms are given over to explore work by a particular artist, group of artists or explore a sub-theme.

A vibrant programme of temporary exhibitions complements the permanent collection and these are staged in the new Linbury Galleries on the lower floor (level 1) and in the north-east corner of the main floor (level 2). The Vorticists were the subject of a recent show and, making the point that new art isn't just the preserve of Tate Modern, the gallery stages up to five 'Art Now' exhibitions every year, dedicated to showcasing new art in the UK, by artists as various as Pablo Bronstein and Corin Sworn.

Awarded annually to a British artist under 50, the Turner Prize is Britain's highest profile contemporary art prize. With all the hype, it's easy to overlook the work of its namesake, JMW Turner, whose bequest to the nation is housed in the Tate's Clore Gallery, a purpose built suite of galleries adjoining the main building. The selection in the 'Turner Gallery' aims to give a flavour of the collection with works like the artist's self portrait of c.1799, classical compositions like *Dido and Aeneas* and dramatic Romantic subjects like *The Fall of an Avalanche in the Grisons*.

If you've still got time on your hands, free daily guided tours focus on highlights from different area of the collection, or you could try to catch the 15 minute 'painting of the month' talks for a more in-depth discussion of just one key work of art. For those who prefer machines to people, multimedia guides can be hired for £3.50 which allow users to listen to interviews with the artists and to learn from the horse's mouth what inspires them – and what critics think of their work. Touch Tours and Raised Images are available for visually impaired visitors but must be booked at least a week in advance – ask at the information desk or telephone 020 7401 5218 for details. The Art Trolley gets rolled out every weekend with a range of activities for children aged 3-11 years. Well stocked with art books and increasingly funky Tate merchandise, the Tate Britain shop is a must for most visitors and features a whole room devoted to postcards. The subterranean café serves decent sandwiches, cakes and coffees, although at busy times it can feel uncomfortably cramped. Just across the corridor, the restaurant offers more gracious and spacious dining in an elegant mural lined room.

Tate Modern

- Bankside, SE1 9TG
- ☎ 0208 7887 8888
- ✐ www.tate.org.uk
- 🚇 Southwark LU
- 🕐 Sun-Thurs 10.00-18.00, Fri-Sat 10.00-22.00
- ℗ Admission free (charges for some special exhibitions or events)
- 🛍 Shop
- 🍽 Cafés and Restaurant
- ♿ Wheelchair access

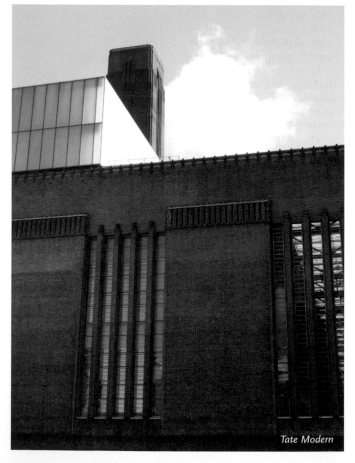

Tate Modern

Tate Modern is architectural recycling at its most audacious. The behemoth that was Bankside Power Station was transformed for the new millennium by Swiss architects Hertzog and de Meuron into a state-of-the-art gallery for the 21st century. First-time visitors cannot fail to be impressed by the sheer scale of the operation – it's quite unlike any other gallery in London. Some 4.2 million bricks and 218 miles of cabling went into making it. To really revel in the power and the glory, avoid the small riverside doorway and go in by the west entrance where a huge ramp leads you down into the Turbine Hall. At some 500ft long and 115ft high, this is the centrepiece of the building and the setting for a succession of specially-commissioned sculptures. Size does matters here and its fascinating to see how contemporary artists tackle this vast space – Anish Kapoor's giant 'hearing trumpet', Olafur Eliasson's mesmeric *Weather Project* and Doris Salcedo's crack in the floor *Shoibboleth* have been some of the responses so far.

But it's not just an ace building – there's a pretty good art collection too. Now that the former Tate Gallery on Millbank has become Tate Britain (British art from 1500 to present, see entry on p. 214), Tate Modern is home to the national collection of international 20th century art as well as a venue for new art. Its permanent collection displays are thematic rather than chronological and have recently been redisplayed around pivotal moments in 20th century art history. 'Material Gestures' can be found on level 3 along with 'Poetry and Dream', while level 5 houses 'Energy and Process') and 'States of Flux'. Each themed 'suite' contains several galleries, some devoted to individual artists, or pairs of artists, others to movements like Pop Art or Expressionism or aspects such as Cubist Drawings. Some galleries compare the work of two different artists such as Lichtenstein and Boccioni, Bacon and Picasso.

Displays are changed regularly, making life interesting for the regular visitor but expect a challenging mix of big hitters like Picasso, Matisse, Leger, Beuys, Dubuffet, Giacometti, Pollock and Warhol as well as more recent stars such as Cornelia Parker and Langlands and Bell. Special exhibitions and displays are held in the galleries on level 4 and recent shows have included Joan Miro and Gauguin. Each of the four themed 'suites' offers a complete visit in its own right and there are free daily guided tours of their highlights. Alternatively the Tate multimedia guide (£3.50) is a technologically advanced way of contextualising the collection – a mini-hand-held computer that offers interviews with artists, footage of them in action, commentaries on the works, music and interactive games. The guide also includes a children's tour. Free 'Tate Teaser' activity sheets for young visitors are available from the information desk while 'Start' is an educational resource offering a range of fun, drop-in activities. It's based on level 3 and is open the first

Sunday of the month (11.00-17.00). There's also a full programme of events aimed at adults such as film screenings and drop-in talks.

The astounding popularity of Tate Modern means that even its spacious galleries and concourses can still get crowded, with queues at its cafés and shops. Friday and Saturday late night openings are a good way of avoiding the hordes and have a pleasantly mellow atmosphere. If it all gets too frenetic the Rothko room on level 3 provides an ideal chill-out zone – its suite of maroon abstracts (originally destined for the Four Seasons Restaurant in New York) and subdued lighting are beautifully meditative, and there are plenty of benches for weary art lovers. Not all Tate Modern's rooms have such ample seating but portable viewing stools can be picked up from concourses and, given the distances you may find yourself covering, are a wise precaution.

Modern art can be thirsty, hungry work and Tate Modern has three options for those in need of refreshment. The restaurant in the glass lightbeam on level 7 offers table service and spectacular views of London, while the café on level 2 although minus the panorama, offers a good menu and reasonable coffee. Queues may be a problem at peak times but if it's just a coffee and a sandwich you're after then the Espresso bar on level 4 may do the job. Drinking fountains can be found on levels 1, 3, 4, and 5 and there is a picnic area for family use at weekends and during holidays.

Tate Modern's retail operation matches the scale of the rest of the building. The shop in the Turbine Hall includes a comprehensively stocked art bookshop with over 10,000 titles and an imaginative range of artist designed merchandise as well as the usual posters, prints and postcards.

For those planning a double dose of Tate, a fast boat service serves the two venues, capitalising on their riverside locations. Dashingly decorated by Damien Hirst, the boat runs every 40 minutes between Tate Britain and Tate Modern. Its journey time of 18 minutes includes a stop off at the London Eye. Tickets can be purchased at the respective Tates, on board or on-line.

Since its triumphant arrival onto London's cultural scene – on time and within budget – in May 2000, Tate Modern has proved to be the very model of a Millennium project. Over 25 million people have flocked to see it since it opened, *Time Out* readers voted it their favourite London building and it attracts around 5 million visitors annually. It is with some justification that Tate Modern can claim to be the most popular museum of modern art in the world but that doesn't mean that it's sitting back and taking it easy. A bold new building by Hertzog and de Meuron on the south side of the existing gallery was given planning permission in 2007 which, when it is completed in 2012, will provide additional gallery space for 21st century art as well as education and recreational facilities.

Two Temple Place

🖼 2 Temple Place, WC2R 3BD

☎ 020 7836 3715

✍ www.twotempleplace.org

🚌 Temple LU

🕓 Building only open during exhibitions - see website for opening times

🎟 Admission Free

🛍 Shop

☕ Café

♿ Wheelchair access

The high-Victorian, neo-Gothic opulence of William Waldorf Astor's one time London townhouse is the setting for London's newest public art gallery, opening in October 2011. Two Temple Place will show publicly owned art from UK regional collections, its inaugural exhibition being a display of works from the William Morris Gallery (see p. 171) collection. Exhibits will have to compete with some serious fin-de-siècle interiors – the Renaissance style Great Hall features a massive hammerbeam ceiling carved from Spanish mahogany while the Library is decorated with carved panels depicting Art and Science – but the chance to see this previously hidden building, combined with Britain's regional art treasures should prove irresistible.

UCL Art Collections

🖼 Strang Print Room, South Cloisters, Main Building,
University College London, Gower Street, WC1E 6BT

☎ 020 7679 2540

✍ www.ucl.ac.uk/museums

🚌 Euston LU/Rail, Euston Square LU, Goodge Street LU,

🕓 Mon-Fri 13.00-17.00

🎟 Admission free

♿ Wheelchair access

The UCL Art Collections comprise over 600 hundred paintings, 7,000 prints and drawings and some 150 sculptures. The Print Room itself is home to works by Old Masters such as Dürer, Cranach and Rembrandt and each term hosts a new exhibition of works drawn from the UCL collections. John Flaxman's sketches and Early Modern Treasures from the UCL Collection are examples of recent shows. The permanent collections are open by appointment and include the Slade collection, which traces the development of art education in England and includes early works by Stanley Spencer and Augustus John as well as 20th-century drawings by professors and students at the Slade School. UCL also houses the Flaxman Collection, the largest single group of works by the neo-classical sculptor John Flaxman. Forty of his full scale plaster models (mostly relief plaques) are displayed in the Flaxman Gallery.

The Wallace Collection

⬚ Hertford House, Manchester Square, W1U 3BN

☎ 020 7563 9500

✐ www.wallacecollection.org

🚇 Baker Street LU, Bond Street LU, Oxford Circus LU

🕐 Daily 10.00-17.00

💷 Admission free

🛍 Shop

☕ Café (lunch booking advised, tel 020 7563 9505)

♿ Wheelchair access

Bequeathed to the nation in 1897, the Wallace Collection is that rare creature, a seriously sexy museum. Housed in a sumptuous Italianate palazzo in a leafy Marylebone square, it's chock full of fine and decorative art works acquired in the 18th and 19th centuries by the aristocratic and scandalous Hertford family. Its 25 galleries are a cornucopia for connoisseurs, but the casual visitor will enjoy the Collection's ambience as much its artefacts: it has an old-fashioned aura of discreet luxury, with antique clocks ticking quietly in gracious rooms, and friendly, helpful room stewards.

Many famous paintings reside here – Frans Hals *The Laughing Cavalier*, Poussin's *A Dance to the Music of Time* and Fragonard's deliciously frothy *The Swing* among them. Hertford House is also home to top-notch old master paintings by Titian, Rubens, Murillo and Canaletto, and portraits by Gainsborough and Reynolds. Some of the subject matter is on the racy side – there's a wonderfully louche portrait of Nelson's squeeze Lady Hamilton, reclining on a leopardskin in a state of semi undress, as well as a clutch of risqué Dutch genre paintings like Jan Steyn's *The Lute Player*.

Clearly, the Hertford family had an appetite for the good things in life, and today a sumptuous refurbishment programme is bringing the gracious interiors of the Wallace back up to the mark – at the time of writing the three East Galleries are closed while they are returned to their original 19th-century top lit, high ceilinged splendour. First time

visitors, or lapsed regular ones, should prepare to have socks blown off by the lavish new interior schemes of the Oval Drawing Room and The Small Drawing Room. The former is a late Rococo masterpiece, decorated in pale blue moiré damask and featuring a suite of fleshy paintings by Boucher and the Comte d'Orsay's rolltop desk. Other recently completed rooms are the Large Drawing Room and the Study, the former a resplendently masculine space decked out in dark green silk against which the Dutch Old Master paintings and black and gold of the Boulle marquetry furniture sing out. In contrast the Study is an entirely feminine space with full-on coral colour scheme, decorated in the style of Marie Antoinette's boudoir and furnished with elegant Riesener furniture once owned by the French queen. Also among the goodies in this room are two lavish Sèvres ice-cream coolers from the 'Catherine the Great' service – one of the most expensive ever produced in Europe. These pieces are just part of the Wallace's collection of Sèvres porcelain, the most complete museum collection of this type in the world.

On the ground floor, four galleries are given over to baronial-style displays of European and Oriental arms and armour, some of it incredibly elaborate. Exhibit A19, a pair of 16th-century chainmail trunks, puts a whole new perspective on macho underwear. Other displays feature gold boxes, Renaissance bronzes, medieval manuscripts and majolica pottery. A suite of galleries on the lower ground floor provide a venue for temporary exhibitions while the Ritblat Conservation Gallery explores some of the intricate processes that went into making Boulle marquetry furniture and 16th century armour.

Public tours help the visitor make the most of this diversity – given by Wallace Collection staff and other experts, these are free of charge and are held on days when there is not a special themed talk (see website for schedule). Independent souls can opt for the audio guide, which offers a selected highlights tour as well as tours for the visually impaired and those with learning difficulties.

Visitor facilities here are in keeping with the high-end surroundings – the Marquessses of Hertford didn't slum it and neither will you. The airy courtyard of Hertford House, complete with glass roof, is now home to some blissfully spacious ladies' loos and a popular café/restaurant – lunch booking is advised. Alternatively, visitors may prefer to head for the cafés of nearby Marylebone High Street. The shop on the ground floor also has a suitably upmarket feel: its scholarly catalogues don't come cheap, but the guidebook to the collection is a good investment at under a tenner. As well as the usual posters and postcards, there's an imaginative range of gifts inspired by the collection including jewellery, colourful and kitsch 'Sèvres' tin picnic plates.

North

Ben Uri Gallery – The London Jewish Museum of Art

- 📠 108a Boundary Road, NW8 0RH
- ☎ 020 7604 3991
- ✐ www.benuri.org.uk
- 🚍 Swiss Cottage LU or St John's Wood LU, bus 31, 139, 189
- 🕐 Mon-Fri 10.00-17.30; Sun 12.00-16.00 (the gallery closes at 15.30 on Fridays between 1 November-1 March)
- 💷 Admission free
- ♿ Disabled access (ground floor only)

The Ben Uri Art Society was founded in 1915 and is dedicated to promoting Jewish art as a fundamental part of Jewish heritage. Its permanent collection contains nearly 1,000 works by artists such as Lucien Pissarro, Jacob Epstein and R. B. Kitaj and is the world's largest holding of Anglo Jewish art. Treasures include David Bomberg's seminal *Ghetto Theatre* (1920), Mark Gertler's *Rabbi and Ribbitzin* and *Nude Standing* (1954) by Frank Auerbach.

After several years without a home of its own, the Society (rebranded as Ben Uri Gallery) moved to its current premises in 2001, but is now on the hunt for a bigger space in Central London where is can establish a permanent museum and exhibition space. In the meantime the gallery continues to mount a regular programme of exhibitions and events. The exhibitions usually (but not always) draw on works from the permanent collection and have included important retrospectives of Jewish artists like Jacques Lipchitz, David Bomberg and Jacob Estein and Droa Gordine. The Ben Uri is co-organiser of the Jewish Artist of the Year competition, held biennially.

Camden Arts Centre

- Arkwright Road (corner of Finchley Road), NW3 6DG
- ☎ 020 7472 5500
- ✐ www.camdenartscentre.org
- Finchley Road LU, Hampstead LU, Finchley Road, Frognal Rail
- ◷ Tues-Sun 10.00-18.00, Wed until 21.00
- ⅏ Admission free
- ◈ Bookshop
- ☐ Café
- ♿ Wheelchair access

A redevelopment in 2004 (to the tune of £4.2 million) breathed new life into this respected contemporary art venue. The upgraded new facilities include improved access, enhanced gallery space, on-site artists' studios, a ceramic studio, and a rather fine café. What hasn't changed is the Centre's inspirational 'roll up your sleeves and get stuck in' approach to the visual arts with visitors being encouraged to get involved in the integrated programme of exhibitions, educational projects and courses, artist-led workshops, exhibition tours and talks. The centre maintains its policy of showing both established and emerging artists and past exhibitions have showcased Dutch artist René Daniëls and German born American artist Eva Hesse. A rolling programme of artists' residencies is an added draw – residencies tend to last 6-8 weeks with regular 'open studio' slots allowing the public to see work in progress and talk to the artist. The foyer bookshop stocks an impressively up to the minute choice of art books, catalogues and periodicals as well as a range of limited edition and specially commissioned publications.

Centre for Recent Drawing

- 2-4 Highbury Station Road, N11SB
- ☎ 020 3239 6936
- ✐ www.c4rd.org.uk
- Highbury and Islington LU/Rail
- ◷ Thurs-Sat 13.00-18.00
- ⅏ Admission free (nb gallery is only open to the public during exhibitions)

The centre is run on a not-for-profit basis and its public exhibition space is dedicated to the often overlooked art of drawing. Regular exhibitions turn the spotlight on different drawing techniques and the centre also houses residencies – both studio and online - for artists for whom drawing is at the core of their work.

Estorick Collection of Modern Italian Art

⌂ Northampton Lodge, 39a Canonbury Square, N1 2AN

☎ 020 7704 9522

🖉 www.estorickcollection.com

🚃 Highbury and Islington LU/Rail

🕒 Wed-Sat 11.00-18.00 (Thurs until 20.00), Sun 12.00-17.00

💷 £5 (adults), £3.50 (concessions), free (under 16s/students)

🛍 Shop

☕ Café

♿ Limited wheelchair access

Works by Futurist artists Balla, Severini and Boccioni are at the heart of this superb private art collection, amassed by Eric and Salome Estorick after World War II. Opened in January 1998 and housed in a beautifully refurbished Georgian building, the collection has the distinction of being Britain's first museum devoted to modern Italian art. Works by Futurist artists such as Boccioni, Severini and Balla form the core of the collection but other major 20th-century Italian artists represented are metaphysical painter Giorgio de Chirico, Giorgio Morandi and master of the anorexic portrait, Amedeo Modigliani. Bronzes by Marino Marini and Giacomo Manzù are among the sculptures. Displays of the permanent collection change periodically for conservation reasons.

West

The Louise T Blouin Foundation

⌖ 3 Olaf Street, W11 4BE

☏ 020 7985 9600

✐ www.ltbfoundation.org

🚌 Latimer Road LU, Shepherd's Bush LU, Holland Park LU

🕐 Tues-Fri 10.00-18.00 (thurs until 21.00), Sat 12.00-18.00 during exhibitions; Mon-Fri 10.00-18.00 (when no exhibition)

🎟 Admission free

☕ Café

♿ Wheelchair access

Since opening in 2006, this sleek, white contemporary exhibition space has shown, among other things, lightworks by James Turrell and held a major retrospective of American architect Richard Meier. A programme of lectures and other events, such as music recitals, accompany the exhibitions.

Serpentine Gallery

⌖ Kensington Gardens, W2 3XA

☏ 020 7402 6075

✐ www.serpentinegallery.org

🚌 Lancaster Gate LU, South Kensington LU, Knightsbridge LU

🕐 Daily 10.00-18.00

🎟 Admission free

📖 Bookshop

♿ Wheelchair access

Art and nature combine perfectly at this publicly-funded art gallery. Set in the pastoral 18th-century landscape of the Royal Park, and housed in a former 1930s tea pavilion, the Serpentine provides an informal, relaxed location for viewing exhibitions of modern and contemporary art. Often challenging and controversial, recent shows have profiled Anish Kapoor and Wolfgang Tillmans. The gallery's facilities were enhanced by a £4 million renovation a few years ago and its unique atmosphere and abundant natural light have been praised by artists and critics alike. In 2012 the Serpentine's much-loved premises will be supplemented by The Serpentine Sackler Gallery, which will be housed in a listed, former munitions stores a short distance away on West Carriage Drive. The new gallery, which is being designed by Zaha Hadid, will be a centre of specially commissioned work and promises to nearly double the Serpentine Gallery footprint, as well providing the modern refinements of a shop, restaurant and café.

South

Café Gallery

- 🏢 By the lake, Southwark Park, SE16 2UA and Dilston Grove, Southwark Park, SE16 2DD
- ☎ 020 7237 1230
- ✏ www.cgplondon.org
- 🚌 Canada Water LU
- 🕐 Wed-Sun 11.00-16.00, Sat 12.00-16.00 (winter); Wed-Sun 12.00-18.00 (summer)
- 💷 Admission free
- ♿ Disabled access

Tucked away in Southwark Park – one of London's oldest Metropolitan parks – this artist-run enterprise has been described as 'the best kept art secret in Britain'. That perhaps shouldn't be a badge of honour for a public gallery that's been running for over 24 years but its exhibition programme of work by emerging artists is an invigorating one and Café Gallery Projects has not one but two spaces to its name. The gallery also runs a highly inclusive learning programme – everything from a craft club to a DIY Allotment project for local families and every year hosts a 'hang the lot' open exhibition.

Dulwich Picture Gallery

- 🏢 Gallery Road, SE21 7AD
- ☎ 020 8693 5254
- ✏ www.dulwichpicturegallery.org.uk
- 🚌 North Dulwich Rail, West Dulwich Rail
- 🕐 Tues-Fri 10.00-17.00, Sat-Sun and Bank Holidays 11.00-17.00
- 💷 £5 (adults), £4 (senior citizens), free (unemployed/disabled/students/children), additional £4 charge for special exhibitions
- 🛍 Shop
- ☕ Café
- ♿ Wheelchair access

Tucked away in a pleasant backwater of London, the DPG's small but perfectly-formed collection of Old Master paintings is a delight for art lovers. Arranged by school, the display has been described as a progression from the beer drinkers (Northern European artists) to the wine drinkers (the French, Spanish and Italian schools). A quick glance around the walls reveals a fair smattering of milk drinkers too – as in Rubens' voluptuous *Venus, Mars, Cupid* or Poussin's *The Nurture of Jupiter*.

Dulwich Picture Gallery

Rembrandt's *Girl leaning on a window sill* is perhaps the gallery's most famous work and in days gone by was the one most copied by art students – an honour which today falls to Poussin, who is represented in the gallery by seven superlative paintings. The gallery is full of familiar faces and names – Murillo's *Flower Girl*, Joshua Reynold's bespectacled self-portrait, and Gainsborough's double portrait of beautiful chanteuses, the Linley sisters. Another famous beauty of her day, Lady Venetia Digby, appears here in a poignant deathbed portrait of her by Van Dyck. Guido Reni's *St Sebastian* has been restored to its original place of honour overlooking the gallery's central enfilade while, around the corner in the Italian Baroque gallery, Sebastiano Ricci's action-packed canvas *The Fall of the Rebel Angels* should be warning enough to keep viewers on the straight and narrow.

Concise, entertaining wall labels accompany the paintings and free tours are held on Saturdays and Sundays at 15.00. The gallery's distinctive building is as noteworthy as its contents – built by Sir John Soane (see p.76), it is England's oldest public gallery and was the inspiration behind Sir Giles Gilbert Scott's design for the classic

red telephone box in the 1920s and many other art museums world-wide. Unlike your common or garden art gallery however, the DPG also includes a built-in mausoleum, where the mortal remains of the gallery's three founders are kept to this day.

The subject of a major millennial refurbishment, the gallery looks resplendent and also boasts a beautiful new visitor wing – a bronze and glass 'cloister' designed by Rick Mather. The elegant café housed here serves tasty light lunches, coffees and teas while over in the foyer of the main building, the shop stocks a good selection of books, cards and original gifts. A lively programme of loan exhibitions supplements the permanent collection – recent shows have included the Wyeth Family, Savlator Rosa and Norman Rockwell.

Pump House Gallery

- Battersea Park, SW11 4NJ
- 020 8871 7572
- Sloane Square LU; Battersea Park or Queenstown Road Rail
- Wed, Thurs, Sun and Bank Holidays 11.00-17.00;
 Fri-Sat 11.00-16.00 (during exhibitions)
- Admission free
- Café nearby in park

Occupying a pretty lakeside setting in Battersea Park, this former Victorian waterpumping building now houses Wandsworth's only public art gallery. The gallery is dedicated to contemporary art and hosts around six exhibitions a year of work by emerging and established artists, often featuring specially commissioned pieces, as well as touring exhibitions and locally curated projects.

South London Gallery

- 65 Peckham Road, SE5 8UH
- 020 7703 6120
 020 7703 9799 (info line)
- www.southlondongallery.org
- Elephant & Castle LU, then bus P3, 12 or 171;
 Oval LU, then bus 436, 36
- Tues-Sun 11.00-18.00 (Wed until 21.00)
- Admission free
- Café
- Wheelchair access

Founded over a century ago to bring the best in contemporary art to the 'working people of South London', the South London Gallery continues to stage an exciting, free programme of new art exhibitions, off-site projects and live art events in parallel with an education programme

working with local people. The gallery's acclaimed exhibitions have profiled the work of established international artists such as Alfredo Jaar and Tom Friedmann, as well as showcasing younger and mid-career British artists such as Eva Rothschild and Ryan Gander. In 2010 the SLG's Baroque-style Victorian gallery was joined by three new exhibition spaces, a flat (for artists in residence) and a café, conjured out of an adjacent derelict house by 6a Architects. The new premises also include an education room and an events studio. The gallery's collection of Victorian and later British art, which includes work by Leighton, Millais and Spencer, is held in storage and may be viewed by appointment.

South London Gallery

East

Chisenhale Gallery

- 64 Chisenhale Road, E3 5QZ
- 020 8981 4518
- www.chisenhale.org.uk
- Bethnal Green LU, Mile End LU
- Wed-Sun 13.00-18.00
- Admission free
- Disabled access

Located in a capacious former veneer works, Chisenhale runs as a non-profit making charity. It's a great place to see new work, specially commissioned by the gallery for the site, by artists at the start of their careers. Up to five new pieces are commissioned every year and recent shows have included Josephine Pryde and Florian Hecker.

Matt's Gallery

- 42-44 Copperfield Road, E3 4RR
- 020 8983 1771
- www.mattsgallery.org
- Mile End LU
- Wed-Sun 12.00-18.00 during exhibitions
- Admission free
- Bookshop
- Wheelchair Access

Another gallery with charitable status and like the Chisenhale (above), all work exhibited here, be it painting, video installation or sculpture, is commissioned specially for the gallery space. Matt's also represents a number of artists – its 'stable' of well-respected contemporary artists includes Mike Nelson, Willie Doherty, Nathaniel Mellors and Lucy Gunning. The bookshop sells the gallery's own publications and there's a reading room and archive.

The Showroom

- 63 Penfold Street, NW8 8PQ
- ☎ 020 7724 4300
- ✍ www.theshowroom.org
- 🚌 Edgware Road LU
- 🕐 Wed-Sat 12.00-18.00
- 🎫 Admission Free

This publicly-funded contemporary art gallery stages four exhibitions a year, with an emphasis on cross-disciplinary and collaborative shows. Artists are commissioned to make new work for the space and it's cutting-edge stuff – Showroom allumni include Jim Lambie, Sam Taylor-Wood and Eva Rothschild.

Whitechapel Art Gallery

- 80-82 Whitechapel High Street, E1 7QX
- ☎ 020 7522 7888
- ✍ www.whitechapelgallery.org
- 🚌 Aldgate East LU
- 🕐 Tues-Sun 11.00-18.00 (Thurs until 21.00)
- 🎫 Admission free
- 📚 Bookshop
- 🍴 Café and Dining Room
- ♿ Disabled access

Now one of Britain's leading venues for exhibitions of modern and contemporary art, the Whitechapel opened in 1901 with the aim of bringing major artworks to London's East End. It's certainly achieved that goal with distinction – Picasso's *Guernica* was shown here in 1939 and in the post-war period the Whitechapel showcased trailblazing artists such as Jackson Pollock, Joseph Beuys and David Hockney. More recently, artists as various as Cornelia Parker, Langlands & Bell, and Marcus Coates have featured here. A multi-million pound development project opened in 2009 and has seen this East London institution double in size with its expansion next door into the former Passmore Edwards Library building. The new enlarged Whitechapel now includes a gallery for showing international art collections, a gallery for specially commissioned work, an archive gallery and an education/research room, as well as a new street facing café.

Outskirts

Bethlem Gallery

🖃 Bethlem Royal Hospital, Monks Orchard Road,
Beckenham, Kent, BR3 3BX

☎ 0203 228 4835

✐ www.bethlemgallery.com

🚌 Eden Park or East Croydon Rail then bus 119/194

🕘 Call before visiting as opening times vary

💰 Admission free

This gallery, located within the creative workshops building of the Bethlem Royal Hospital, shows contemporary work by artists with mental health problems. Part of the Bethlem Royal Hospital, the gallery holds several exhibitions a year, showcasing work in a variety of media. The Bethlem Royal Hospital Archives & Museum (see p. 172) has been known to purchase works for their collection from the exhibitions and the gallery's programme always has a waiting list of artists.

Marianne North Gallery

🖃 Royal Botanic Gardens, Kew, TW9 3AB

☎ 020 8332 5655 (Information line)

✐ www.kew.org

🚌 Kew Gardens LU

🕘 Daily 9.30 onwards (phone or see website for closing time)

💰 Admission (includes entrance to Kew Gardens) £13.90 (adults),
£11.90 concessions, free (under 17s)

🛍 Shops

🍵 Cafés

Marianne North was a Victorian artist who specialised in painting flowers with remarkable single-mindedness. An indefatigable traveller, Miss North voyaged across the world to paint plants in their natural habitat, visiting Australia and New Zealand at the suggestion of Charles Darwin. Although she lacked any formal art training, Miss North was a fast worker and today some 832 of her distinctive oil paintings can be seen in the purpose-built gallery she gave to the Botanic Gardens, whose collection of exotic plants had first inspired her. Described by one commentator as a 'botanical stamp album', the gallery contains a colourful narrative of flowers, fruits, landscapes and people, taking in harvest scenes in Java, the flora of Borneo and Koalas in New Zealand. When Miss North's request that her gallery should serve refreshments to visitors was not honoured, the redoubtable artist pointedly included portraits of tea and coffee plants above two of the doors.

The gallery – a curious Greek-temple-meets-colonial villa hybrid – re-opened in 2009 after major restoration and today the floor-to-ceiling display of beautifully conserved paintings is supplemented by an intepretation room and touch-screens, which allow us to see what the views painted by Miss North look like today. The passage of time has not necessarily been kind and the then and now images of a pristine Jamaican bay obliterated by a modern tourist resort make for a damning indictment of human rapaciousness. More conventional botanical illustration can be admired in the adjoining building, the Shirley Sherwood Gallery (see p.235).

Marianne North Gallery

Orleans House Gallery & the Stables Gallery

⌗ Riverside, Twickenham, TW1 3DJ

☎ 020 8831 6000

✎ www.richmond.gov.uk

🚌 Richmond LU/Rail, St Margarets Rail, Twickenham Rail

🕐 Tue-Sat 13.00-17.30 (closes 16.30 Oct-Mar),
 Sun & Bank Hols 14.00-17.30

💰 Admission free

🛍 Small shop

☕ Café

♿ Wheelchair access (to ground floor and Octagon Room)

A vibrant and varied programme of events means a new exhibition opens here every ten weeks or so. The work of local artists, designers and photographers, and of young curators is showcased in these two galleries, as well as items from the Borough of Richmond's Art Collection (18th-20th century art). Orleans House was once a royal residence, but if that doesn't cut any ice with the kids, the activity packs and half term and weekend workshops should do the trick. An injection of Lottery cash has paid for a much-needed upgrade of the Stables area – improved lighting and heating, the installation of a studio for an artist in residence and a café. If you run out of things to do on this side of the river, you can hop on a ferry to Ham House (see p.180) on the other bank.

The Riverside Gallery

⌗ Old Town Hall, Whittaker Avenue, Richmond TW9 1TP

☎ 020 8831 6000

✎ www.richmond.gov.uk/arts

🚌 Richmond LU/Rail

🕐 Mon & Wed 10.00-18.00; Tues, Thurs & Fri 10.00-17.00;
 Sat 10.00-13.30

💰 Admission Free

♿ Disabled Access

Managed by Orleans House Gallery, the Riverside runs a year-round rolling programme of art exhibitions. Shows are usually of work by living artists and embrace a wide range of media from photography, painting, poetry and sculpture to installation art. The Old Town Hall also houses the Museum of Richmond (see p. 187) as well as the local studies collection, reference library and tourist information centre.

Shirley Sherwood Gallery

🏛 Royal Botanic Gardens, Kew, TW9 3AB

☎ 020 8332 5655 (information line)

✎ www.kew.org

🚇 Kew Gardens LU

🕐 Daily 9.30 onwards (phone or see website for closing time)

💷 Admission (includes entrance to Kew Gardens) £13.90 (adults),
£11.90 concessions, free (under 17s)

🛍 Shops

☕ Cafés

Kew holds one of the world's greatest collections of botanical art but until this gallery opened in 2008, had nowhere to display these often fragile works. Designed by architects Walters & Cohen and built next to the Marianne North Gallery (see p.232), this sleek, purpose built gallery finally allows the public the chance to see Kew's gems, along with pieces from Dr Sherwood's own impressive collection of contemporary botanical illustration.

Stanley Picker Gallery

🏛 Faculty of Art, Design & Architecture, Kingston University,
Knights Park, Kingston upon Thames, KT1 2QJ

☎ 020 85478074

🚇 Kingston Rail then 10 minute walk

🕐 Tue-Fri 12.00-18.00, Sat 12.00-16.00, Mon by appointment

💷 Admission free

Established in 1997, this gallery holds a rolling programme of events and exhibitions. The Fellowship Programme of the same name provides leading Fine Art and Design practitioners with the opportunity to develop an innovative project that is premiered at the Gallery.

The Toilet Gallery

🏛 Nipper Alley, Kingston Upon Thames, KT1 1QT

☎ 07881 832291

✎ www.toiletgallery.org

🚇 Kingston Rail

🕐 see website for details

💷 Admission free

Located in a former 1950s ladies' toilet block, this is surely one of London's most unusual art venues. Rescued from dereliction by Paul Stafford, the Director of Kingston University's Studies in Art & Design, the loos were transformed into a gallery space and opened by Gilbert and George in 2003 (appropriately by cutting toilet roll). This artist-run gallery is now a focus for avant garde art exhibitions and events.

Commercial
Galleries

Commercial Art Galleries

Lazarides

As befits one of the world's pre-eminent art capitals, London is positively brimming over with commercial galleries. In fact there are literally scores of these 'art shops', catering for all tastes and pockets but, given the vagaries of commerce, this introduction doesn't attempt to provide exhaustive listings. Rather, its selection aims to give some idea of the range of galleries in London and to act as a springboard for independent exploration.

Art lovers planning to do some serious gallery-going should look out for *Galleries*, a monthly magazine with gossipy art world editorial, reviews and a reasonably comprehensive listings of current shows. In a similar vein, the more specialised bi-monthly listings leaflet *New Exhibitions of Contemporary Art* gives the lowdown on where to sample the latest trends. Both publications come complete with maps and are available free of charge at participating galleries.

Once Cork Street was shorthand for the place to see the best in contemporary art but, although 'the street' is still home to some prestigious and long-established galleries, top-quality, cutting edge art emporia can now be found all over London. In the east of London, Hackney has reinvented itself as the city's artist quarter and is chock-a-

block with galleries and studios, many of which are part of the 'Hidden Art' network (ring 020 7729 3800, or visit www.hiddenart.com for more details). Hoxton too has got in on the act while over at Bankside, Tate Modern has helped to transform Southwark into a new focal point for contemporary and modern art. Although Bond Street and St James's remain the heartland of the most exclusive Old Masters and modern art dealers, really dedicated gallery-goers now have to venture well beyond the cosseted confines of W1 to keep up to date. But the extra travelling is well worth the effort – London's gallery scene is diverse and vibrant.

For those short on time or energy, art fairs are a great way of cutting down the legwork. A variety of these shindigs are held throughout the year in the capital, conveniently uniting often far flung galleries under one roof. Some – like The London Original Print Fair – are more specialist than others but all are perfect for those intent on seeing (or indeed, buying) a lot of art in one hit. A listing of some of the most well known is included below.

Of course there's no denying that with their minimalist, white-walled interiors, telephone-number price tags and well-bred staff, some galleries can appear intimidating. Look beyond the classy accoutrements though and the bottom line is that galleries are essentially shops selling a commodity – and remember that no retailer ever made money by turning people away. There's no need to brazen it out, galleries are just as much a magnet for scruffy art students as they are for Gucci-clad collectors. (Incidentally, if you're not 'just looking' but in the market for a little something to put over the mantelpiece, do bear in mind that most galleries, no matter how plush, carry stock at a wide range of prices, and that it's always worth asking a dealer for their 'best price'). Look out for galleries that are part of the Arts Council backed 'Own Art' scheme – aimed at helping artists, galleries as well as consumers – this is a great package that offers up to £2,000 worth of interest free credit to customers at participating galleries (www.artscouncil.org.uk/ownart).

In the context of this guide though, what's equally pertinent is that commercial galleries can often be the place to see museum-quality art work. Many galleries put on a new exhibition every 4-6 weeks (a much faster turnaround than bureaucracy-bound museums), with particularly important shows being accompanied by glossy, sometimes scholarly catalogues, and attracting serious media coverage. As exhibitions at public art galleries increasingly come with a hefty entrance fee, perhaps it's not so far-fetched to see commercial galleries as fulfilling an egalitarian, even educational, role – after all, they're open to the public, are free of charge and generally less crowded than congested blockbuster shows at museums. Perhaps culture and capitalism aren't such strange bedfellows after all.

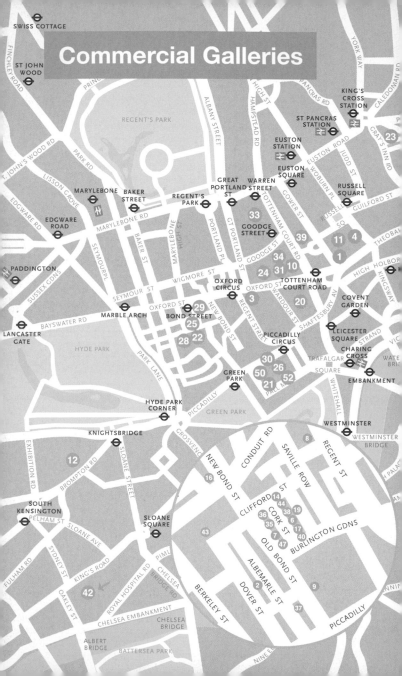

Commercial Galleries

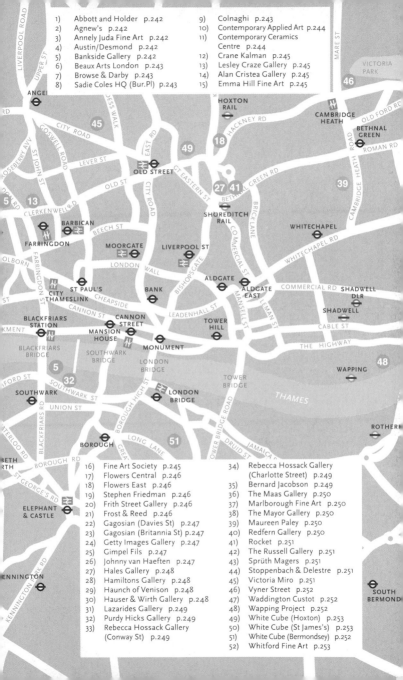

Commercial Gallery Listing:

Abbott and Holder

- 30 Museum Street, WC1A 1LH
- 020 7637 3981
- www.abbottandholder.co.uk
- Mon-Sat 09.30-18.00 (Thurs until 19.00)

A browser's (and buyer's) paradise. Abbott and Holder was founded in 1936 and deals in reasonably priced English watercolours, drawings and oils from the 18th-20th centuries. Ranged over three floors, the displays nearly always include a temporary exhibition on the first floor.

Agnew's

- 35 Albemarle Street, W1S 4JD
- 020 7290 9250
- www.agnewsgallery.com
- Mon-Fri 10.00-17.30, Sat by appointment only

The gallery is known for its stock of Old Masters, but it also deals in English paintings, drawings and watercolours as well as 20th century and contemporary British work.

Annely Juda Fine Art

- 23 Dering Street, W1S 1AW
- 020 7629 7578
- www.annelyjudafineart.co.uk
- Mon-Fri 10.00-18.00, Sat 11.00-17.00

Top-notch contemporary and modern art.

Austin/Desmond

- Pied Bull Yard, 68-69 Great Russell Street, Bloomsbury, WC1B 3BN
- 020 7242 4443
- www.austindesmond.com
- Mon-Fri 10.30-17.30, Sat 11-14.30

Modern British paintings, ceramics and sculptures.

Bankside Gallery

- 48 Hopton Street, SE1 9JH
- 020 7928 7521
- www.banksidegallery.com
- Daily 11.00-18.00 during exhibitions
- Shop

Bankside Gallery is the gallery of two distinguished artists' organisations: the Royal Watercolour Society, and the Royal Society of Painter-

Printmakers, and its changing programme of exhibitions showcases the best in contemporary watercolour and original print. Founded in 1804 the RWS is the oldest watercolour society in the world, while the painter-printmakers set up their society in 1880; the latter hold their annual members' exhibition in May. Almost all works, both framed and unframed, are available for sale.

Beaux Arts London

22 Cork Street, W1S 3NA

020 7437 5799

www.beauxartslondon.co.uk

Mon-Fri 10-17.30, Sat 10-13.30

Best-known for showing Modern British names like Frink and Hepworth, this gallery increasingly shows young, upcoming British artists.

Browse & Darby

19 Cork Street, W1S 3LP

020 7734 7984

www.browseanddarby.co.uk

Mon-Fri 10.00-17.30, Sat 11.00-14.00

Late 19th-century and early 20th-century English and French art, as well as contemporary paintings and sculpture.

Sadie Coles HQ

69 South Audley Street, W1K 2QZ

020 7493 8611

www.sadiecoles.com

Tue-Sat 10.00-18.00

And

4 New Burlington Place ,W1S 2HS

Tues-Sat 11.00-18.00

This gallery shows work by emerging and established contemporary artists from around the world.

Colnaghi

15 Old Bond Street, W1S 4AX

020 7491 7408

www.colnaghi.co.uk

Mon-Fri 10.00-18.00

Old Master paintings and drawings. Founded in 1760, the gallery is one of the oldest and most distinguished in Europe and its Bond Street gallery is hung in suitably museum-like fashion.

Contemporary Applied Art

2 Percy Street, W1T 1DD

020 7436 2344

www.caa.org.uk

Mon-Sat 10.00-18.00

This well-respected artists' organisation celebrated its 60th anniversary in 2008. The gallery holds changing exhibitions upstairs, with a selection of members' work on show downstairs. Offering covetable jewellery, textiles, ceramics, furniture, metal and wood work.

Contemporary Ceramics Centre

63 Great Russell Street, WC1B

020 7242 9644

www.cpaceramics.com

Mon-Sat 10.30-18.00

Now housed in sleek architect-designed premises just opposite the British Museum, the gallery of the Craft Potters Association is the place for buying gorgeous ceramics by established makers such as Jane Cox, John Pollex, Richard Godfrey and Sean Miller. The gallery also hosts 'Setting Out', an annual exhibition of the work by the latest crop of ceramics graduates.

Contemporary Ceramics Centre

Crane Kalman

178 Brompton Road, SW3 1HQ

020 7584 7566

www.cranekalman.com

Mon-Fri 10.00-18.00, Sat 10.00-16.00

Handily located on the Knightsbridge shopping drag, this gallery is a specialist in post-war Modern British, international and contemporary art. Artists include Bomberg, Hans Hofmann and Winifred Nicholson.

Lesley Craze Gallery

33-35A Clerkenwell Green, EC1R 0DU

020 7608 0393

www.lesleycrazegallery.co.uk

Tues, Wed, Fri 10.30-18.00; Thurs 10.30-19.00; Sat 11.00-17.30

Delectable contemporary jewellery, metalsmithing and textiles from an international stable of makers.

Alan Cristea Gallery

31 & 34 Cork Street, W1S 3NU

020 7439 1866

www.alancristea.com

Mon-Fri 10.00-17.30, Sat 10.00-13.00

Twentieth century graphics, with a stable of artists ranging from Anni Albers to Eilidh Young, via Ben Nicholson and Andy Warhol.

Emma Hill Fine Art Eagle Gallery

159 Farringdon Road, EC1R 3AL

020 7833 2674

www.emmahilleagle.com

Wed-Fri 11.00-18.00, Sat 11.00-16.00

Mainly conceptual and abstract art on show here, although the gallery also publishes limited edition artists' books.

Fine Art Society

148 New Bond Street, W1S 2JT

020 7629 5116

www.faslondon.com

Mon-Fri 10.00-18.00, Sat 10.00-13.00

If you're trawling up Bond Street having done the rounds of Cork Street, keep some time and energy in reserve for this superb gallery – or, indeed, make it first on your list. Always a pleasure to visit, the FAS stocks a carefully edited selection of British art and design from the 17th century to the present day. The Society's Contemporary Gallery was inaugurated in 2005 to show work by artists such as Keith Coventry and Jason Martin.

Flowers

⌨ 21 Cork Street, W1S 3LZ
☎ 020 7439 7766
✐ www.flowersgalleries.com
🕘 Mon-Fri 10.00-18.00, Sat 10.00-14.00
And
☎ 82 Kingsland Road, E2 8DP
☎ 020 7920 7777
✐ www.flowersgalleries.com
🕘 Tues-Sat 10.00-18.00

Contemporary art with a strong graphics element – gallery artists include Glen Baxter, Tom Phillips and Peter Howson.

Stephen Friedman

⌨ 25-28 Old Burlington Street, W1S 3AN
☎ 020 7494 1434
✐ www.stephenfriedman.com
🕘 Tues-Fri 10.00-18.00, Sat 11.00-17.00

An interesting international roster of established contemporary artists that include Yinka Shonibare, Thomas Hirschhorn, Yoshimoto Nara, Catherine Opie and David Shrigley.

Frith Street Gallery

⌨ 17-18 Golden Square, W1F 9JJ
☎ 020 7494 1550
✐ www.frithstreetgallery.com
🕘 Tue-Fri 10.00-18.00, Sat 11.00-17.00

Established in 1989, this gallery moved from its original Frith Street premises in 2007. The gallery represents a stable of 22 contemporary artists from Britain and abroad. Every summer they stage an independently curated group show of non gallery artists.

Frost & Reed

⌨ 2-4 King Street, St James's,SW1Y 6QP
☎ 020 7839 4645
✐ www.frostandreed.com
🕘 Mon-Fri 10.00-18.00, Sat 11.00-14.00

Established in 1808, this gallery deals in 19th and 20th century art featuring big names like Giacommetti, Chagall, and Dufy. They recently opened a contemporary gallery within its King Street premises, showing works by artists such as Marcel Dyf and Karen Gunderson.

Gagosian Gallery

17-19 Davies Street, W1K 3DE

020 7493 3020

www.gagosian.com

Mon-Sat 10.00-18.00

Post-war and contemporary international art.

And

6-24 Britannia Street, WC1X 9JD

020 7841 9960

www.gagosian.com

Tues-Sat 10.00-18.00

This vast branch of the Gagosian empire opened in May 2004. Formerly municipal garages in the eternally up-and-coming King's Cross, the premises is host to high profile, large scale shows.

Getty Images Gallery

46 Eastcastle Street, W1W 8DX

020 7291 5380

www.gettyimagesgallery.com

Mon-Fri 10.00-17.30, Sat 12.00-17.30

Life through a lens at London's largest independent photographic gallery. Regularly changing exhibitions with prints available to buy in a huge variety of formats and framing options.

Gimpel Fils

30 Davies Street, W1K 4NB

020 7493 2488

www.gimpelfils.com

Mon-Fri 10.00-17.30, Sat 11.00-16.00

Long-established gallery with a commitment to contemporary art. Represented artists include Corinne Day, Albert Irvin, Peter Lanyon, as well as newer names such as Andres Serrano and Hannah Maybank.

Johnny van Haeften Gallery

13 Duke Street, St James's, SW1Y 6DB

020 7930 3062

www.johnnyvanhaeften.com

Mon-Fri 10.00-18.00

Specialists in 17th and 18th century Dutch and Fleming Old Master paintings.

Hales Gallery

⊞ Tea Building, 7 Bethnal Green Road, E1 6LA

☎ 020 7033 1938

✎ www.halesgallery.com

◷ Wed-Sat 11.00-18.00

Hales Gallery shows contemporary art by young British and international artists. Among the artists on its books are Bob and Roberta Smith, Richard Slee and Tomoko Takahashi.

Hamiltons Gallery

⊞ 13 Carlos Place, W1K 2EU

☎ 020 7499 9494

✎ www.hamiltonsgallery.com

◷ Tues-Fri 10.00-18.00, Sat 11.00-16.00

Modern and contemporary photography, with David Bailey, Alison Jackson and Don McCullin among the artists represented.

Haunch of Venison

⊞ 6 Haunch of Venison Yard, W1K 5ES

☎ 020 7495 5050

✎ www.haunchofvenison.com

◷ 10:00 - 18:00 Mon - Fri, 10.00 – 17.00 Sat

And

⊞ 6 Burlington Gardens, W1S 3ET

◷ 10:00 - 18:00 Mon - Fri, 10.00 – 17.00 Sat

One of the contemporary art scene's biggest names, you can see a real mix at the Haunch of Venison, from the emerging to the established.

Hauser & Wirth Gallery

⊞ 196a Piccadilly, W1J 9DY

☎ 020 7287 2300

✎ www.hauserwirth.com

◷ Tues-Sat 10.00-18.00

Housed in a magnificent Lutyens building (formerly a bank), this London branch of Swiss gallery Hauser & Wirth opened in 2003. Their stable of contemporary artists includes some impressive names – Louise Bourgeois and Paul McCarthy to name but two – and the gallery also owns the estate of Eva Hesse.

And

⊞ 23 Savile Row, W1S 2ET

☎ 020 7287 2300

Lazarides Gallery

- 11 Rathbone Place, W1T 1HR
- ☎ 020 7636 5443
- www.lazinc.com
- 🕐 Tues-Sat 11.00-19.00

A gallery that delights in its unconventionality. Lazarides sells "outsider art" and represents photographers, sculptors, agent provocateurs and the odd taxidermist.

Purdy Hicks Gallery

- 65 Hopton Street, Bankside, SE1 9GZ.
- ☎ 020 7401 9229
- www.purdyhicks.com
- 🕐 Mon-Fri 10.00-18.00, Sat 11.00-18.00

Estelle Thompson and Arturo di Stefano are among the contemporary artists represented by this Southwark-based gallery.

Rebecca Hossack Gallery

- 2a Conway Street, W1T 6BA
- ☎ 020 7436 4899
- www.r-h-g.co.uk
- 🕐 Mon-Sat 10.00-18.00

Specialists in Aboriginal and non-western art as well as contemporary art. Arranged over 3 storeys, the gallery's Conway Street exhibition space also includes a garden, which is sometimes used to display sculpture.
And

- 28 Charlotte Street, W1T 2NA
- ☎ 020 7255 2828

Smaller premises than above but also with changing programme of exhibitions.

Bernard Jacobson

- 6 Cork Street, W1S 3NX
- ☎ 020 7734 3431
- www.jacobsongallery.com
- 🕐 Mon-Fri 10.00-18.00, Sat 11.00-13.00

Contemporary and Modern, with a particular focus on British and American art.

The Maas Gallery

🏢 15a Clifford Street, W1S 4JZ
☎ 020 7734 2302
✎ www.maasgallery.com
🕒 Mon-Fri 10.00-17.30

Victorian and Pre-Raphaelite art. 'Antiques Roadshow' viewers will recognise proprietor Rupert Maas as one of the art experts.

Marlborough Fine Art

🏢 6 Albemarle Street, W1S 4BY
☎ 020 7629 5161
✎ www.marlboroughfineart.com
🕒 Mon-Fri 10.00-17.30, Sat 10.00-12.30 (closed Sat during August)

Another big name on the contemporary art scene. Marlborough's impressive stable includes artists such as Francis Bacon, Lucien Freud and Paula Rego. The gallery also sells graphics by modern masters like Picasso.

Maureen Paley

🏢 21 Herald Street, E2 6JT
☎ 020 7729 4112
✎ www.maureenpaley.com
🕒 Wed-Sun 11.00-18.00, and by appointment

Contemporary art – and how. The gallery's stable of artists includes Gillian Wearing, Hamish Fulton, Wolfgang Tillmans and Rebecca Warren.

The Mayor Gallery

🏢 22a Cork Street, W1S 3NA
☎ 020 7734 3558
✎ www.mayorgallery.com
🕒 Mon-Fri 10.00-17.30, Sat 12.00-15.00

The first gallery to open on Cork Street way back in 1925, the Mayor Gallery specialises in Dada and Surrealist art, as well as showing Pop art and works by British artists.

Redfern Gallery

🏢 20 Cork Street, W1S 3HL
☎ 020 7734 1732
✎ www.redfern-gallery.com
🕒 Mon-Fri 11.00-17.30, Sat 11.00-14.00

Founded in 1923 as an artists' co-operative, the Redfern has been in its current Cork Street premises since 1936. Today its roster of modern and contemporary artists include Eileen Agar, Leon Underwood, David Tindle and Annabel Gault.

Rocket

Tea Building, 56 Shoreditch High Street, E1 6JJ

020 7729 7594

www.rocketgallery.com

Tues-Fri 10.00-18.00, Sat & Sun 12.00-18.00

Rocket deals with international artists, specialising in abstract and minimalist art, as well as exhibiting work by photographers such as Martin Parr.

The Russell Gallery

12 Lower Richmond Road, SW15 1JP

020 8780 5228

www.russell-gallery.com

Tues-Sat 10.00-17.30

This Putney based gallery opened in 2003 and is primarily concerned with figurative art, specialising in work by artists such as Mary Fedden and Christopher Hall as well as younger painters like Julian Bailey, Tom Clifford and Susan Hocking.

Sprüth Magers

7A Grafton Street, W1S 4EJ

020 7408 1613

www.spruthmagerslee.com

Tues-Sat 10.00-18.00

This gallery shows international contemporary work and represents big names such as Dan Flavin and Nan Goldin.

Stoppenbach & Delestre

25 Cork Street, W1S 3NB

020 7734 3534

www.artfrancais.com

Mon-Fri 10.00-17.30, Sat 10.00-13.00

French 19th and 20th-century art, including works by the Barbizon school, can be found at this gallery.

Victoria Miro

16 Wharf Road, N1 7RW

020 7336 8109

www.victoria-miro.com

Tues-Sat 10.00-18.00

Not one but four Turner Prize nominees are represented by the gallery: Ian Hamilton Finlay, Peter Doig, Isaac Julien and Phil Collins, as well as two winners Chris Ofili and Grayson Perry.

commercial galleries

Vyner Street Gallery

- 23 Vyner Street, E2 9DG
- 07970484316
- www.vynerstreetgallery.co.uk
- Wed– Sun 12.00-18.00, except 'First Thursdays' 1pm – 9pm www.firstthursdays.co.uk

A contemporary space with two galleries showing anything from photography, to sculpture and video work.

Vyner Street has become a real art hub in recent years, with lots of galleries now to be found on this Hackney back street. On the first Thursday of each month the galleries open late and turn Vyner Street into one big arty party. Other Galleries on Vyner Street include:

Dialogue Art Space

- 43a Vyner Street
- 020 8980 5809
- www.dialogueatvynerst.com

Gift

- 10 Vyner Street
- 020 8983 7896
- www.10vynerstreet.com

Fred London

- 45 Vyner Street
- 020 8981 2987
- www.fred-london.com

Wilkinson

- 50-58 Vyner Street, E2 9DQ
- 020 8980 2662
- www.wilkinsongallery.com

Waddington Custot Galleries

- 11 Cork Street, W1S 3LT
- 020 7851 2200
- www.waddington-galleries.com
- Mon-Fri 10.00-18.00, Sat 11.00-13.30

A Cork Street landmark, Waddington Custot is a favourite haunt of serious collectors and scruffy art students alike. Expect to see interesting hangs of blue chip modern and contemporary art by the likes of Antoni Tàpies, Jean Dubuffet, Ian Davenport, Barry Flanagan and Patrick Caulfield.

Wapping Project

- Wapping Hydraulic Power Station, Wapping Wall, E1W 3SG
- 020 7680 2080
- www.thewappingproject.com
- Mon-Sat 12.00-15.30; 18.30-23.00; Sat 10.00-12.30, 13.00-16.00; 19.00-23.00; Sun 10.00-12.3-, 13.00-16.00
- Café & Restaurant

White Cube

48 Hoxton Square, N1 6PB

020 7930 5373

www.whitecube.com

Tues-Sat 10.00-18.00

And

25-26 Mason's Yard (off Duke Street), St James's, SW1Y 6BU

020 7930 5373

Tues-Sat 10.00-18.00

So cutting-edge it hurts, White Cube is the ne plus ultra of galleries dealing in contemporary art. The sleek purpose built new gallery in Mason's Yard opened in 2006 and houses two gallery spaces while the Hoxton gallery is based in a chic converted 1920s industrial building. Perhaps most famous for representing Damien Hirst, White Cube also exhibits a range of European and British artists.

And

144-152 Bermondsey Street, SE1 3TQ

020 7930 5373

Wed-Sat 10.00-18.00, Sun 12.00-18.00

The latest addition to the White Cube empire opened in October 2011 and clocking in at a whopping 58,000 square feet, at a stroke became the UK's biggest commercial gallery space. Housed in a 1970s former warehouse, the the new gallery ramps up the White Cube's art-world heft with 3 main exhibition spaces as well as a museum-y type features such as bookshop and an auditorium for showing films and staging lectures. If you're a punter, private viewing rooms are available in which to contemplate potential purchases.

Whitford Fine Art

6 Duke Street St James's, SW1Y 6BN

020 7930 9332

www.whitfordfineart.com

Mon-Fri 10.00-18.00

Well-established gallery dealing in top-end French and British 20th century paintings and sculpture.

Appendix

Exhibition & Heritage Venues

appendix

Age Exchange Reminiscence Centre

⌨ 11 Blackheath Village, SE3 9LA

☎ 020 8318 9105

✉ administrator@age-exchange.org.uk

✉ www.age-exchange.org.uk

🚌 Blackheath Rail

🕐 Mon-Fri 10.00-17.00, Sat 10.00-16.00

♿ Admission free (charge for groups)

☕ Café

This voluntary organisation arranges inter-generation activities and projects, based around the reminiscences of older people. The organisation also runs a small museum and shop.

Asia House

⌨ 63 New Cavendish Street, W1G 7LP

☎ 020 7307 5454

✉ enquires@asiahouse.co.uk

🚌 Oxford Circus LU, Regents Park LU, Portland Street LU

🕐 Mon-Fri 09.00-19.00, Sat 10.00-18.00 (during exhibitions only); Gallery open Mon-Sat 10.00-18.00

♿ Admission free

☕ Café

Based in an elegant neo-Classical 18th-century townhouse, Asia House is a pan-Asian organisation promoting appreciation and understanding of Asian countries, their arts, religions and economies. Its state of the art gallery is used for exhibitions of historical and contemporary visual arts, crafts and photography.

BFI Southbank

⌨ Belvedere Road, SE1 8XT

☎ 02 7928 3232

✎ www.bfi.org.uk

🚌 Waterloo Rail/LU, Charing Cross Rail/LU, Embankment LU

🎨 Gallery free

🛍 Shop

☕ Café

Film buffs love to 'bag' unusual movies in the much the same way that climbers 'bag' mountains – and this is one of the key places in London to do just that. A heady programme of classic and contemporary films, special film seasons, festivals and events make this a must for film fans. There's also a purpose built gallery for free entry 'moving image art' exhibitions as well as a Mediatheque offering on-demand access to hours of digital film.

Brunei Gallery

⌨ School of Oriental & African Studies,
University of London, Thornhaugh Street, WC1H 0XG

☎ 020 7898 4915 / 020 7898 4046 (recorded information)

✎ www.soas.ac.uk/gallery

🚌 Russell Square LU

🕐 Tues-Sat 10.30-17.00

🎨 Admission free

🛍 Bookshop

☕ Café

A gallery dedicated to showing works from Asia and Africa, historic and contemporary. The Japanese-inspired roof garden is also open to the public (same opening hours at the gallery). Dedicated to forgiveness, the garden opened in 2001 and offers a place for quiet contemplation as well as being a venue for theatrical and musical events, and tea ceremonies.

Canada House Gallery

⌨ Trafalgar Square, SW1Y 5BJ

☎ 020 7258 6421

🕐 Mon-Fri 10.00-18.00

🚌 Charing Cross Rail/LU, Leicester Square LU

🎨 Admission free

♿ Disabled access

Canada House hosts regular exhibitions of Canadian art with an emphasis on the contemporary.

Discover Greenwich - Royal Naval College

🖼 King William Walk, SE10 9LW

☏ 020 82694799

✎ www.oldroyalnavalcollege.org

🚌 Cutty Sark DLR, Greenwich Rail/DLR

🕓 Daily 10.00-17.00

💷 Admission free

🛍 Shop

☕ Café

♿ Wheelchair Access

Packed with history and sensational classical architecture, Maritime Greenwich has rightly been designated a World Heritage Site. As well as being the location of London's oldest Royal Park and top attractions such as the Royal Observatory, the Cutty Sark, and the National Maritime Museum, Greenwich is also home to the Old Royal Naval College, designed by Christopher Wren. The Painted Hall and Chapel can be viewed daily 10.00-17.00 and are well worth a peek, en route up to the RO and NMM. Probably the finest dining hall in the West, Wren's Painted Hall contains paintings by James Thornhill, including a vast ceiling decoration, a 19-year labour of love for which he was paid by the yard and finally knighted.

The visitor centre is a good starting point for first time visitors to Greenwich. It re-opened in early 2010 under the name 'Discover Greenwich' with a permanent exhibition about the history of Greenwich, from its early days as one of Henry VIII's many royal palaces to its development as a hub of naval activity, providing a home to the Royal Hospital for Seamen and later the Royal Naval College. The facilities feature a Tourist Information Centre, but also a 'learning suite' as well as all the usual places for you to spend your money – a shop, café, bar and brasserie.

The Hellenic Centre

🖼 16-18 Paddington Street, W1U 5AS

☏ 020 7487 5060

✎ www.helleniccentre.org

🚌 Baker Street & Bond Street LU

🕓 Mon-Sun 10.00-19.00

💷 Admission free

🛍 Shop

The Hellenic Centre hosts one major exhibition a year – such as 'Icons through the Centuries' – and occasional smaller shows on a Greek theme.

The Mall Galleries

Carlton House Terrace, The Mall, SW1Y 5BD

020 7930 6844

www.mallgalleries.org.uk

Charing Cross LU/Rail, Piccadilly Circus LU

Daily 10.00-17.00 (during exhibitions)

£2.50 (adults), £1.50 (concessions), free (children)

Bookshop

Café

The Mall Galleries is run by the Federation of British Artists, an umbrella organisation which represents the work of nine art societies. Exhibitions change regularly so it's advisable to phone in advance before visiting.

Royal College of Art Gallery

Kensington Gore, SW7 2EU

020 7590 4444

www.rca.ac.uk

Daily 10.00-18.00 (during exhibitions)

High Street Kensington LU

Admission free

The Royal College stages its degree show between May and July, but also plays host to other exhibitions featuring the work of its post-graduate students and external shows organised by selected partners. Lectures by leading figures from the worlds of art and design are another draw.

Salvation Army International Heritage Centre

House 14, William Booth College, Denmark Hill, SE5 8BQ

0207 326 7800

www.salvationarmy.org.uk/history

Tues-Fri 9.30-16.00

Exhibits concentrate on the history of the early Salvation Army and include a free audio tour lasting 45 minutes, fun worksheets for children, and videos of historic moments in army history. The centre is suitable for wheelchair access. Research facilities are available by appointment.

Somerset House

- Strand, London, WC2R 1LA
- ☎ 020 7845 4600
- www.somersethouse.org.uk
- Charing Cross LU/Rail, Covent Garden LU, Holborn LU, Temple LU (except Sun)
- Daily 10.00-18.00
- Admission free
- Wheelchair access
- Shop
- Café & Restaurant

This magisterial 18th-century complex was the work of Sir William Chambers, architect to King George III. Built on the site of the Renaissance palace belonging to Lord Protector Somerset, the present Somerset House was designed as what amounted to an early government office block, housing public offices for the Surveyor General and 'the Register of Births, Marriages and Deaths' (also known as Hatched, Matched and Dispatched). Chambers' rather austere Palladian creation was also the original home of the Royal Academy (see p. 212) so it was entirely fitting the Courtauld Gallery (see p. 200) moved here from Portman Square in 1990.

 A major refurbishment and restoration was undertaken and today a fountain now plays in the expansive central courtyard where civil servants once parked their cars. On summer evenings the courtyard plays host to open air music concerts and film screening, in winter it transforms into an ice rink. The space inhabited until recently by the Gilbert Collection has now been replaced by the new Embankment Galleries which will host a distinctive programme of curator led exhibitions covering architecture, art, design, fashion, and photography. Thankfully the Gilbert Collection has not been lost to London visitors – this dazzling array of gold, silver objets d'arts and micro-mosaics transferred to the V&A in 2009.

Thames Barrier Visitor Centre

- Unity Way, Woolwich, SE18 5NJ
- ☎ 020 8305 4188
- www.environment-agency.gov.uk
- Charlton Rail (then bus 177 or 180), North Greenwich LU (then bus 472 or 161)
- Daily 10.30-16.30 (April-Sept), 11.00-15.30 (Oct-March)
- £2 (adults), £1.50 (OAPs), £1 (children)
- Café

The Visitor Centre gives you a great view of the barrier and includes a display board exhibition, working model of the barrier and an 8 minute video documenting its construction.

Somerset House

Archives & Libraries

This listing is not intended to be exhaustive – London's archives and libraries merit a guide in their own right. In addition, many of the museums and galleries listed in this book also have their own research libraries and archives and more information about these can usually be found on the relevant institution's website.

African and Asian Visual Artists Archive

⌨ Diversity Art Forum, Learning Resources Centre,
University of East London, Docklands Campus, Royal Albert Way,
E16 2RD
☎ 020 8223 3132
✎ www.aavaa.org.uk
✎ P.Desouza@uel.ac.uk
🕘 by appointment only

An archive of material on visual artists and crafts people of African and Asian origin working in Britain.

Ashmole Archive

⌨ Dept of Classics, King's College London, Strand, WC2R 2LS
✎ classics@kcl.ac.uk

The Ashmole is a photographic archive of ancient Greek sculpture, which can be viewed by appointment only.

Black Cultural Archives

⌨ 1 Othello Close, SE11 4RE
☎ 020 7582 8516
✎ www.bcaheritage.org.uk
🕘 Archive currently closed to receive visitors

The Black Cultural Archive is a community based heritage organisation and archive which collects, preserves and celebrates the history and culture of black people in Britain. The archive's collection is currently closed to visitors while a major cataloguing project takes place. Work is also underway to establish a black Heritage Centre and purpose built archive in Brixton which will open in late 2012.

British Airways Archive and Museum Collection

British Airways Heritage Collection, Waterside, Speedbird Way
Harmondsworth, Middlesex, UB7 0GA

02085625777

www.bamuseum.com

Wed, Thurs, Fri 9.30-16.00 by appointment only

An extensive document archive recording the formation, development
and operations of British Airways and its predecessor companies.
Memorabilia and artefacts are joined by over 450 uniforms from
the 1930s to the present day, along with a large collection of aircraft
models and pictures. An important collection of thousands of photo-
graphs is also available as well as probably the most complete set of
aviation posters in the UK.

RIBA British Architectural Library

66 Portland Place, W1B 1AD

020 7307 3882

www.architecture.com

Tues 10-20.00, Wed-Fri 10-17.00, Sat 10-13.30

The UK's largest archives relating to architecture and architectural his-
tory, and one of the finest in the world. Free public access to the library
was introduced in January 2008. See also the RIBA Architecture Study
Rooms at the V&A (p. 261).

British Library

96 Euston Road, NW1 2DB

020 7412 7332

www.bl.uk

The British Library Galleries are already mentioned in this book, but
the library offers many other services and events including lectures
and concerts, a bookshop and educational services. Public tours of
the building take place every Monday, Wednesday, Friday and Saturday.
Oh and by the way, it also has just about the largest collection of
books in the world.

British Olympic Association Collection

Archives Department, University of East London,
University Way, E16 2RD

www.uel.ac.uk/lls/archives

The University of East London was chosen to host the historical ar-
chive and book collection of the British Olympic Association in the run
up to the 2012 London Olympic Games. The collection comprises of
records relating to the history and work of the BOA from 1906-2009,

and includes material on the history of the Olympic Movement, sport, sports science & sports administration, architecture and design. The collection is open to researchers, access is by appointment only.

BT Archives

⌖ Third Floor, Holborn Telephone Exchange,
 268-270 High Holborn, WC1V 7EE
☎ Historical enquiries 020 7440 4220
✎ www.bt.com/archives
🕓 Tues & Thurs 10.00-16.00 by appointment only

BT Archives preserves the historical information of British Telecommunications plc and its predecessors from the early part of the 19th century up to the present day. The archive contains telephone directories dating back to 1880, historical records, as well as the historic photographic, video and film collections of BT and Post Office Telecommunications.

City of Westminster Archives Centre

⌖ 10 St Ann's Street, SW1P 2DE
☎ 020 7641 5180
✎ www.westminster.gov.uk
🕓 Tues-Thurs 10.00-19.00, Fri & Sat 10.00-17.00

The archives contain varied collections relating to the history of Westminster and include the business records for companies such as Liberty, Jaeger and Lobbs as well as theatre programmes, maps and local government records from 1460.

Courtauld Institute of Art Libraries

⌖ Somerset House, Strand, WC2R
☎ 020 7848 2701 (Library) / 020 7848 2745 (Witt & Conway Libraries)
✎ www.courtauld.ac.uk
🕓 Witt & Conway Libraries open Mon-Fri 11.00-16.00 (except Easter & Christmas holidays) by reader's card only; Book Library by appointment

London's pre-eminent centre for the study of history of art has three libraries. The book library is aimed squarely at academics and contains a major collection of art books, periodical and exhibition catalogues, while the Witt Library contains some two million reproductions of works by over 70,000 artists, organised alphabetically within national schools. The Conway Library performs a similar service for architecture and sculpture, with over one million images, photographs and cuttings.

Crafts Council Research Library

44a Pentonville Road, Islington, N1 9BY
020 7806 2502
www.craftscouncil.org.uk
Wed & Thurs 10.00-13.00 or 14.00-17.00 by appointment

A free to browse library containing books, journals and videos relating to craft technique and practice, funding directories, as well as exhibition catalogues and Crafts Council research reports.

The Women's Library

London Metropolitan University, 25 Old Castle Street, E1 7NT
020 7320 2222
www.londonmet.ac.uk/thewomenslibrary
Reading Room open Tues-Fri 9.30-17.00 (Thurs until 20.00), Sat 10.00-16.00; Exhibitions open Mon-Fri 9.30-17.30 (Thurs until 20.00), Sat 10.00-16.00

This archive of women's history and reference material is the oldest and most extensive women's resource in Europe, established in 1926. Thanks to a Lottery grant the Library moved to its current, well-appointed premises in 2002. Its facilities include a reading room and an exhibition hall which hosts high quality changing exhibitions on often challenging themes.

Lambeth Palace Library

Lambeth Palace Road, SE1 7JU
020 7898 1400
www.lambethpalacelibrary.org
Mon-Fri 10.00-17.00

This library, founded in 1610 by Archbishop Bancroft, is one of the oldest public libraries in Britain. It is the principal library and record office for the history of the Church of England.

London Metropolitan Archives

40 Northampton Road, EC1R 0HB
020 7332 3820
www.cityoflondon.gov.uk
Mon 09.30-16.45; Tues, Wed and Thurs 09.30-19.30; for Saturdays openings (once monthly) check website

A treasure trove for anyone researching anything about London or Londoners. As country record office for Greater London, the LMA holds authority records for bodies such as the GLC and LCC, records for over 900 London parishes, business records, family papers and hospital archives (including letters from Florence Nightingale).

Marx Memorial Library

37a Clerkenwell Green, EC1R 0DU

020 7253 1485

www.marx-memorial-library.org

Mon-Thurs 13.00-18.00, reseachers only,
Mon-Thurs 13.00-14.00 visitors (for tours)

Books, pamphlets and periodicals covering all aspects of Marxism, the 'science' of Socialism and the history of working class movements. The library also contains an archive on the Spanish Civil War and an extensive picture library.

London Archaeological Archive & Research Centre

Mortimer Wheeler House, 46 Eagle Wharf Road, N1 7ED

020 7566 9317

www.museumoflondon.org.uk

Mon-Fri 10.00-16.00, first and third Sat of the month 10.00-16.00 (researchers only, by appointment)

Wheelchair access

The LAARC holds information on over 5,000 London sites and archaeological projects from the past 100 years, including records and finds from archaeological digs. This Museum of London venue is also home to the museum's social and working history collections.

National Art Library

V & A Museum, Cromwell Road, SW7 2RL

020 7942 2400

www.vam.ac.uk

Tue-Sat 10.00-17.30 (Fri until 18.30)

A major public reference library on the fine and decorative arts. Entry by reader's ticket.

National Portrait Gallery

Heinz Archive and Library, St Martin's Place, WC2H 0HE

020 7321 6617

www.npg.org.uk

By appointment Tues-Fri 10.00-17.00

This archive contains drawings, prints and photographs of British portraits dating from 1400 to the present day.

National Sound Archive

🖻 (part of The British Library), 96 Euston Road, NW1 2DB

☎ 020 7412 78317

✑ sound-archive@bl.uk

✑ www.bl.uk/nsa

🕓 Listening Service: by appointment

One of the largest sound archives in the world with over 3 million sound recordings. The extensive collection covers music (classical, popular, world and folk), drama and literature, oral history, dialects and accents, and wildlife sounds. Open to the public but readers using the Readers' Room must apply for a pass.

The National Archives

🖻 Kew, Surrey, TW9 4DU

☎ 020 8876 3444

✑ www.nationalarchives.gov.uk

🕓 Mon & Fri 09.00-17.00, Tues & Thurs 09.00-19.00,
 Wed 10.00-17.00, Sat 09.30-17.00

📚 Bookshop

🍽 Restaurant & Café/Bar

What used to be the Public Record Office has amalgamated with the Historical Manuscripts Commission to form the National Archives. Based in an impressive waterside building in Kew, this is the UK government's official archive and holds 900 years of official records, from the Domesday book to the latest government paper. Records are normally made available to the public when they have been archived for 30 years and can be accessed by anyone over the age of 14 on production of proof of address and identity (for UK/Eire citizens) or passport (for citizens of other countries).

For those researching family history, Kew is now also home to the archive of the Family Records Centre. This is the repository for census returns from 1841-1891, non-conformist records and records of the Prerogative Court of Canterbury, wills and administrations, as well as records of birth, deaths and marriages, dating back to 1837.

Regular exhibitions drawing on material in the National Archives are also held here – recent offerings have included a look at 'Britain during the Cold War' and 'The History of Alcohol'.

If you can't make it to Kew, the DocumentsOnline service (www.nationalarchives.gov.uk/documentsonline) provides online access to over a million digital images of documents held in the National Archives.

appendix

The Poetry Library

🖻 Level 5, Royal Festival Hall, Belvedere Road South Bank, SE1 8XX

☎ 020 7921 0943/0664

✍ www.poetrylibrary.org.uk

🕓 Tues- Sun, 11am - 8pm

The most comprehensive and accessible collection of poetry from 1914 in Britain, The Poetry Library within the Southbank Centre contains 90,000 items and is still growing. The Arts Council collection consists mostly of poetry from the UK and Ireland, a large selection from English-speaking countries worldwide, poetry in translation, poetry by and for children but also rap and concrete poetry. Audio and video facilities are available in addition to a large variety of magazines, press cuttings and downloadable poems in MP3 format. Finding a volume of poetry and tucking yourself away in The Poetry Library on Level 5 of the Royal Festival Hall overlooking the Thames is one of London's most enjoyable means of escapism.

The Puppet Centre Trust

🖻 BAC, Lavender Hill, SW11

☎ 020 7228 5335 (enquiries)

✍ www.puppetcentre.org.uk

🚍 Clapham Junction Rail

🕓 Library open by appointment only

♿ Wheelchair access

The Puppet Centre Trust is the national development agency for the art form of puppetry. The centre houses a collection of over 4,000 books, journals, videos, DVDs and photographs on puppetry and related art forms.

Royal Geographical Society

🖻 1 Kensington Gore, SW7 2AR

☎ 020 7591 3000

✍ www.rgs.org

🚍 South Kensington LU

🕓 Mon-Fri 10.00-17.00

♿ Wheelchair access

The Society holds one of the most important geographical collections in the world. The collection includes more than 150,000 books (dating from as far back as 1830), 800 current journal titles, expedition reports (including David Livingstone's), maps and charts, atlases and a picture library holding more than 500,000 images from around the world. If all of this stimulates the itchy feet the RGS provides a great deal of information on planning expeditions.

RIBA Architecture Study Rooms

V&A Museum, South Kensington, Cromwell Road, SW7 2RL

020 7307 3708

www.vam.ac.uk

Tues-Fri 10.00-17.00

A partnership between the V&A and the RIBA allowing access to the RIBA's outstanding collection of architectural drawings and manuscripts in the RIBA Architecture Study Rooms, housed alongside the V&A's Prints & Drawings Study Room. The collections comprise the RIBA's collection of drawings and archive and the V&A's collection of drawings, photographs and prints. An appointment system operates for the RIBA material.

The Royal Mail Archive

Freeling House, Phoenix Place, WC1X 0DL

020 7239 2570

www.postalheritage.org.uk

Mon-Fri 10.00-17.00 (Thurs until 19.00)
selected Saturdays 10.00-17.00

The archive, tucked away near Mount Pleasant sorting office, contains records of the Post Office and Royal Mail from 1636 to the present. It's a great place to find out more about the history of the postal service – the archive of staff records are a useful resource for family history researchers while the collection of British stamps runs from the Penny Black onwards. A small exhibition area holds regularly changing philatelic displays.

The Salvation Army International Heritage Centre

House 14, William Booth College, Denmark Hill, SE5 8BQ

020 7326 7800

www.salvationarmy.org.uk/heritage

Tues-Fri 9.30-16.00 by appointment

The Heritage Centre includes a reference library and archive and is open to researchers by appointment. Among the treasures in the archive are the papers of Sally Am founders William and Catherine Booth, plus a host of SA publications and records from UK local centres.

Science Museum Library

🖼 Imperial College Road, SW7 5NH

☎ 020 7942 4242

✐ www.sciencemuseum.org.uk

🕓 Mon-Fri 10.00-17.00

A national reference library for the history of science and technology.

The V&A Archives

🖼 Blyth House, 23 Blyth Road, W14 0QX

🕓 Archive of Art and Design: 020 7603 7493

🕓 Beatrix Potter Collections: 020 7603 7260

🕓 V&A Archive: 020 7602 8832

✐ www.vam.ac.uk/resources

🕓 Tues-Fri 10.00-16.30 by appointment

The V&A Archives contain 3 different archives. The Art and Design archive offers rich picking for art researchers. This archive's holdings reflects the V&A's own collections but has a particular emphasis on 20th and 21st century designers. The archives of key players such as Eileen Grey, Lucienne and Robin Day and Eduardo Paolozzi are just some of the treasures. The Beatrix Potter Collections hold important material relating to the famous writer/illustrator and include drawings, watercolours and original literary manuscripts. The V&A's own institutional archives are another significant resource for researchers and include details of the history of museum itself and the provenance of its millions of objects.

The Wiener Library

🖼 29 Russell Square, WC1B 5DP

☎ 020 7636 7247

✐ www.wienerlibrary.co.uk

🕓 Mon-Fri 10.00-17.30

The Wiener Library is one of the world's most extensive archives on the Holocaust and Nazi era. Formed in 1933 by Dr Alfred Wiener, the Library's unique collection of over one million items includes published and unpublished works, press cuttings, photographs and eyewitness testimony. The Library aims to provide a resource to oppose anti-Semitism and other forms of prejudice and intolerance.

Useful Addresses

Arts Council England, London

14 Great Peter Street, SW1P 3NQ
Tel: 0845 300 6200
enquiries@artscouncil.org.uk
www.artscouncil.org.uk
The national development agency for the arts.

Artsline

C/o 21 Pine Court, Wood Lodge Gardens, Bromley BR1 2WA
Tel: 020 7388 2227
admin@artsline.org.uk
www.artsline.org.uk
A campaigning disability access charity that provides details of access at arts venues. Artsline has an online website of approved accessible arts and entertainment venues and the website has recently undergone a transformation into an interactive online database. The friendly telephone advice service however continues for those who prefer to speak to a 'real person'.

Campaign for Drawing

7 Gentleman's Row
Enfield, EN2 6PT
Tel: 020 8351 1719
info@campaignfordrawing.org
www.campaignfordrawing.org
The Campaign for Drawing's aim is to encourage everyone to draw. Its annual drawing fest, The Big Draw, proves that drawing can be a public activity. Every October, 1,000 venues across Britain, from large national institutions to village halls, join in to offer many thousands of people of all ages the chance to discover that drawing is enjoyable, liberating and at everyone's fingertips.

Contemporary Art Society

11-15 Emerald Street, WC1N
Tel: 020 7831 1243
cas@contempart.org.uk
www.contempart.org.uk
A national non-profit agency that supports contemporary artists through the promotion of collecting and commissioning by individuals, and public and private bodies across the UK. The Society offers a programme of tours and events for its members and gives advice to companies and individuals who want to start their own collections.

ENGAGE (The National Association for Gallery Education)

Rich Mix
35-47 Bethnal Green Road, E1 6LA
Tel: 020 7729 5858
info@engage.org
www.engage.org
A membership organisation for gallery, art and educational professionals which promotes access to, enjoyment and understanding of the visual arts through education.

English Heritage

PO Box 569, Swindon, SN2 2YP
Tel: 0870 333 1181
customers@english-heritage.org.uk
www.english-heritage.org.uk
English Heritage manages historic houses and sites throughout the country, over 400 of which are open to the public (with free entry for EH members). If you want to find out more, phone and ask for an information pack.

The Museums, Libraries & Archives Council (MLA)

Wellcome Wolfson Building
165 Queen's Gate
South Kensington, SW7 5HD
Tel: 020 7273 1444
info@mla.gov.uk
www.mla.gov.uk
The government agency for museums, galleries, libraries and archives, launched in 2000 as the strategic body for this sector.

Museums Association

24 Calvin Street, E1 6NW
Tel: 020 7426 6910
www.museumsassociation.org
The MA represents the people and institutions that make up Britain's museums and galleries. Its publication, *Museums Journal*, is a must read for those working in the sector and for those hoping to do so.

The National Art Collections Fund

Millais House
7 Cromwell Place, SW7
Tel: 020 7225 4800
info@artfund.org
www.artfund.org
Becoming a member of the NACF gives free entry to over 200 museums and galleries as well as discounts on special exhibitions, access to special events and behind the scenes tours as well as an excellent free magazine. Your money contributes funds for the purchase of works of art for Britain's museums and galleries.

The National Trust

Central Office: Heelis, Kemble Drive, Swindon, SN2 2NA
Tel: 01793 817400
Tel: 0844 800 1895 (membership enquiries)
enquiries@thenationaltrust.org.uk
www.nationaltrust.org.uk
Founded in 1895 this independent heritage charity today protects some 350 gardens and houses, over 550 miles of coastline and 600,000 acres of countryside across England, Wales and Northern Ireland. Membership ensures free entry to all their sites.

VisitBritain

Head Office, 1 Palace Street
London, SW1E 5HE
Tel: 0207 578 1000
www.visitbritain.com
Britain's national tourism agency.

London Degree Shows

Degree and foundation shows are held by art colleges and universities in London during the summer months from May to August. They are a great opportunity to view the latest in art and craft, and if you attend on the opening day you can mingle with trendy art students, view their creations, drink cheap wine and maybe spot a potential art investment. Contact details for the various London art institutions are listed below. For current information about degree shows throughout the country, see the website set up by the Candid Arts Trust (candidarts.com).

Byam Shaw School of Art

🖃 2 Elthorne Road, Archway, N19 4AG

☎ 020 7514 2350

🖉 www.csm.arts.ac.uk

The degree show is normally held in June/July. For further information phone the college administration.

Camberwell College of Arts

🖃 Peckham Road, SE5 8UF

🖃 Wilsons Road, SE5

☎ 020 7514 6302

🖉 www.camberwell.arts.ac.uk

The degree and foundation shows are held during June, the MA shows in July at Peckham Road. Phone their office for details.

Central Saint Martin's College of Art & Design

🖃 Granary Building, 1 Granary Square, London, N1C 4AA

☎ 020 7514 7022

🖉 www.csm.arts.ac.uk

Now under one roof, Central Saint Martin's puts on both undergraduate and post graduate shows in June. The disciplines covered include fine art, scenography and theatre, textile and fashion design, ceramics and graphic design.

Chelsea College of Art & Design

🖃 16 John Islip St, SW1P 4JU

☎ 020 7514 7751

🖉 www.chelsea.arts.ac.uk

The foundation, MA and design shows usually take place between May and September with the popular MA Fine Art show being hosted in June/July, depending on term dates.

appendix

Goldsmiths College

New Cross, SE14 6NW

☎ 020 7717 2210

⌨ www.gold.ac.uk

Fine art, creative curating and textiles are the things to see here. Undergraduate shows are held in June, postgraduate shows in July although the exact dates vary from year to year. Check the website or phone for more information.

Kingston University

Faculty of Art, Design & Architecture, Knights Park, Kingston, KT1 2QJ

☎ 020 8417 4646

⌨ www.kingston.ac.uk

The university's degree show includes the work of fashion designers, photographers, graphic artists, architecture and landscape design students, product designers, and students of fine art. Shows tend to take place in mid June. The faculty is also home to the Stanley Picker Gallery (see p. 235), an exhibition space that holds a rolling programme of lectures and exhibitions. The University also runs the Dorich House Museum (see p. 175) and the avant-garde Toilet Gallery (see p. 235).

London College of Fashion

20 John Princes St, W1G 0BJ

☎ 020 7514 7400

⌨ www.fashion.arts.ac.uk

Most of the degree catwalk shows are in June and are by invitation only, but please enquire about related exhibitions. The College includes the Cordwainers College (182 Mare Street, E8 3RE) who hold their shows in June and July.

London College of Communication

Elephant & Castle, SE1 6SB

☎ 020 7514 6500

⌨ www.lcc.arts.ac.uk

This college, formerly known as the London College of Printing, has degree and foundation shows from mid May to the end of July. The disciplines covered include Graphic Design, Typography, Photography, Photojournalism as well as film and video making.

Sir John Cass Department of Art, Media & Design

London Metropolitan University, Central House, 59-63 Whitechapel High St, E1 7PF

☎ 020 7133 4200

⌨ www.londonmet.ac.uk

This university hosts its degree show in June. The disciplines include fine art, design, restoration and jewellery making.

Middlesex University

The Bourroughs, NW4 4BT

☎ 020 8411 5555

⌨ www.mdx.ac.uk

Middlesex University's School of Art holds its degree show in June and displays work from many disciplines from printed textiles to jewellery design to fine art.

Royal College of Art

- Kensington Gore, SW7 2EU
- The Sculpture School,
 15-25 Howie St, Battersea,
 SW11 4AS
- ☎ 020 7590 4498 (show hotline)
- www.rca.ac.uk

The Royal College hosts its degree shows on two sites between May and July. The disciplines covered include fine and applied arts, design, architecture and graphics, fashion & textiles which are all held at the Kensington Gore address, while sculpture and painting are exhibited at the Howie Street site.

The Slade School of Art

- University College London,
 Gower Street, WC1E 6BT
- ☎ 020 7679 2313
- www.ucl.ac.uk/slade

The Slade School holds undergraduate and post graduate shows in May and June. The disciplines covered include fine art, sculpture, photography and fine art media (photography, film and video and print).

University of East London

- 4-6 University Way, E16 2RD
- ☎ 020 8223 3000
- www.uel.ac.uk

The UEL holds its degree shows between June and July. Subjects include fine art, graphic design, textile design, fashion, digital arts and photography.

University of the Arts London

- www.arts.ac.uk

This new university launched in 2004 and is the only one dedicated to the arts in the UK and the biggest of its kind in Europe. Its collegiate structure brings together six London art and design institutions, namely Chelsea College of Art, Camberwell College of Art, London College of Communication, London College of Fashion, Central St Martin's and Wimbledon College of Art (see separate listings for details).

Wimbledon College of Art

- Main Building,
 Merton Hall Rd, SW19 3QA
- ☎ 020 7514 9641
- www.wimbledon.ac.uk

This school holds its undergraduate degree show in June and its postgraduate show in July. Disciplines include sculpture, printmaking, fine art and theatre design. The foundation course show is held at the Palmerston Road site in June.

London Art Fairs

January

The London Art Fair

Business Design Centre,
Islington, N1
www.londonartfair.co.uk
This busy art fair brings together
over 100 galleries, showcasing
the brightest and best in modern
British and international contem-
porary art.

February

20/21 International Art Fair

Royal College of Art, Kensington
Gore, SW7
www.20-21intartfair.com
Launched in 2007, this fair shows
modern and contemporary art
from around the world but with a
strong UK content.

March/October

The Affordable Art Fair

Battersea Park, SW11
www.affordableartfair.com
Insanely popular biannual art fair
aimed at first time art buyers and
showing contemporary art with a
price ceiling of £4,000.

April

The London Original Print Fair

Royal Academy of Arts, Burlington
Gardens, W1
www.londonprintfair.com
This well-established event at the
RA brings together nearly 50 deal-
ers, between them showing the
gamut of graphic work from early
printmakers to contemporary
practitioners like Bridget Riley
and David Hockney.

May

Animal Art Fair

Fulham Palace
www.animalartfair.com
A recent addition to London's
art fair calendar, but one whose
exclusive focus on animal subject
matter, distinguishes it from the
pack. Given Britain's well-known
soft spot for the animal kingdom,
it looks set to be a fixture.

Collect

Saatchi Gallery, Chelsea
www.craftscouncil.org.uk/collect
International art fair for museum
quality contemporary applied art
— that's glass, jewellery, metal-
work, textiles, woodwork and
furniture to you and me.

September

20/21 British Art Fair
Royal College of Art,
Kensington Gore, SW7
www.britishartfair.co.uk
Celebrating its 20th anniversary
in 2008, this fair is the only one
exclusively devoted to British art
from 1900 to the present. Fifty
or so leading dealers wheel out
the big names of this century and
last, but this is also a place to
spot overlooked and up and com-
ing artists too.

September/October

The Goldsmiths Fair
Goldsmiths' Hall, junction of
Foster Lane/Gresham Street, EC2
www.thegoldsmiths.co.uk
A magnet for magpies and jewel-
lery lovers, this fair showcases
a glittering selection of work by
top jewellery designer-makers.
It's a great opportunity to meet
the makers themselves, find out
more about their work and per-
haps even purchase or commis-
sion a piece.

October

Origin
Old Spitatlfields Market, E1
www.originuk.org
Now part of the London Design
Festival, Origin retains its focus
on high quality original craft with
a tempting range of ceramics,
furniture, fashion accessories,
jewellery and textiles.

Frieze Art Fair
Regent's Park, NW1
www.friezeartfair.com
This international contemporary
art fair has gone from strength to
strength since its launch in 2003,
attracting visitors and column
inches in numbers. Organised by
the publishers of frieze art maga-
zine, it brings together around 150
handpicked galleries from around
the world and places them in the
sylvan setting of Regent's Park. A
dynamic programme of artists'
projects, events and talks accom-
panies the event.

Art London
Royal Hospital, Chelsea, SW3
www.artlondon.net
An invigorating mix of work by
established artists and young
unknowns, shown in an outsized
marquee in the grounds of the
Royal Hospital.

January/April/October

The Decorative Art and Antiques Fair
Battersea Park, SW11
www.decorativefair.com
Thrice yearly art fair, held in a
marquee in Battersea Park, and
dedicated to 'antiques for interi-
ors' and 20th century design.

General Index

index

index

index

Subject Index

index

index

Image Credits

p.3 Head of a Bhuddha © Victoria & Albert Museum p.4 Frieze from the Parthenon © British Museum, p.7 Apsley House © Apsley House, p.9 Banqueting House © Historic Royal Palaces, p.10 Dental Equipment© British Dental Association Museum and Library, p.15 The Great Court, British Museum © Stephen Millar , p.19 © British Optical Association Museum, p.21 © Churchill War Rooms, p.23 © Cartoon Museum, p.27 Design Museum © Ashley Woodfield, p.31 Fashion and Textile Museum © Michael Cockerham, p.33 © Foundling Museum, p.35 © Benjamin Franklin House, p.40 © Handel House Museum, p.45 Crystal Gallery in the Hunterian Museum © The Royal College of Surgeons of England, p.49 © Imperial War Museum, p.51 © Dr Johnson's House, p.52 © Kirkaldy Testing Museum, p.58 © London Transport Museum, p.58 © Museum of London, p.67 © Old Operating Theatre Museum & Herb Garret, p.68 © Petrie Museum of Egyptian Archaeology, p.74 Shakespeare's Globe © Andy Bradshaw, p.77 Sir John Soane's Museum © Martin Charles, p.80 Tower Bridge © Stephen Millar, p.81 Tower of London © Historic Royal Palaces, p.84 *A Vanitas Tableau* © Wellcome Library, p.87 © Westminster Abbey Museum, p.88 © Arsenal Football Club Museum, p.91 © Fenton House, p.92 © The Freud Museum,p.95 © Iveagh Bequest, p.96 © Jewish Museum, p.99 © Jewish Military Museum p.100 © Keats House, p.102 © London Canal Museum, p.104 © Royal Air Force Museum, p.107 © NTPL/Dennis Gilbert, p.110 © Chiswick House, p.115 © Leighton House Museum, p.116 © Museum of Brands, Packaging and Advertising, p.120 © National History Museum, p.123 © National History Museum, p.125 © Stephen Millar, p.128-131 © Science Museum, p.132 © 18 Stafford Terrace, p.134,137 © V&A Museum, p.138 ©Brunel Museum, p.140 © Cuming Museum, p.143 Eltham Palace © English Heritage Photo Library, p.147 © Horniman Museum & Gardens, p.149 © National Maritime Museum, p.152 Queen's House © National Maritime Museum, p.154 Royal Observatory Greenwich © National Maritime Museum, p.156 © Wandsworth Museum, p.159 © Dennis Severs House, p.161 Geffrye Museum © Morley Von Sternberg, p.165 © Museum of London Docklands, p.167 © Ragged School Museum, p.169 © V&A Museum of Childhood, p.174 © Bexley Heritage Trust, p.176 Down House © English Heritage Photo Library, p.179 © Bexley Heritage Trust, p.181 Hampton Court Palace © Historic Royal Palaces, p.179 Museum No.1 © RBG Kew, p.188 © Musical Museum, p.91 © Bexley Heritage Trust, p.194 © BH&M architects, p.197 © Dulwich Picture Gallery, p.199 © British Library, p.200 Van Gogh © Samuel Courtauld Trust/The Courtauld Gallery, p.203 © Hayward Gallery, p.207 Hans Holbein, The Ambassadors © The National Gallery, p.208 © Colin Streater/National Portrait Gallery, p.212 © Royal Academy of Arts, p.214 © Tate Britain, p.216 © Stephen Millar, p.218 © Tate Britain, p.219 © Two Temple Place, p.220 © Wallace Collection, p.222 © Ben Uri Gallery, p.224 © Estorick Collection, p.227 © Dulwich Picture Gallery, p.229 © Mairi McCann/ South London Gallery, p.233© Marianne North Gallery./ RGB Kew, p.237 © Wapping Project, p.238 © Ian Cox/ Lazarides Gallery, p,244 © Contemporary Ceramics Centre, p.252 © White Cube, p.261 © Richard Bryant / Somerset House

Order our other Metro Titles

The following titles are also available from Metro Publications. Please send your order along with a cheque made payable to Metro Publications Ltd to the address below. Postage and packaging is free, please allow 14 days for delivery.

Alternatively call our customer order line on 020 8533 7777 (Visa/Mastercard/Switch), Open Mon-Fri 9am-6pm

metropublications ltd
PO Box 6336, London, N1 6PY
www.metropublications.com / info@metropublications.com

||

Veggie & Organic London
by Russell Rose
£7.99

Book Lovers' London
by Lesley Reader
£8.99

London Market Guide
by Andrew Kershman
£7.99

||

The London Cookbook
by Jenny Linford
£14.99

London Architecture
by Marianne Butler
£12.99